SOFA
CHICAGO
SCULPTURE OBJECTS & FUNCTIONAL ART

The Twelfth Annual International Exposition of Sculpture Objects & Functional Art

October 28-30
Navy Pier

A project of Expressions of Culture, Inc.

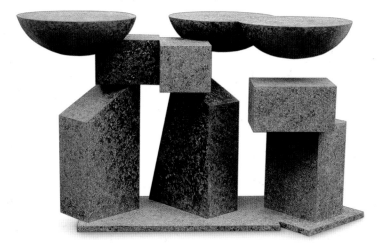

front cover:
Robert Marsden
Just to be on the Safe Side, 2003
patinated brass
represented by Barrett Marsden Gallery
photo: Khashayer Naimanan

All dimensions in the catalog
are in inches (h x w x d)
unless otherwise noted

Library of Congress – in Publication Data

SOFA CHICAGO 2005
The Twelfth Annual International
Exposition of Sculpture Objects & Functional Art

ISBN 0971371466
2005930545

Published in 2005 by Expressions of Culture, Inc., Chicago, Illinois

Graphic Design by Design-360° Incorporated, Chicago, Illinois
Printed by Pressroom Printer & Designer, Hong Kong

SOFA
CHICAGO
SCULPTURE OBJECTS
& FUNCTIONAL ART

Expressions of Culture, Inc.
4401 North Ravenswood, #301
Chicago, IL 60640
voice 773.506.8860
fax 773.506.8892
www.sofaexpo.com

Mark Lyman, president
Anne Meszko
Julie Oimoen
Kate Jordan
Jennifer Haybach
Greg Worthington
Barbara Smythe-Jones
Patrick Seda
Bridget Trost

Conte

SOFA
CHICAGO
SCULPTURE OBJECTS
& FUNCTIONAL ART

Welcome to SOFA CHICAGO 2005!

Welcome to SOFA CHICAGO 2005!

It is wonderful to look back and reflect on our twelve years of producing SOFA expositions, during which time we have been fortunate enough to be part of something larger, to have witnessed both the emergence and maturity of a new art form and a community.

We owe much to the remarkable ascent of galleries and dealers in the contemporary decorative arts, which, because of their vision and hard work, exists as a bonafide category of today's pluralistic arts. There is no longer any hard and fast separation between decorative and fine art. Rich hand-crafted traditions have been pushed to exquisite heights of sculptural form, allusive meaning and technical virtuosity.

Critical discourse has also made great strides; thankfully gone in the main are the craft versus art, form versus function, design versus decoration arguments. The artworks at SOFA have proven themselves again and again with their extraordinary presence – a quality that emerges from a complex aesthetic dialogue between artist, process and materials. And this year we are pleased to note that some galleries will present top-quality two-dimensional work; perhaps, in our own way, we too are becoming more inclusive, so as not to "define" contemporary decorative arts as strictly dimensional.

We owe much also to the SOFA community of collectors, curators, and arts professionals whose support has spawned truly exceptional Lecture Series and Special Exhibit presentations. Both good fortune and synergy behind the scenes coalesce into vibrant "happenings" that cut across cultures, art movements and even politics. One strong example is the Special Exhibit presented by the Association of Israel's Decorative Arts, now in its third year at SOFA. A response to the isolation of Israeli artists during the second wave of the *Infidata,* sponsors Charles and Andrea Bronfman and Doug and Dale Anderson, along with many other key individuals, committed themselves to bringing top Israeli artworks and artists to SOFA where they might have an opportunity to be part of a larger community of contemporary decorative arts enthusiasts. It has been a truly reciprocal exchange.

SOFA has been at the forefront of creating a broad public for new art forms. Through the sponsorship of the Furniture Society, we are honored to present the Special Exhibit *Convergence: Crossing the Divide, The Studio Furniture of Tasmania and America,* an exhibition first presented by the Oceanside Museum of Art and the San Francisco Museum of Craft + Design. An estimated 35,000 persons are expected to attend SOFA CHICAGO 2005 and delight in the cross-cultural presentation of cutting-edge furniture, which like most of fine artworks at SOFA, express both culturally specific qualities and globally human ones. We are also very pleased to bring to life from the pages of **Metalsmith** magazine, the *2005 Exhibition in Print: Flatware: Function + Fantasy,* presented by Society of North American Goldsmiths.

Many thanks to the Hot Glass Roadshow of The Corning Museum of Glass, Corning, NY, returning to SOFA CHICAGO for the fourth straight year; and the Chicago Woodturners, sponsored by The Collectors of Wood Art. These exciting live presentations of hot glass-blowing and woodturning animate a visitors' experience at SOFA CHICAGO, and contribute to an understanding of the extraordinary process and skill behind the artworks.

A final word of thanks to the hardworking staff of SOFA CHICAGO and its sister show, SOFA NEW YORK. Your enthusiasm and camaraderie make our work a pleasure. And to the public and press, your support has been critical to our success.

ENJOY!

Mark Lyman
President, Expressions of Culture, Inc.

Anne Meszko
Director of Advertising and
Educational Programming

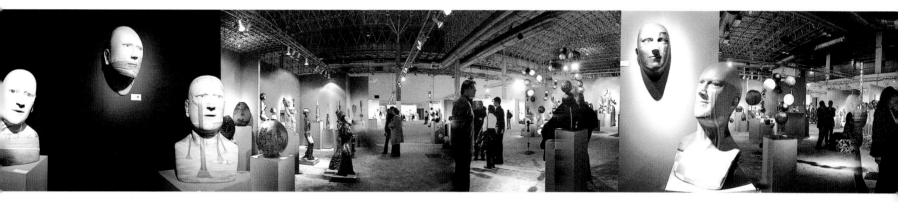

Expressions of Culture, Inc. would like to thank the following individuals and organizations:

Participating galleries, artists, speakers and organizations
American Airlines
American Craft Council
Aaron Anderson
Dale Anderson
Doug Anderson
Art Alliance for Contemporary Glass
Art Jewelry Forum
Association of Israel's Decorative Arts
Nancy Babich
Ann Bachman
Bruce Bachman
Thomas Samuel Bailey
Boris Bally
Barefoot Wines
David Barnes
Barbara Berlin
Sandra Berlin
Kathy Berner
Jim Bradaric
Lou Bradaric
Kirk Bravendar
Andrea Bronfman
Charles Bronfman
John Brumgart
Desiree Bucks

Chicago Art Dealers Association
Chicago Event Graphics
Chicago Woodturners
Julian Chu
Kelly Colgan
Collectors of Wood Art
Steve Compton
Camille Cook
Keith Couser
John Cowden
Design-360°
Dietl International
Digital Hub
Floyd Dillman
Hugh Donlan
Anne Dowhie
Lenny Dowhie
Helen W. Drutt English
Marianne Encarnado
D. Scott Evans
Jane Evans
Sean Fermoyle
Fine Art Risk Management
Focus One
The Furniture Society
Don Friedlich
Friends of Contemporary Ceramics

Friends of Fiber Art International
Steve Gibbs
Andrew Glasgow
Judith Gorman
Fern Grauer
Kathryn Gremley
Lauren Hartman
Evan Haughey
Matt Haughey
Adam & Paula Haybach
Bruce Heister
Wayne Higby
Scott Hodes
Holiday Inn City Centre
Holly Hotchner
Hotel Indigo
J & J Exhibitor Service
Scott Jacobson
James Renwick Alliance
Howard Jones
John Keene
Ryan Kouris
Penelope Koven
Lakeshore Audio Visual
LaSalle Bank-Wealth Management
Matthew Lipinski
Ellie & Nate Lyman

George Mazzarri
Michael Macigewski
Jeanne Malkin
Arthur Mason
Jane Mason
David Revere McFadden
Brad Merrick
Metropolitan Pier & Exposition Authority
Dara Metz
Gretchen Meyer
Mark Moreno
Bill Murphy
Cathy Murphy
Nancy Murphy
Susan Murphy
Kathleen G. Murray
Museum of Arts & Design
Museum of Contemporary Art
Ann Nathan
National Basketry Organization
Wells Offutt
John Olson
Therese O'Malley
Karen Orlich
Bruce Pepich
Bin Pho
Pilchuck Glass School

Lara Poyas
Pressroom Printer & Designer
Rosanne Raab
Racine Art Museum
Bruce Robbins
Jesse Robertson
Pat Rodimer
Christina Root-Worthington
Linda Schlenger
Sheraton Chicago Hotel & Towers
Dana Singer
Aviva Ben Sira
John Smith
Penny Smith
Society of North American Goldsmiths
Cyndi Solitro
Surface Design Association
Richard Thompson
Stacy Tidmore
VU Case Rentals
Natalie van Straaten
Israel Vines
The W Hotel Lakeshore
Kiwon Wang
Danny Warner
James White

OFFICE OF THE MAYOR

CITY OF CHICAGO

RICHARD M. DALEY
MAYOR

October 27, 2005

Greetings

As Mayor and behalf of the City of Chicago, it is my pleasure to welcome everyone attending the Twelfth Annual International Exposition of Sculptural Objects and Functional Art: SOFA CHICAGO 2005 at Navy Pier.

SOFA CHICAGO 2005 features a wide variety of artistic styles and media from glass, ceramics and wood to metal and fiber. This twelfth annual art exposition showcases the works of more than 700 artists from over 90 international galleries and dealers. Continuing this year will be sculptural glass presentations, a lecture series and special exhibits.

Chicago has a long and vibrant artistic tradition and we are proud to host SOFA CHICAGO. I commend the artists represented here for their talent and hard work, as well as Expressions of Culture, Inc. for bridging the worlds of contemporary decorative and fine art. May you all have an enjoyable and memorable exposition.

Sincerely,

Mayor

CHICAGO ART DEALERS ASSOCIATION

730 North Franklin
Suite 308
Chicago, Illinois
60610

Phone
31.649.0065

Fax
312.649.0255

October 28, 2005

Mark Lyman
Executive Director
Expressions of Culture, Inc.
4401 N. Ravenswood, #301
Chicago, IL 60640

Dear Mark,

Your 12th annual SOFA CHICAGO marks more than a decade of bringing outstanding exhibits to Navy Pier and Chicago. With work bridging decorative and fine arts in a wide range of media, SOFA offers a great resource to local and international collectors and visitors who look forward to the exposition each year. SOFA contributes greatly to the cultural activity of the city.

On behalf of the members of the Chicago Art Dealers Association, I extend our congratulations and best wishes to you and all the participating galleries and artists for a most successful show. Thanks to you, your staff and everyone involved in this outstanding event for bringing it to Chicago.

Sincerely yours,

Roy Boyd, President
Chicago Art Dealers Association

Le

Lecture Series and
Special Exhibits

ectures

Lecture Series

sponsored by SOFA CHICAGO 2005

Friday

October 28

9:00 – 10:30 AM, Room 301

The Soft Side of Sculpture 1
Fiber artists **Lissa Hunter, Judy James, Laura Foster Nicholson, Lindsay Rais** and **Donna Rhae Marder** express and explain the soft side. *Presented by Friends of Fiber Art International*

9:00 – 10:00 AM, Room 309

Emerging Talent 2005
Three of jewelry's rising stars, **Anya Pinchuck, Sergey Jivetin** and **Melanie Belinker,** speak about the development of their brilliantly obsessive jewelry. *Presented by the Society of North American Goldsmiths*

10:00 – 11:00 AM, Room 305

Turning Point: The Inspiration of the Edward Jacobson Collection of Turned Wood Bowls
An exploration of the Edward Jacobson collection of turned wood, and subsequent exhibitions and acquisitions of contemporary art in wood at the ASU Art Museum, by **Heather S. Lineberry,** senior curator, Arizona State University Art Museum. Presented by Collectors of Wood Art

10:00 – 11:30 AM, Room 309

Flatware: Function + Fantasy
An exploration of the past, present and future of flatware with a panel of makers from *Metalsmith's Exhibition in Print 2005,* on display at SOFA. Artists **Phil Carrizzi, Fred Fenster** and **Michel Royston,** moderated by co-curator **Rosanne Raab.** *Presented by the Society of North American Goldsmiths*

10:30 AM – noon, Room 301

The Soft Side of Sculpture 2
More about the soft side by fiber artists **Mary Merkel-Hess, Leah Danberg, Linda Behar, Pamela Becker** and **Karen Halt.** *Presented by Friends of Fiber Art International*

11:00 AM – noon, Room 305

Come One, Come All
Judy Onofrio focuses on her current traveling museum exhibition, *Come One, Come All,* illustrating the transformation of her sculpture over the last 10 years.

11:30 AM – 1:00 PM, Room 309

Artists & Emergencies: The Journey Back
Artists **Michael Bauermeister, Laura Donefer, Karen Karnes** and **Richard Royal** discuss the career-threatening emergencies each experienced in their lives, and what it took to sustain their careers. Moderated by **Bruce Pepich,** executive director, Racine Art Museum, WI. *Presented by the Craft Emergency Relief Fund*

Noon – 1:30 PM, Room 301

Studying a Passion: Views on Collecting
Academic and personal interpretations of collecting, presented by **Stacy Tidmore,** Ph.D., collectors **Arthur Mason, Anna Mendel** and **Dudley Anderson,** moderator.

1:00 – 2:00 PM, Room 309

Philosopher's Stone
Dutch artist **Ruudt Peters** discusses the direct relationship of our daily environment to art jewelry in general, and specifically, the influence of the modern environment on his work. *Presented by Art Jewelry Forum*

1:30 – 2:30 PM, Room 305

Taking Flight: The Making of the "Wing"
Czech artist **Ivan Mares** documents the creative and physical process involved in the casting of his massive glass sculpture, "Wing".

1:30 – 3:00 PM, Room 301

The Growing Role of Museums in the Crafts
Growth of interest in the high crafts by fine art museums, with a focus on wood art. **Patricia Kane,** Curator of Decorative Arts, Yale University Art Gallery; **Jack Larsen,** President, LongHouse Reserve; moderated by **Kevin Wallace,** writer and curator. *Presented by Collectors of Wood Art*

2:30 – 3:30 PM, Room 305

Organic Ornament
Artist **Tom Lundberg** looks at the language of ornament and its conversation between indoors and outdoors, as evidenced in his stitched textiles.

2:30 – 3:30 PM, Room 309

Pilchuck Glass School and its Colleagues: An Educational Theme with Variations
Artist, teacher and Pilchuck Glass School trustee **Fritz Dreisbach** takes a look at the school's history and the way that art education in glass has blossomed worldwide since Pilchuck's beginnings in 1971. *Presented by Pilchuck Glass School*

3:00 – 4:00 PM, Room 301

An Artist and Educator Reflects on His Work
Fred Fenster, metalsmith and 2005 American Craft Council Gold Medalist, discusses his work and the ideals that have driven his career. *Presented by American Craft Council*

3:30 – 4:30 PM, Room 309

International Contemporary Basketry/Sculpture: Looking East, Looking West for Influences
Innovation, complexity of form and weave structure are some of the sculptural qualities that will be discussed by artist and author **Nancy Moore Bess.** *Presented by the National Basketry Organization*

Special Exhibits

Saturday
October 29

9:00 – 10:00 AM, Room 309
**Stephen Powell:
Symmetry to Asymmetry**
Powell traces the evolution of his
work, from traditional symmetrical
vessel forms to his most recent
asymmetrical forms.

10:00 – 11:30 AM, Room 301
**Convergence: Crossing
the Divide—The Studio
Furniture of Tasmania
and America**
A panel discussion by studio
furniture artists in this special
exhibit, on view at SOFA.
Co-curators Wendy Maruyama,
San Diego, and John Smith,
Hobart, Tasmania; Tom Loeser,
Madison, WI and Patrick Hall,
Mount Nelson, Tasmania.
*Presented by The Furniture
Society*

10:00 – 11:00 AM, Room 305
**Flo Perkins:
New Work/New Mexico**
Nature informs us, the man-made
world tells on us. Perkins talks
about her new work.

10:00 – 11:00 AM, Room 309
**Richard Slee: A
Retrospective View**
The artist will explore and
illustrate eight clear phases
in his thirty-year output of
ceramic work.

11:00 AM – noon, Room 305
**Material Presence/
Body Absence**
Artist Brian Boldon discusses
his synthesized language of elec-
tronic image and ceramic form
questioning the sustainability of
the absent body.

11:00 AM – noon, Room 309
**Bob Ebendorf:
A Continuing Journey**
Ebendorf discusses his 40
year journey as a studio jeweler,
designer, and distinguished
educator.

11:30 AM – 12:30 PM, Room 301
**Rare Trades: Making Things
by Hand in the Digital Age**
Technology often transforms
traditional skilled trades beyond
recognition overnight. Who and
what trades remain? What can
we learn from the remaining
makers? Mark Thomson, author
and curator, Australia

12:30 – 1:30 PM, Room 309
Topic: Surface and Structure
Artist Barbara Lee Smith searches
beneath surface design to reveal
the structure of idea, intention,
methods, and materials that
coalesce to make today's textile
art compelling. *Presented by
Surface Design Journal*

1:00 – 2:00 PM, Room 301
**Contemporary Latin
American Art in Glass:
Silvia Levenson and Einar
and Jamex de la Torre**
The work of Silvia Levenson
and the de la Torre brothers
is presented and discussed in
the context of topics in contem-
porary Latin American art. Tina
Oldknow, Curator of Modern
Glass, The Corning Museum
of Glass

1:30 – 2:30 PM, Room 309
**Dennis Nahabetian: Merging
Metal, Fiber and More**
Nahabetian describes the inven-
tion of process and exploration
of form that define his wire ves-
sels and jewelry. *Presented by
the Society of North American
Goldsmiths*

2:00 – 3:00 PM, Room 301
Village People
Hank Adams, artist and creative
director at Wheaton, discusses
his work, the nature of a commu-
nal creative sanctuary, and the
unique interface of the individual
artist within a public institution.
*Wheaton Village is the recipient
of Art Alliance for Contemporary
Glass' annual award to a program
or institution that has significantly
furthered the studio-glass
movement.*

2:00 – 3:00 PM, Room 305
Jennifer Lee: Ceramic Artist
An overview of the British artist's
work from the last 25 years,
focusing on her one-off handbuilt
ceramic vessels and her travels in
Egypt, India and North America.

2:30 – 3:30 PM, Room 309
Visions in Stitch
Fiber artists Rozanne Hawksley
and Audrey Walker, of Wales,
share their vision, techniques
and experiences in the art world.

3:00 – 4:00 PM, Room 301
The Pleasure of Light
Louis Mueller looks at the
25 year evolution of his work
with sculptural lighting.

**Convergence: Crossing the
Divide – The Studio Furniture
of Tasmania and America**
Studio furniture makers from
opposite sides of the world
present the most recent designs
in contemporary studio furniture.
Presented by The Furniture Society

Flatware: Function + Fantasy
An exhibit of flatware from
*Metalsmith magazine's Exhibition
in Print 2005,* co-curated by
Rosanne Raab and Boris Bally.
*Presented by The Society of
North American Goldsmiths (SNAG)*

Updating Traditions
A curated exhibit of contemporary
decorative artwork by artists
currently living in Israel. *Presented
by the Association of Israel's
Decorative Arts in cooperation
with the Eretz Israel Museum*

**Corning Museum
of Glass Presents**
The Hot Glass Roadshow.
Ongoing artist presentations
feature live glass blowing

Woodturning Demonstration
Ongoing demonstrations by
well known artists. Organized
by the Chicago Woodturners.
*Presented by Collectors of
Wood Art*

Essays

Essays

On Collecting: A Folkloric View

By Stacy Tidmore

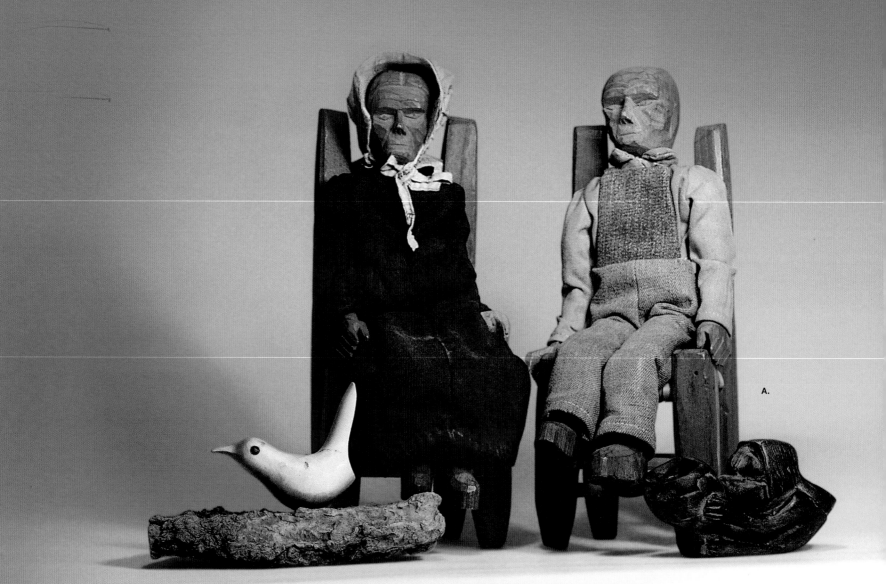

A.

Recent estimates hold that approximately one in three people living in the United States collect some form of object. Moreover, two in three American households likely contain at least one collection. The popularity of collecting is often described as a result of life in a materialistic society. Indeed, the cultural landscape that accommodates this proportion of collectors is well-equipped to support such activity, but understanding collecting behavior as a mere response to a public environment of consumption fails to grasp the individual motivations and responses of collectors themselves. I first became interested in collecting during a visit to Graceland, where I and a fellow Folklore student investigated souvenirs. Though the place and its material culture is fascinating enough to warrant return trips, I went back to talk with Elvis fans and learn about their souvenir collecting. The individuals I met did not just react to an environment saturated with sentimental collectibles; they created thoughtful testaments through which they presented themselves and connected to others. After Graceland, I studied collection through the experiences of collectors I met in North Carolina. Several individuals generously gave of their time to teach me how collection functions in their lives. Within this group, patterns emerged that signal the inherent complexity of collecting – patterns that belie descriptions offered by some who theorize the phenomenon.

Collection suffers from its prevalence; its ubiquity within and across cultures makes it difficult to study. Although a well-known activity, much of the existing scholarship on collection is limited by the few examples of collecting chosen to study. Those with a psychological view often select instances of hoarding through which they classify collecting in general, and people trained in art frequently work with collectors whose work is sanctioned by key cultural institutions and thereby established as exclusive. Hence, collectors are often considered through a lens of illness or connoisseurship – two considerable if limited perspectives. Scholars of cultural studies attempt to mediate this polarity with attention to the everyday collecting of middle-class people, but their social theory-based work often lacks the focus on individual collectors that make the psychological and art historical studies so compelling. In order to understand more about collecting, it needs to be considered through the experiences of collectors themselves. The search for patterns may span collections of all sorts, letting the democratic existence of the phenomenon be reflected in the academic studies of it.

My own disciplinary perspective led me to consider collection as a process of artful communication. Collections, organized assemblages of objects, are understood as texts with legible forms. The human behaviors and circumstances that relate to and surround collections serve as context. Relationships between text and context frame much of the investigative work of Folklore. And through attention to the stories collectors weave in objects as well as to the interactions with groups and other individuals that these stories inspire, much is to be learned about the humanity of this cultural phenomenon.

One such bit of humanity expressed among the North Carolina collectors is an enigmatic tone that pervades collection birth stories. Collectors often liken such beginnings to the "bite of the collecting bug," as if the collection is an animate force that infects its unsuspecting victim. The "bug" is also frequently considered a genetic phenomenon, an innate personality characteristic that needs only a stimulus to activate its expression. In light of these popular ideas to which the collectors casually referred in moments of gentle self-ridicule, individuals were not easily able to articulate why they started to collect a particular object, for they often did not intellectualize – in the beginning – why they were drawn to it. As they considered their creation's early development in an attempt to locate the germ from which the collection sprang, collectors thought back to relevant experiences of their childhoods. Many of them fondly remember adult-led activities with material culture: trips to museums and antique shops, artifact hunts, tours of potteries. These individuals also recall childhood play experiences, such as model airplane or doll collecting, that were supported by adults if not initiated by them.

A.
Wren on Driftwood
Attributed to Dexter
Dockery, woodcarver
Brasstown, NC

Articulated Mountain Dolls
c. 1950
Attributed to Pauline Page
Pleasant Hill, TN

Steatite Smoking Pipe
Maker Unknown
Western North Carolina

B.
Chestnut Chalice
Edd Presnell, woodtuner/
instrument maker
Avery County, NC

Saltglazed Stoneware Pigs
Ina Owens Bolick
Caldwell County, NC

Oak Splint Buttocks Basket
Maker Unknown
Western North Carolina

C.
Three Bears, c. 1967
Sue McClure, woodcarver
Brasstown, NC

Copper Moonshine Still
Maker Unknown
Western North Carolina

B.

C.

To the degree that a collection was born, collectors logically turned to their childhoods to express the mystery in why an object seized their attention. The reasons to collect as a child are usually simple – children collect because they like to. They have a visceral reaction that sufficiently satisfies their inquiring minds as well as the expectations of adults. Collecting is a form of play readily understood in childhood. One collector shared a story about a four year-old student who collects beer bottle caps. The boy regularly carried a handful in his pockets to school, and this collector believes he enjoyed the sound they made as well as their feel and visual designs. Sensory pleasure, the collector posits, is explanation enough for his collection. And this collection, as play, is socially acceptable despite the fact that a preschool aged child owns countless caps from beer bottles. Adults though often struggle to harmonize this impulse with their worldview; the visceral is difficult to articulate, but they react to it. Many of the collectors' purchases that initiated their collections were spontaneous responses to objects they found "moving." Often, their first pieces were unplanned acquisitions, spur-of-the-moment finds. The inference that may be drawn from such narratives, which mystify a collection's origin and recall childhood feelings elicited from experiences with artifacts, is that an "affecting presence," as formulated by Robert Armstrong, motivates collection. Collectors often find it difficult to communicate the feelings that surface from their reactions to the physical forms of objects. Armstrong asserts that the affecting presence "is most uniquely an address from and to man's interiority."[1] Such interiority, often expressed as "a gut feeling," "falling in love," or the subconscious self, becomes the locus of the collecting drive for many adults. Moreover, the relevance of Armstrong's concept continues to impact collectors' experiences as they search for meaning in their collecting.

Though the collections I studied are mature and thus highly defined by their collectors, nascent collections often are not yet understood. One individual recently began a collection of Virgin Mary portraits. The small, framed images hang above her bed and mys--tify her. She does not yet have an explanation for them; they simply "speak" to her. Another collector's collection of moonshine still models serves no discreet "purpose" yet, beyond its ability to interest him. The meanings of these young collections are not immediately clear, or effective, because they are affective. Because the connections here between person and object are ambiguous, time must be granted for these collectors to process their feelings and develop experiences that will articulate the connotations. It is what collectors do with their collections that make them meaningful.

Narratives that describe a collection's meaning were produced by each of the profiled collectors. Such narratives reveal a desire to see the creation as functional, as of value. In this way, adults move beyond their visceral reactions to objects in order to create intellectual reasons for collecting. Furthermore, with the creation of meaning, follows the experience of belief in the collection's significance to others beyond the single collector. Collections are thereby valuable not only in a personal manner, but also socially. Within the group of North Carolina collectors, scholarship, art, and culture were interrelated fields of value attributed to all the collections. Individuals used their collections to inspire creative academic writing, artistic pieces, and cultural projects. Meanings are concepts unique to the collector's personal motivations and experiences, and they are socially connective ideas that allow the formation of community. The narratives of meaning that the collectors generate reveal collecting to be a social process. As valuable to the collector personally as well as to others through the contexts of culture, art, and scholarship, collections serve as a web through which relationships are formed. These collections, though personal, are not narcissistic, and though social, are not generic. They are socially acceptable expressions of identity.

The narratives regarding collection origins and meanings imply that the process of collecting is traditional. Although collectors lightheartedly say they are born and not made, collecting, in the case of the profiled group, is a learned behavior. Each collector experienced either a childhood where collecting was a familiar and positive activity, a profession where collecting was understood to be integral to productivity as with art, or a significant adult relationship in which collecting functioned to build intimacy. Collecting was never described to be a behavior developed in isolation. In addition, the practice of collection building and the activities that revolve around a collection form a community that maintains the tradition. People who collect identify themselves, sometimes after first being identified by others, as collectors. Tradition is the cause and effect of this group identity. In other words, as traditional, collecting enables the ready identification of its practitioners, and its traditionalism is a consequence of its collectors. Also, because collections result from individual experiences, the idea of tradition does not imply stagnancy, but rather constant change. The dynamic nature of collecting makes it a powerful and enduring tradition because it compels people to make their way through their world with the comforting recognition of the past. Collection is a traditional method through which people learn to assimilate into their lives material objects they find affecting and identify themselves as members of a community.

D.

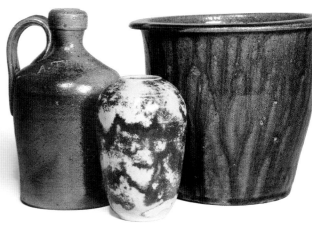

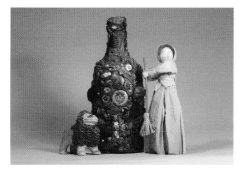

E.

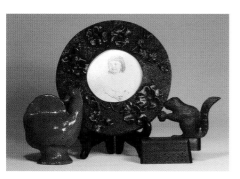

F.

G.

One implication of the tradition of collecting for each collector documented in the portraits, is that the collection functions as a material text of a collector's group affiliations and individual personality. The materiality of the text and the traditionalism of the collecting behavior enable individuals to create enduring alternative histories of their lives. Collectors willfully take control of their own identity and legacy when they collect. They create a text that reflects their own perspective on their life. Their narratives of self may mesh with other identity-forming activities, or they may deviate from a person's typical pursuits. When a collection introduces information not already known about a person, it may be considered as alternative. Moreover, the term "alternative," in its use within Folklore, points to the view of the individual. Regardless of how closely a collection relates to one's public persona, it allows people to willfully express what they value, and these expressions shape a story of self.

As self-reflective texts, collections are not unlike a form of oral alternative history making: the personal experience narrative, forming the acronym, PEN. Much like the collection, the PEN, stories people tell about themselves, is a widespread phenomenon. Tellers of PENs are diverse, and though there are formal regularities to these narratives, their styles vary tremendously. Anybody with the inclination can create a PEN, much as anyone can construct a collection. As outlined by Sandra Dolby, a PEN functions to allow people to represent themselves in a socially acceptable manner, and it is a way for people to build relationships with others and groups.[2] The formal characteristics that enable a PEN to express and connect individuals include a text that exhibits the narrator, variation, authenticity, and dramatic narrative structure, as well as performance that is repetitive, with an expectation in the audience's belief. Though a material manifestation of text, the collection shares many of the characteristics of the oral text of the PEN. The collector is an integral element to the collection, as collections draw attention to the individuals who create them. A collector's collection is usually one of many, and indeed all the collectors I interviewed maintain several collections.

The collection is an authentic creation – it is real to the collector. And the collection's significance is expected to be believed by others; collectors often expect their creations will be valued by institutions, or at least, informed individuals. Finally, a narrative structure in which mystery, the unarticulated affecting presence, leads to meaning, the creation of value, is commonly found in collections. In all these ways, collections, like PENs, act as socially acceptable models through which people represent themselves and create intimacy with others.

Collectors are risk-takers. Despite charges of materialism or eccentricity, they create texts that reveal to themselves and the world a bit of their soul. They take what affects them and create monuments of their ideas and feelings. In this way, collections are not unlike the heart held in an egg described in folktales. This tale type illustrates an ogre who carries his heart outside of his body and thereby puts both in jeopardy. The ogre's egg makes an apt metaphor for the soul of an individual held in a collection. Collectors who expose their hearts to the world in a collection become vulnerable like the folktale's ogre, but such is the work of collecting. Collections are metaphorical creations that represent life through constructed contexts.[3] All collectors work in metaphor, the "ultimate principle" of art.[4] The art of collection is an individual's presentation of self, and as collectors demonstrate, it is one that enriches the collector and others.

[1] *The Affecting Presence: An Essay in Humanistic Anthropology,* Robert Plant Armstrong (University of Illinois Press, Urbana 1971), p. 34.

[2] *Literary Folkloristics and the Personal Narrative,* Sandra Dolby Stahl (Indiana University Press, Bloomington 1989).

[3] *On Longing: Narratives of the Miniature, the Gigantic, the Souvenir, the Collection,* Susan Stewart (Duke University Press, Durham 1993), p. 152.

[4] Armstrong p.xix

Stacy Tidmore completed a combined PhD in Folklore and American Studies at Indiana University in 2003. Her research focuses on the collection of various forms of material culture. She lives in Kansas with her husband and son.

Photographs courtesy of Steve Compton, a collector of North Carolina handmade pottery and other forms of folk art.

D.

Saltglazed Stoneware
Jug, c. 1860
Alexander Teague
Moore County, NC

Chinese Blue Glazed
Stoneware Vase
Ben Owen, Sr., potter
Jugtown Pottery
Moore County, NC

Alkaline Glazed
Cream Crock
James Frankin Seagle
Lincoln County, NC

E.

Redware Lion
Billy Ray Hussey
Moore County, NC

Memory Bottle
Maker Uknown

Cornhusk Doll
Western North Carolina

F.

Pit-fired tree trunk
pottery candlestick
Maude Welch, potter
Cherokee, NC

Saint Francis
Christine Anderson
Brasstown, NC

Bear Carrying Basket
Annie Driver, potter
Cherokee, NC

G.

Redware Chick
Salt Shaker
Jugtown Pottery
Moore, NC

Walnut Frame
Biltmore Industries
carver
Biltmore Village, NC

Squirel Lidded
Stamp Box
Biltmore Industries
carvers
Biltmore, NC

A.

Convergence –
View from the Edge

By John and Penny Smith

Convergence: Crossing the Divide is an exhibition of studio furniture from Tasmania and America that has formed cross-cultural links across the continents. The exhibition features work by Mark Bishop, Patrick Hall, Wayne Hudson, Brodie Neill, Kevin Perkins, Peter Prasil, John Smith and Ross Straker from Tasmania, and North American artists Jon Brooks, Paul Epp, Donald Fortescue, Tom Loeser, Kristina Madsen, Wendy Maruyama, Rosanne Somerson and Peter Walker.

Convergence's US tour was launched at the Oceanside Museum of Art, San Diego earlier in the year and was then shown at the San Francisco Museum of Craft + Design, before being presented at SOFA CHICAGO by the Furniture Society.

Tasmania sits geographically on the very edge of the world – the underbelly of 'down-under' and is sometimes referred to as 'a forgotten teardrop at the bottom of Australia.' It has occasionally been left off the national map. However, its relative isolation has also protected it from uncontrolled development and preserved much of its seductive charm.

"The garden of Australia, a gem suspended from its neck"[1] is a description still mostly applicable even today. With its reputation for the 'clean and green' production of fine foods and wines, Tasmania provides a tourist haven for those Australians and overseas visitors alike who seek a calm respite from the big city blues, and a refuelling of the spirit. Its seemingly tranquil environment and relatively gentle lifestyle is beguiling, and one could be forgiven for thinking that little stirs in this forgotten Eden.

But Tasmania, more so than any other State in Australia, has a dark and troubled history, that in some ways is signified by the harsh beauty and inherent dangers of its 'wild' places. Its violent convict colonial beginnings and its brutal treatment and near total genocide of its indigenous people with no surviving full bloods, casts a long shadow from the past. Out of its dark forests, this is still felt today and contrasts starkly with the sheer magnificence of its landscape.

Even if based in the State capital of Hobart, one is constantly reminded of the close proximity to the 'wild' – the bush. The mountains, rivers and forests that spill across the land from the rugged 'wild west' coast to the more sublime east coast form a majestic backdrop as we sit at the edge, looking out at the rest of the world.

This sense of being on the edge applies to Tasmania's east coast which faces eastward, looking across the seas as it does to the west coast of America, which faces in the other direction, looking westward across the Pacific. This highlights the similarities and parallels between the US and Australia in their histories, landscapes and attitudes.

But sitting on Malibu beach, with ones back to the desert, the 'wilderness' behind and nothing obstructing the view over the western horizon, a small ripple off Marrawah on the north-west tip of Tasmania rises to a surfable swell at Malibu. A common whisper of an image reflected in two distorted mirrors.

This coast-to-coast mirage contains shared ghosts of European colonialism, of population growth through immigration and a frontiersman pioneer attitude of looking forward to a self-made future, leaving history behind. Both cultures have similar legacies of social discord when it comes to finding meaningful reconciliation with the indigenous cultures, which still beat with ancient hearts at their centers. But as edge-dwellers, the majority of our population clings to the coastline; we have slowly been sucked into our adopted lands emotionally and metaphorically.

A.
John Smith
Errol and Essie – Dancing Drawers, 2004
blackwood veneer over marine plywood,
aluminium, stainless steel,
Corian, digital prints, Perspex
66 x 47.5 x 22
Photo: Peter Whyte

B.
Patrick Hall
Lure, 2005
plywood, aluminum, glass, collected
fishing reels, LED lighting
71.5 x 43 x 21
Photo: Peter Whyte

B.

These elements are expressed in studio furniture – not only in a regional sense but also in a dialogue with 'the other' beyond our shores. In Tasmania this is evident in the studio furniture which has retained some of the traditional skills inherited from its colonial heritage of restrained functionalism. Tasmanian studio furniture is also overlaid with some of the more expressive freedom and sculptural narrative that has become so well developed across the North American continent, and is now synonymous with its studio furniture.

In Tasmania, the growth of creativity is inevitably influenced in part by the natural environment where big expansive chunks are still very wild and relatively untouched. Although increasingly threatened by mining and unrelenting forestry pressures, as well as tourism running the risk of 'loving it to death', the wilderness still remains something of a touchstone of spiritual dimensions to the artists working here, including its furniture artists.

Not all artists refer to their natural environment in a direct way. All, however, do use their locale in some part, to position themselves philosophically to form a worldview from their island perspective.

It is the island relationship of Tasmania's 'edge' to the 'beyond' which remains intriguing. Much of Tasmania's design is inspired by the notion of the island's regional particularity, in dialogue with an international design generality. The local is thus informed by the global, and vice versa.

This vision of 'standing on the edge' – looking inwards and outwards simultaneously – is shared by many Tasmanian furniture artists to varying degrees. Their works illustrate their maker's specific viewpoint to form a philosophical perspective on design and life in general, from the peculiar vantage point that is Tasmania.

The island is held as a mental construct in the mind. Its size and shape encapsulated in the imagination like a protective nest where the 'home-bird' can luxuriate in its rich heart or the migratory spirit can push against its boundaries.

But it is inextricably linked to what is happening elsewhere, and the furniture practitioners feed off that as much as local stimulus, but it is all digested through a regional taste. In cultural terms, Australia is a western nation sitting in a southeast-Asian regional context. It has traditionally drawn from its British colonial background culturally, mixed with a wider European immigration growth, though now with a growing Asian immigration mixed with many other cultural backgrounds from elsewhere. The other major cultural influence has been the USA, primarily through the medium of popular culture.

For this reason, the key educational program from which the majority of furniture artists have emerged in Tasmania over the past three decades has deliberately drawn input from Britain initially and the US latterly, tempered by local viewpoints and supplemented by local skills. Although prior to this, summer schools had been conducted in Tasmania during the late 1970s by Don McKinley from the Sheridan School in Canada, which primed interest in the furniture area.

The furniture program at the University of Tasmania was established in 1981 through residencies by British furniture artists, Ashley Cartwright and Hugh Scriven. This structure was based upon the designer-maker practice that was emerging in Britain at the time.

c.

Later, furniture artists from the United States were sought to inject an alternative view point into the scene. Jon Brooks worked at the School as a resident artist and teacher in 1983-84, and returned again in 1990. He brought an organic visual language of free-form sculptural application to furniture. This approach served as a means of making political and social commentary upon a hot issue of the day – the fight to save the wild Franklin River from Hydro-damming – but without compromising furniture's everyday utility. Brooks took away with him a heightened sense of colour as a means to further expand his own decorative palette and a lighter, linear aesthetic using 'stick-wood' instead of 'slab-work' to make tall ladder-back chairs, which were to become his signature pieces.

As an artist resident in 1988, Kristina Madsen brought to Tasmania a delicate but disciplined sensibility of surface relief decoration and, equally importantly, a valuable role model to women who aspired to become furniture artists. Madsen took away with her cemented friendships, a sense of community and collegial critical discourse. She also pursued links to Fiji through Tasmanian artist and bark cloth expert, Dr. Roderick Ewins, which influenced her work thereafter.

D.
Wayne Z. Hudson
Dancing Tigress, *2004*
aluminium base, steel, leather, fabric,
silicon rubber, aluminium rivets,
stainless steel cable
65 x 33.5 x 45.5
Photo: Peter Whyte

E.
Peter Prasil
Debacle 98, *2004*
plywood, polyurethane foam, Fiberglas,
automotive paint, aluminium, stainless steel
47 x 29.5 x 37.5
Photo: Peter Whyte

F.
Wendy Maruyama
You don't know what you've
got til it's gone, *2005*
polychromed mahogany, digital media,
lead, fur
50. x 18 x 14
Photo: Michael James

C.
Ross Straker
Duo, *2005*
laminated plywood, closed cell foam,
stainless steel, kiln-polished glass
28 x 27 x 75
Photo: Peter Whyte

In 1985, Peter Adams from Penland joined the permanent staff of the School, reinforcing the freer sculptural vision that Brooks had introduced earlier. Adams took up permanent residency, contributing a great deal to the emerging philosophy surrounding the development of furniture design within the program. He identified strongly with passionate concerns to protect the environment and to use the forest resources intelligently and with the respect that they deserved. Adams has since left teaching, withdrawing from gallery exhibitions to concentrate fully upon developing his large bush property fronting Roaring Beach on the Tasman Peninsula into a holistic retreat, a sanctuary where his wooden sculptural benches and installations create an ongoing environment for contemplation.

From this edge – which is the 'inner' and which the 'outer'?

Inside the 'edge' the Tasmanians' work, though diverse, can be seen to have some things in common with each other. They all, to varying degrees, incorporate a sense of narrative. The most direct of these would be Patrick Hall whose theatrical cabinets, each like a little stage set, relate personal stories that can universally touch all, with poetic text engraved into their surfaces that draw upon nostalgia and emotional memory.

Wayne Hudson's furniture is very much on the edge, where furniture meets sculpture – where function meets metaphorical gesture. His works are what he refers to as 'props for social discourse' that provide leaning posts, rather than seats. Having grown up in the rural north west of Tasmania, his work relates to those casual situations such as neighbours leaning over the farm gate, on a fence, or at the local public bar, yarning with friends or newly met strangers alike.

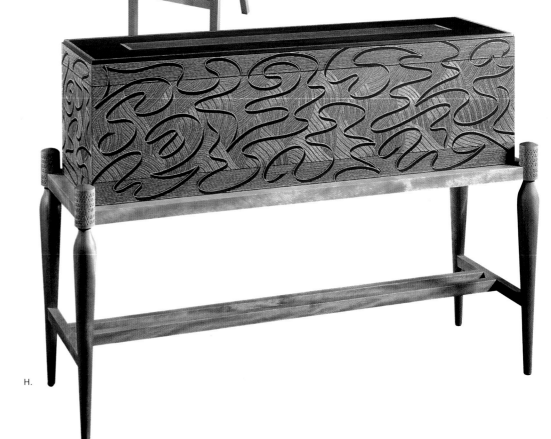

G.

G.
Tom Loeser
Ladderbackcabreddal, *2005*
maple, cherry, paint
87 x 14 x 41
Photo: Bill Lemke

H.
Kristina Madsen
Miss Dovetails, *2005*
pau amarello, maple,
milk paint, gesso
29 x 41 x 13.75
Photo: David Stansbury

I.
Peter Walker
Rock, *2005*
cherry
30 x 32 x 22
Photo: Erik Gould

J.
Jon Brooks
Picton River Chairs, *2004*
maple, stain, colored
pencil, lacquer
84 x 24 x 24
Photo: Dean Powell

H.

To dance with Hudson's *Dancing Tigress* is to court danger – engaging with the dark seductive betrayal of Tasmania's past ghosts of wild history.

The edge of extinction is the subject spotlighted by Kevin Perkins in his work. He deals with extinct and threatened fauna such as the Tasmanian Tiger or Thylacine, now believed to be extinct, and the Cape Barren Goose currently under threat. Through exquisite craftsmanship, Perkins also draws attention to rare Tasmanian rainforest timber species such as Huon Pine, under threat by clear-fell logging practices.

Peter Prasil's work on the other hand, sits at the edge of craft and technology. Seemingly the product of high-tech, and indeed often incorporating such elements like solar panels, CD amplifiers, LCD flat screens, movement sensors and laser beams, his works in fact, parody technology as much as they do to celebrate it.

Whether it be the craft of acting, writing, painting, music or furniture making, John Smith believes that the creative edge is as precarious as rock climbing – balancing skill with risk. His cabinets are metaphors for 'island', and deal with the disruptions of formal boundaries, taking furniture beyond the square box and creating dynamic tensions.

Ross Straker's most current work confronts the edge that separates timeless classicism through highly crafted laminated timber forms, with the product of the 'throwaway society', in the form of closed-cell packaging foam. Despite its whimsical combination, Straker's *Duo* chaise offers durable and comfortable functionality.

The 'outer' edge brings together the work of the American artists in their impressions of their Tasmanian experience. For example, Wendy Maruyama (co-curator for *Convergence*) shares a similar sense of loss for the Thylacine that Perkins and Hudson do - but in her piece, she reveals an open wound in Tasmania's history. What appears from the outside to be a discrete and sedate wall cabinet opens up to confront the viewer with the brutal truth.

Tom Loeser's *Ladderbackcabreddal* blurs and merges the edges of two opposing chairs by hybridising the connecting ladder-back. It has a 'snakes and ladders', 'upside, downside' perspective reminiscent of a Dr. Seuss rhyme.

The landscape plays a pivotal role in Peter Walker's work for the *Convergence* exhibit, where he compares the untidy Tasmanian landscape as unfolding in tangled horizontal layers with that of Haystack Mountain in Maine, which is made up of more orderly vertical stratas. *Rock* literally interweaves these two perceptions into a cohesive whole.

The view from the edge, if you look hard enough, far enough, and for long enough, is the distorted reflection of yourself looking back at you.

Looking back to wherever 'home' is from another 'edge', from the 'otherside', helps to clarify this distorted reflection, bringing into focus the reality that we are not a disjointed and multifaceted series of 'others', but simply 'one-another' – converging into a unified spirit.

John Smith, Curator, Senior Lecturer, University of Tasmania.

Penny Smith, Curator, Senior Research Fellow, University of Tasmania.

Published in conjunction with the SOFA CHICAGO 2005 special exhibit *Convergence: Crossing the Divide, The Studio Furniture of Tasmania and America* presented by the Furniture Society.

[1] 1896 edition of *The Orient Line Guide*

I.

J.

Synergistic Philanthropy: Beyond Art

By Charles Bronfman

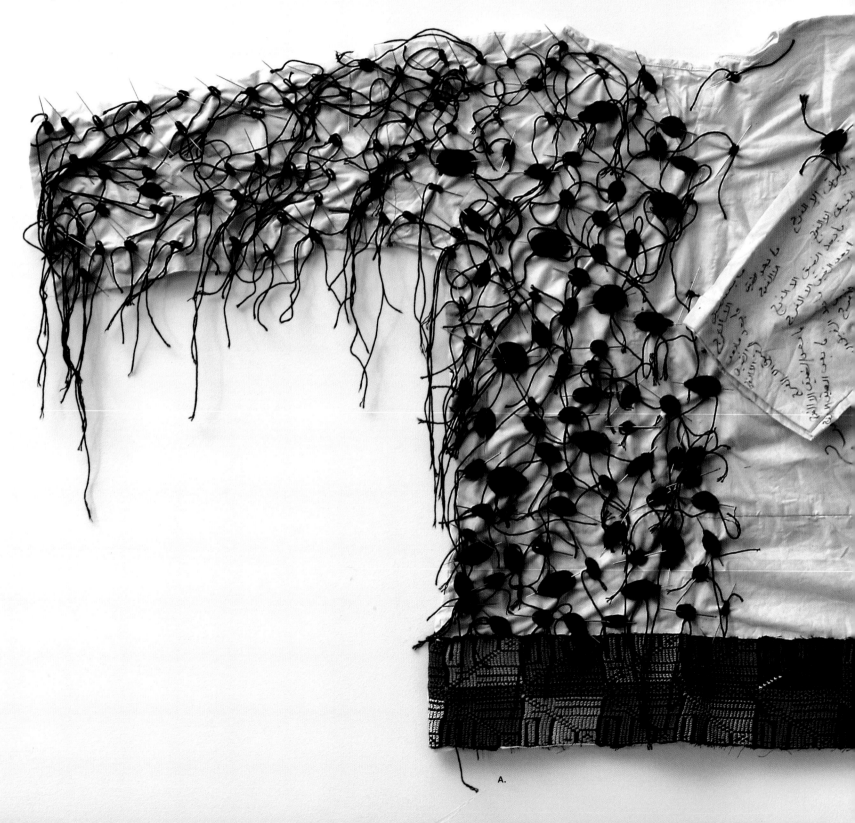

A.

We North Americans are living in a fascinating philanthropic age. Not only has the amount of money invested in good causes risen exponentially, but personal involvement has become today's mantra. We are blessed with a history and a tax system that supports our generosity. The government's encouragement of private foundations is a rare and very special inducement to so many. The cultural world in our society has been a huge beneficiary of this government sponsored, personal and corporate largesse.

Rarely does a day pass without our seeing and being part of some improvement in the quality of our life as the arts become an ever increasing fixture in our society. While there was an historical elitism tied to the patronage of the arts, today they are available to everyone. Strategic relationships between museums and schools, in public spaces and community facilities, are the order of the day.

Imagine being an army recruit, spending your weekend at home and then, rather than hitchhiking or taking a series of buses to your base, you are taken to a play, a movie or, indeed, a performance by members of a philharmonic orchestra. What a way to begin a week in the army! Ridiculous? Perhaps, but I'm talking about the Israel Defense Forces.

And that's what really happens. Our foundation has been the lead funder of what is known as "Sunday Culture in The Army" since its inception, some 18 years ago. Why Sunday Culture? Because the IDF is much more than the normal army. In a country such as Israel, whose Jewish citizens represent over 100 countries in the world, and whose cultural backgrounds are so vastly different, how can some fundamental understanding of all these cultures – real empathy – be gained? The IDF supplies the answer. It is the Israeli "melting pot." A director or star will discuss the play the soldiers have just seen with them. One of the stars of the movie will talk about the "whys and wherefores" of that film, and/or some members of the Philharmonic will play both Eastern and Western music in order to gain appreciation of their differences. Happily, we are no longer the sole funder. Others have joined. And the program only improves.

Andy and I created our Foundation in 1985. As with all start-ups, we learned from our mistakes and today we have a portfolio of philanthropic investments through which we enjoy excellent returns!

Philanthropic return is not measured in dollars. It is an achievement based on vision and programmatic goals and objectives. One of our guideposts has been to seek partners through whom we leverage our investments.

Nevertheless, even within the constraints of that paradigm, I have found that seeking synergy results in greater satisfaction and a more powerful impact. Of course, we do our best to invest in programs that may have secondary effects. And who taught us how to do this? Our parents, naturally!

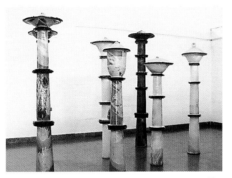

B.

In the early 1950's, my father, Samuel Bronfman, who, as is well known, was the CEO and inspirational leader of Seagram, decided to show the world that Canada was more than just snow and ice and Nelson Eddy dressed in a red Royal Canadian Mounted Police uniform. Dad was a very proud Canadian. He also had a profound interest in selling more of his premium whiskey, "Seagram VO" to world markets. My father thus commissioned 90 paintings and sketches, by more than 20 artists, all chosen by the Royal Canadian Academy of Art, to paint their representations of major Canadian cities and send them on tour. The Seagram Collection of the Cities of Canada traveled almost continuously in 1953-54 visiting Cuba, Mexico, South America, Europe and Scandinavia, returning to Canada for a

two-year cross-country tour. (The exhibition did not travel through the United States as "Seagram VO" was already a very big seller in that country!) The result of this artistic initiative was interesting. The Collection was highly regarded in art circles wherever it was exhibited. Unfortunately, this was not the case for "Seagram VO"! No significant increase in sales of that fine brand was noted in any of those markets!!!

I was born, raised and lived most of my life in Canada. I, too, am so grateful to be a Canadian. I had often noticed though, that unlike Americans, my co-citizens didn't salute their flag with any degree of emotion. How, my colleagues and I asked ourselves, could Canadians come to appreciate their heritage? What was missing? During the bicentennial celebrations of the United States, a thought came to us. Canada lacked heroines, heroes, and myths! Watching the Bicentennial Minutes – a series of short public-service American television segments commemorating the 1976 American Bicentennial – we were inspired. And so the Heritage Minutes, one minute television messages about the heritage of the country, its heroes and heroines, was born. We were aware that the quality of the filmmaking, given the sixty second opportunity, would drive its success. This program has since spun off to become a key part of Historica, Canada's leading organization in promoting history and heritage. I am pleased to report that the artistic quality of these vignettes has, for the first time, made Canadians somewhat curious about their history. Historica, I am sure, will be the avenue for the restructuring and teaching of that subject in Canadian schools.

A.
Buthina Abu Milhem
The Needle Vanquished
the Sower (or the Tailor...),
2005
thread, needles
19 x 27

B.
Michal Alon
Pillars, 2004
wheel-thrown stoneware,
glazes
78.75 x 157.5 x 59

Following the tragic events of September 11th, Andy believed that culture could help healing. With that, The Gift of New York was created to offer families of the victims of that terrible day, free admission to every museum, cultural venue, sports and entertainment venue in the tri-state metropolitan area. With more than 60,000 visits, 85% of the families used this gift as part of their healing process. Letters from mothers who witnessed their child smile for the first time since September 11th at a cultural venue confirmed we were in the midst of a cultural synergy.

Andy's mother had a great eye for art, as well as a love for Israel. It is no wonder, then, that she, a London resident, became the Founding Chair of the British Friends of the Art Museums of Israel. Andy's pioneering of AIDA, the Association of Israel's Decorative Arts, along with Dale and Doug Anderson, with me as cheerleader, is then, no surprise! The ability to exhibit world class works in ceramic, glass, textile and jewelry is always a privilege. We began this program during the middle of the second Intifada, when Israel was regularly facing the nightmare of suicide bombers, terrorism and the death of more than 1,000 of her inhabitants, which created an economic crisis for the entire country. Needless to say, industries related to tourism were those that suffered most. The arts were very high on that sad list. Providing Israeli artists exposure to North American (and now, through COLLECT at the Victoria and Albert Museum, European) galleries and collectors has changed their lives.

Dale, Doug and Andy had hoped to lead a mission to Israel of decorative arts aficionados. The trip was well along in the planning stages when that terrible and continuing terror was unleashed. Dale and Andy realized that the trip would have to be postponed. If Americans would be reluctant to go to Israel, was there any way that Israeli artists could be introduced to Americans? If so, where? Doug leaped into action!! A meeting with Mark Lyman and Anne Meszko was arranged. The next thing Andy and I knew, Mark had offered the fledgling AIDA consortium a complimentary booth at

SOFA CHICAGO and so the "game was on!!" That was the beginning! Norman and Elisabeth Sandler, well known design architects, volunteered to develop the booth! In order to choose the artists to exhibit at SOFA, a team needed to be put in place. Rivka Saker, who runs Sotheby's in Israel and has become our dear friend, offered her services. Aviva ben Sira, the fabulous "boss" of the Gift Shop at the Eretz Israel Museum in Tel Aviv became the sleuth, and later, so much more, as she combed the country in search of qualified artists. Dale agreed to act as curator and asked her friends Jane Adlin, a curator of contemporary decorative arts at the Metropolitan Museum of Art, and Davira Taragin, Chief Curator of Exhibitions at the Racine Art Museum, to work with her as advisors. Suddenly, it all came about. A resounding success at SOFA CHICAGO 2003, followed by SOFA CHICAGO 2004, and now, 2005!!

I have mentioned our parents and their influence on us. Philanthropy was very much an important part of our upbringing. Andy's incredible father, known to all as Scotty, instilled in her his passion for supporting those causes near and dear. My dear mother was so very involved in the arts in Canada! To the point that, on her 80th birthday, my siblings and I established the Saidye Bronfman Award for Excellence in the Crafts. It became a Canadian success story, which has done much to elevate the status of that country's craft artists. The Award celebrates its thirty-fifth anniversary this fall.

Andy was having one of those "Big Birthdays" this past May. What to do to mark the occasion became simple. Using the award in my mother's name as a template, and combining that with the success of AIDA, and Andy's love for Israel, the solution was at hand. During the first week of June this year, I had the great pleasure of announcing the establishment of The Andy!!! It will be awarded annually to an Israeli decorative artist in the fields of glass, textile, ceramics, or fiber. The winner will receive a cash award and, in addition, will have an exhibition at the Eretz Israel Museum,

a catalogue from said exhibition, and a work that will be purchased and donated to the Israel Museum, Jerusalem, in order to "kick start" a collection of contemporary decorative arts at that prestigious institution. Yes, one thing has led to another as we have pursued our philanthropic lives. And every new venture has benefited from past experience.

I have taken the liberty to recount this chapter of our philanthropy. Not to blow our collective horn but rather to reflect on the joy that we have had in our involvement. We have gained so much. The thrill of accomplishment, the pleasure of knowing that we have helped change people's lives, and, perhaps, what has been the most meaningful to us - the great friendships we will always cherish of those who have been our mentors and have become so happily entwined in our lives.

Charles R. Bronfman is Chairman of The Andrea and Charles Bronfman Philanthropies, a family of charitable foundations operating in Israel, the United States and Canada. A Canadian citizen, Mr. Bronfman has been awarded his country's highest civilian honors. Mr. and Mrs. Bronfman have been named Honorary Citizens of Jerusalem, the second and third North Americans to be so recognized. They are avid collectors of decorative arts.

Published in conjunction with the SOFA CHICAGO 2005 special exhibit: *Updating Traditions,* presented by the Association of Israel's Decorative Arts in cooperation with Eretz Israel Museum.

C.
Gali Cnaani
untitled, c. 2004-2005
Hand-woven copper
cotton, Kasury dye,
burn-out printing
10.25 x 9.5

D.
Rory Hooper
My Memories, 2005
smashed silver and
gold rings
28d

E.
Dina Kahana-Gueler
Collar, 2005
silicon, paper, gold leaf
18d

F.
Einat Cohen
Fragile, 2004
slab-built porcelain,
paper clay
35h

C.

E.

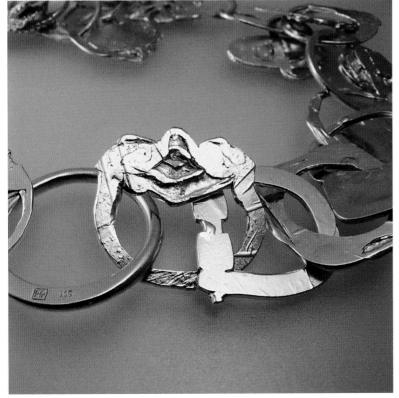

D.

F.

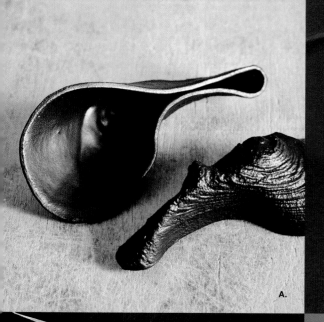

A.

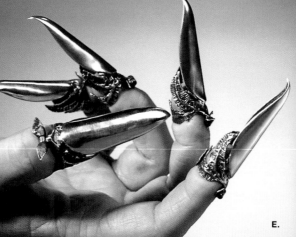

B.

Flatware: Function + Fantasy
By Boris Bally and Rosanne Raab

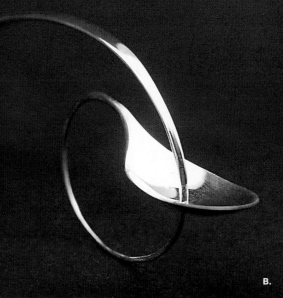

E.

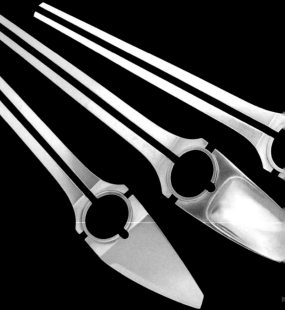

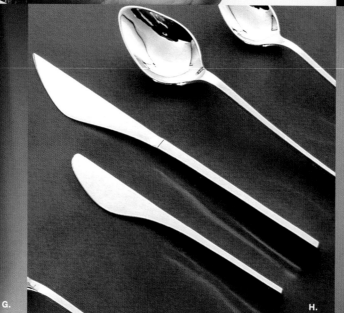

G.

H.

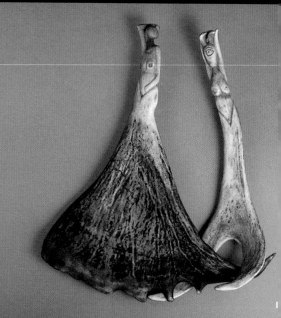

I.

Has everything become fast, large, tasteless, and disposable in contemporary America? Is it true that only a handful of us remain attentive to the implements we use to prepare and consume food? Those who design and fabricate such implements are hyper-aware, and attempt to integrate what is practical for production with what is sensible for use, en-route to finding innovative design solutions.

Boundaries are rapidly disappearing between designers, craftspeople and artists. The world is smaller as the information age yields more ways to channel creativity through rapid prototyping methods and varying scales of production and design. In this century, it seems that much of the cutting-edge, high volume design-for-industry is changed by "prototype makers" such as Eva Eisler and Joost During. Visually, a masterfully forged John Cogswell spoon is not a far stretch from the Porsche-designed *Chroma 301 Knife,* although the production methods and volumes could not be more different.

Flatware: Function + Fantasy initiated a dialogue about work in relation to creative process and material culture. Forty-two participants were selected from more than one hundred portfolios representing industrial designers, artists, and artisans with specialties in flatware, cutlery, and jewelry design. We identified conceptual ideas that went beyond traditional form to flatware that was hand-forged and machine-made for use. There are relationships with industry and alternatives that favor small workshops. Materials include silver, gold, various alloys of steel, rubber, plastics, ceramic, anodized aluminum, and a variety of stones, wood, bone, even bread. Techniques range from hi-volume drop-forging to hand-forging and pattern-welding, various fabrication and casting skills, chasing, *mokume-gane,* and granule construction.

Looking back to the early history of flatware provided a context for this collection. Primitive societies used pointed and forked sticks, chipped flint, or stone and shells that served as early supplements to the fingers. These forms were replaced by knives of bronze and later iron, as well as wood and horn scoops or spoons. Egyptians had spoons of ivory and slate, and silver, bronze, and brass utensils were used in early Greek and Roman societies.

Bowl-and-handle spoons, similar to modern-day forms, date from 700 B.C. Early knives, used not only for eating but also as weapons, introduced a protective handle to shield the user's palm from the blade. In the Middle Ages, individuals carried their own knife to table since it represented a precious accessory not provided by the host. Personal silver or gold forks appeared in inventories as early as the eleventh century, mainly for special purposes such as eating mulberries or other foods likely to stain the fingers. Two-pronged forks, originally used for serving, became eating implements for the table during the sixteenth century in Italy after Catherine de Medici initiated the use of one table fork for each guest at the French court. England was introduced to the fork when Londoner Thomas Coryate claimed to be the first man in town to use it in 1611. However, the knife was the primary utensil used by most Englishmen as late as the eighteenth century.

Inventories from upper-class colonial households listed silver spoons and forks. By the mid-eighteenth century, major cities like Boston, New York, and Philadelphia boasted scores of smiths vying for the booming business. The South continued to trade with England long after the northern colonies had established local industries, and it was not until much later that southern silversmiths developed a local clientele.

The discovery of the Comstock Lode in Nevada (1839), The Tariff of 1842 spear-headed by Senator Henry Clay, and the Industrial Revolution, expanded the manufacture and distribution of American-made flatware during the nineteenth century. The Victorian dining table displayed a wide range of designs for specialty foods such as forks for asparagus, lettuce and ice cream, spoons for oranges and bouillon, and knives for macaroni and waffles. The economic and social status of a family was clearly reflected in the accouterments on their dining table.

These historical artifacts are valued for their aesthetic beauty; material culture study yields further understanding of flatware and its relationship to people and place. What will future design historians conjecture about this collection of knives, forks, and spoons?

The two world wars and the Great Depression of 1929 altered America's lifestyle. During these time periods, the design and manufacture of flatware came almost to a halt, and many of the vestiges of metalsmithing by independent silversmiths were erased; artisans took on vocational roles, mainly as shop teachers in public schools and on assembly lines at airplane plants and shipyards.

The rebirth of metalsmithing at American universities in the late 1940's is credited to Margret Craver. Under the auspices of Handy and Harmon, she established a series of conferences that encouraged American art teachers to learn the skills of silversmithing. Workshops were taught by European silversmiths, including William E. Bennett, Reginald H. Hill and Baron Eric Von Fleming. Apprenticeship programs were replaced by degree programs at Cranbrook Academy of Art (Richard Thomas), School for American Craftsmen (John Prip), Cleveland Institute of Art (John Paul Miller, Fred Miller) and Indiana University (Alma Eikerman). Kurt Matzdorf founded the gold and silversmithing program at the State University of New York (New Paltz), and Hans Christensen, who left Georg Jensen in 1954, joined the faculty at the Rochester Institute of Technology. These early years reflected European influence, particularly of Scandinavian design, but subsequent generations pursued an American spirit that supported innovation in place of imitation.

In the 1950's, industry worked with John Prip, Arthur J. Pulos and Earl Pardon giving them freedom to develop flatware designs. A major success was scored by Ronald Pearson in 1954 when his design *Vision* was awarded first prize in a "New Flatware" competition at The American Craft Museum (renamed Museum of Arts & Design). International Silver produced the pattern until 1982. Thirty years

later, David Tisdale, a young designer and recent graduate of the San Diego State University Metals Program, further challenged the offerings of contemporary flatware by introducing dyed aluminum and embracing forward-thinking design.

Where do we find flatware beyond the mainstream commercial market? An excursion to Moss/New York, praised as "the best design store in America" by *The New York Times* in April 2003, and retail markets supported by American Craft Council, George Little Management, The Philadelphia Museum and The Renwick Gallery fill this small niche. It requires a great deal of homework and unique projects like *Exhibition in Print* to discover practitioners of innovative American flatware design.

Searching for evidence of the creative process was paramount to the selection of work for *Flatware: Function + Fantasy.* We looked for insightful designs that provoked an aesthetic response. No barriers separated machine or handmade, or design executed by the computer. Our choices included objects that were influenced by nature, that celebrated and glorified the delight of eating, and that felt the devastating nature of hunger. We selected forks, spoons, and knives that conjured memories of past relationships and shared times, and others that were successful expressions of playfulness and joy. Interpretations of other cultures stimulated our eye but craftsmanship and attention to detail were primary criteria.

Original ideas overflowed in David Damkoehler's *Breadbasket,* a construction of Volrath serving forks intended to "enhance the theater and spectacle of dining," and in Charles Lewton-Brain's *Fork* braced to the arm, a metaphor for restrictions that society places upon itself. Rebecca Sheer relished the extraordinary by capturing a moment when "matter met spirit." Function is not essential in these designs, which illustrate that freedom to explore unknown territory enhances our everyday life.

Exploring the structure of a design for its intrinsic beauty yielded strong aesthetics in flatware designed by David Peterson and Curtis La Follette; each revealed structures that were honest and unfettered by pretense. This description can also be applied to the forged flatware by John Cogswell.

"Learning all the technical skills to their perfection taught me how to make things right," stated Joost During, a young designer trained in Amsterdam; he currently works as a freelance designer in America, marketing his own designs successfully to manufacturers such as Dansk and Nambe.

A flair for the fresh is demonstrated in *Verge* by Phil Carrizzi, a designer with an uncanny understanding of market requirements. His ergonomically adjustable table setting prototype sports a choice of color (powder-coated) and has a built-in "Palate-Scald Mitigation System"™ that allows you to "have fun, play with your food," all the while cooling hot morsels to your personal temperature preference.

Nature served as inspiration for several designs, including the porcelain spoons modeled from tree knots by Jozefien Gronheid, Lin Stanionis's knife, fork, and spoon, which narrated the growth, change, and vitality of plant life, and the *Spring Greens Salad Servers,* which reflected James Obermeier's concerns about man and his environment. Shona Rae carved forks and spoons from bones found in the wilderness of the Arctic tundra. She described these materials as cultural symbols of the Inuit, who "survived in a brutal and perilous environment." The bird, serving as metaphor, inspired a set of silver talons by Rose Sellery. She challenges us to think about what we eat and how we struggle to maintain an "ideal" proportion.

Cultural influences are skillfully handled by Robert Farrell in *Fish Set,* serving pieces demonstrating *mokume-gane* that captured the beauty of reeds floating in a koi-filled pond. Chunghi Choo's epoxy coated salad servers, folded and cut to resemble origami

paper or suggesting oversized chopsticks, brings a touch of Asian flavor to the dining experience.

Vintage flatware inspired new work by Roberta and David Williamson and acted as a canvas for Billie Jean Theide. Martin Learch rescued throwaway plastic utensils, cast them in gold and packaged them into a suitcase. Re-interpretation, hybridization, and reconfiguration inspired Masuda, Bates, and Keyte to think about flatware as a scholarly subject. We are challenged to look at flatware without formal directives. Let us applaud the artists, designers, and craftspeople who step beyond the boundaries of the past and build an innovative pathway to the future.

What is the future for the objects highlighted in this exhibition? Will these pieces be given fifteen minutes of fame and then be tossed in the trash? Or will they be treasured icons of the twenty-first century and cherished by owners who savor each meal with a special fork, knife, and spoon? Bon Appetit...

Boris Bally is a metalsmith who designs and produces flatware.

Rosanne Raab is an independent curator and collection advisor for twentieth century craft and design.

This essay was first published in *Metalsmith* magazine's "Exhibition in Print" issue. Reprinted in conjunction with the SOFA CHICAGO 2005 special exhibit *Exhibition in Print 2005, Flatware: Function + Fantasy* presented by the Society of North American Goldsmiths.

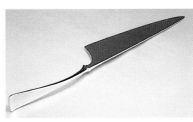

L. M.

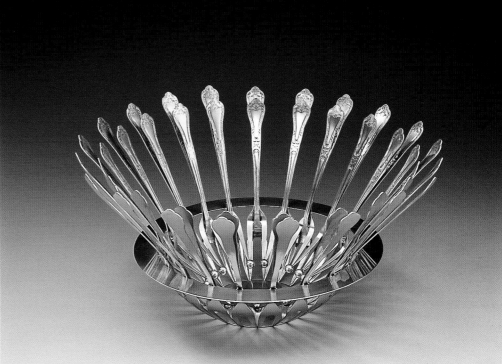

J.

K.

N.

J.
John Cogswell
Cake Knife, 2002
sterling silver
10.5 x 2.5
photo: John Cogswell

K.
Curtis LaFollette
Three Piece Flatware Set
1216/04-2 Flatware
Series, 2004
sterling silver, steel
largest: 1 x 1.5 x 8
photo: Nash Studio

L.
Arthur J. Pulos
for Flatware Design, 1961
Special Collections
Research Center, Syracuse
University Library

M.
David Tisdale
Mangia *(portable flatware*
set, three pieces with
cover), 1993
Zelco Industries, Inc.
stainless steel,
plastic cover
set with cover: 8 x 1.5

N.
David Damkoehler
Bread Basket for Joseph
Holtzman, 2004
42 Volrath #46554 serving
forks, stainless steel
11 x 24 x 24
photo: Dean Powell

Dreams and Visions: A Theater of Daily Life
The Work of Torben Hardenberg

By Dave Revere McFadden

A.

"The theater, which is in no thing, but makes use of everything – gestures, sounds, words, screams, light, darkness – rediscovers itself at precisely the point where the mind requires a language to express its manifestations…To break through language in order to touch life is to create or recreate the theater."

Antonin Artaud (1896-1948), *The Theater and Its Double*, chapter 1 (1938; trans. 1958)

It was about twenty years ago that I first saw the jewels being made by Torben Hardenberg in his Copenhagen studio. Immediately I was struck by the drama, whimsy, fantasy, and elegance of his designs. In those years Torben transformed cheap copper ornaments salvaged from flea markets – gothic arches, baroque shells, and rococo putti – along with radiant cut glass stones of rainbow hues into dramatic and highly theatrical necklaces and brooches. Embedded in each piece was a hidden narrative that could be unraveled through careful observation of the forms and motifs the artist chose. If one's best efforts to decipher the narrative fail, the jewels respond to dreams and fantasies brought to the work by the viewer. Like the experience of the theater, Hardenberg asks for the willing suspension of our disbelief; our willing participation in a fantasy. His jewels were (and are today) vessels overflowing with creativity and exuberance that reveal the artist's imagination, perception, and emotion brought to life by the imaginations of the wearer or viewer of his jewels.

Torben Hardenberg's jewels have always been distinctive in appearance and often unorthodox in the selection of precious and worthless materials (often used in the same jewel) and tried and true metalworking techniques such as soldering and chemical patination. Silver, gold, and rare stones are conjoined with seashells, bits of coral, and the carapaces of insects. In his work, Hardenberg reminds us of the art history of jewelry, particularly jewelry made in the sixteenth and seventeenth centuries. An explosion of creative energy in goldsmiths' workshops in these years generated prodigious marvels wrought in metal; nautilus shells held aloft by writhing assemblies of figures, animals, dragons, or angels, jewels composed of bizarrely shaped pearls and rich enamels, and exotic collectibles (such as porcelain and lacquer) which found their way to European destinations from distant China and Japan. From such prolific goldsmithing workshops as Augsburg, Nuremberg, Danzig, and Budapest hundreds of prized and expensive objects appeared in the marketplace.[1] All were intended for a select audience of consumers, many of whom were educated to decipher and appreciate complex classical or biblical iconographic programs, and all of whom had the financial wherewithal to acquire and display their treasures.

Goldsmiths' works – classified among the "artificilia" or manmade works – were displayed alongside "scientifica" (scientific and medical instruments) and "naturalia," (natural history specimens such as minerals, shells, plants) in *wunderkabinetten*, cabinets of wonder or curiosity.[2] Hardenberg's figural and narrative jewels – magical, strange, and engaging – would not have been out of place in such a setting.

At the same time, Hardenberg's jewels are consistent with a design tributary in modern and contemporary jewelry that depends on pictorial imagery, a phenomenon particularly identified with American art jewelry in the second half of the twentieth century.[3] A second major trend in jewelry and one that had an enormous international impact was that of abstraction, which reflected the intersection of jewelry design and the fine arts of painting and sculpture from the 1940s forward.[4] Hardenberg's narratives, however, are not generally linear and sequential. Rather, he juxtaposes familiar images and motifs in unexpected combinations that tweak the viewer's imagination and address issues more related to poetry than description. Hardenberg's aesthetic is kin to both sixteenth-century Mannerism and to Surrealism in the twentieth century.

A necklace in gold and pearls is exemplary of Hardenberg's unique approach to pictorial imagery. The bizarre qualities of the individual elements that comprise the work – misshapen baroque pearls and twisted branches – are underscored in the overall asymmetrical composition. From a twisted and gnarled branch hang pendant pearls, evoking the appearance of unharvested fruits that were allowed to wither and freeze in the winter. One of Hardenberg's favorite forms – the cabochon stone – appears in an intertwined element centered by a dark cabochon. Like the dead and dying fruit on the branches, the stone suggests an abandoned egg in a bird's nest, a reminder of the potential and ultimate decay of life itself. Emerging from the branches is a winged demi-figure of vaguely classical origins; the living energy in the branch is escaping as pure spirit, having left behind its earthly incarnation. The story suggested by this work is mysterious, obscure, and haunting, but the imagery itself speaks to cyclical issues of life and death not generally addressed by body ornaments.

c.

Hardenberg returns again and again to nature as a source of designs, and has developed a personal visual vocabulary of "naturalia." Some of these designs are lyrical and delicate, such as his calligraphic *Dragonfly and Weeds*. Others, like his *Snail Pendant* reveal a darker side of the natural world. Here a brilliant green-shelled snail traverses a dark branch. While the colors are seductive, the surface textures that Hardenberg creates border on the repulsive. Beauty, for this artist, is a dual-edged sword, a Manichaean duality that attracts and repels at the same moment.

Fragments of natural forms appear in both Hardenberg's jewelry and his larger scale sculptures. A group of pendants take the form of an encrusted branch of coral trapped midway between the underwater world and our own. The floating branches of deep pinkish red are draped with various accretions, ranging from graduated pearl pendant to seaweed in cast metal. These inanimate objects seem to take on a life of their own, strange mutations or hybrids of the world of nature we inhabit. Transformation and change run through Hardenberg's work as a contemporary metaphor for genetic shifts, but also as a reference to the inevitability and permanence of the spiritual in all aspects of daily life.

One of the more striking jewels created by the artist is a macabre tiara composed of the carapaces of green Brazilian beetles that surround the head like a corona of iridescence. The "jewel" in the center is an animal skull with luminous dark eyes. The surreal quality of this work results from the juxtaposition of apparently incongruous elements; again the artist plays an attraction/repulsion dialogue with the viewer (not to mention the wearer!)

Hardenberg's fidelity to the aesthetics of Mannerism is best seen in his mounted nautilus shell standing cups, inspired directly by the virtuoso craftsmanship found in Augsburg ateliers around 1600. While evoking the mysterious world of sea creatures, dragons, and chimeras favored by Mannerist goldsmiths,

the design has a decidedly contemporary touch in the prow-like turquoise embellishment that crowns the front of the vessel. The shell is supported on a mélange of coral fragments at the base and metal spikes combined with coral at the juncture of stem and cup. This is not, however, a simple essay in excess; embedded in each of the artist's works is a pervasive sense of time, particularly time past. Time is given life through memory, and Hardenberg's assembled elements are like fragments of dreams, each eliciting a specific corporeal and spiritual presence.

Hardenberg's vessels and sculptures are intended for ritualistic display. When assembled as a group the works recreate a world of the *wundekabinett*. The intricate nature of the iconography is made possible by the artist's ability to select and combine fragments of the valuable and the valueless in objects that only vaguely refer to their original functions. These assemblages recast the history of the decorative arts, especially the baroque convention of display within an architectural setting, another subtle reference to theater.

The Argentinean writer Jorge Luis Borges explored our ambivalent relationship with time: "Time is the substance from which I am made. Time is a river which carries me along, but I am the river; it is a tiger that devours me, but I am the tiger; it is a fire that consumes me, but I am the fire."[5] Time and the memories it brings along with its inevitable progress is captured with particular beauty in Hardenberg's Temple. Resting on a stone base, the classical temple is supported on paired Ionic columns arranged to give a sense of depth to the structure. The entablature is embellished with cameo portraits and in the center, at the high altar, is a glowing fragment that hovers like a deity. The temple structure is diminutive and shallow, while the overall effect is one of monumentality and depth, another instance of Hardenberg using his jewelry designs and sculpture as theatrical sets lacking only the actors.

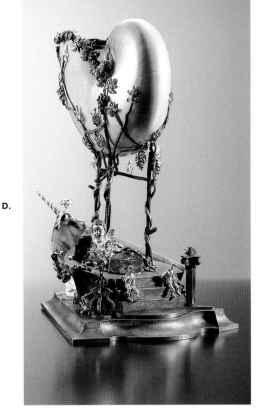

D.

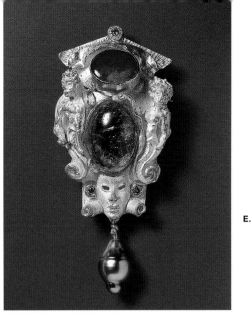

E.

The actors in Hardenberg's dramas are sometimes fragmentary allusions to historical figures. A brooch is a composition consisting of three turquoise cabochons, two of them fixed and the third suspended between them. From behind these jeweled shields is glimpsed a female figure and the head of stag. Who is this actor? Does it refer to the beautiful mistress of Henri II, Diane de Poitiers, whose visage inspired so many French artists, and whose otherworldly beauty and elegance was the stuff of life itself? Or does the figure suggest another Diana, the Roman Artemis, virgin huntress and patron of childbirth and inextricably linked to death and resurrection? Hardenberg raises these questions in the mind of the viewer, inviting us to project our own dreams and fantasies into the work, and to compose our own narrative.

These figures may be cavorting cherubs installed atop gilded shell salt cellars that would not look out of place on the dining table of King Louis XV, or they may be muscular sea gods that hold aloft a flat and shallow vessel made of semi-precious gold. They may also be strange inhabitants of the world of nature out of control, enmeshed in the flora and fauna worthy of a sixteenth century plate by Bernard Palissy. None of these works are portraits in the usual sense of the word. These are masks that hide the figure beneath, transforming a humble actor into a character from the Greek theater.

Jewelry always has at least two stories to tell, that of the maker and that of the wearer. Jewelry is a bridge between our inner states of being, our precious and fragile sense of self, and our outer persona. We communicate who we are, and who we wish to believe ourselves to be through the ornaments we display on our bodies. The story woven by the artist is equally complex, but can we ever fully know it? The beauty of Hardenberg's jewels and vessels is seductive and visually alluring. As we look more deeply and meditatively at the forms and motifs – figural or otherwise – that the artist selects, combines, and presents, it is possible to garner perhaps a glimpse into the artist's heart and soul. These works are intensely personal, yet they are freely shared with the world at large. Their meanings shift and change according to the context in which they are viewed. They are, ultimately, scripts for an open-ended dialogue between the artist and us.

Torben Hardenberg weaves dreams and visions in his jewels and sculpture. It is up to the viewer to write the dialogue in the artist's theater of daily life.

[1] John Hayward, *Virtuoso Goldsmiths and the Triumph of Humanism* (London: Sotheby Parke Bernet Publications, 1976).

[2] *Cabinets of Curiosities,* with essays by Diane Douglas, Michelle Holzapfel, Ursula Ilse-Neuman, Brock Jobe, Tom Loeser, and Rick Mastelli. (Philadelphia: Wood Turning Center and The Furniture Society, 2003).

[3] Susan Grant Lewin. *American Art Jewelry Today* (London: Thames and Hudson; New York: Harry N. Abrams, Inc., 1994). See also Lloyd Herman, *Brilliant Stories: American Narrative Jewelry* (Hamilton, New Jersey: International Sculpture Center, 1994).

[4] Montreal Museum of Decorative Arts, *Messengers of Modernism: American Studio Jewelry 1940-1960,* with essay and catalogue by Toni Greenbaum. (Paris-New York: Flammarion, 1996).

[5] Jorge Luis Borges, "A New Refutation of Time" in *Labyrinths* (1964).

David Revere McFadden is Chief Curator, Museum of Arts & Design, New York, NY. Reprinted from *Dreams and Visions: A Theater of Daily Life* by David McFadden, edited by Bente Scavenius and published Fall 2005 by Gyldendal, Copenhagen.

Torben Hardenberg is represented at SOFA CHICAGO 2005 by Galerie Tactus, Copenhagen, Denmark.

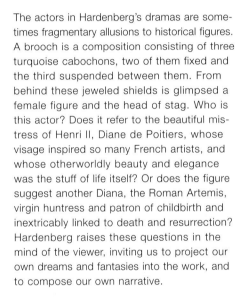

C.
Colour Change,
brooch, 1995
sterling silver,
18k and 24k gold,
lapis lazuli,
brown diamond
1.5 x 2

D.
Nautilus Cup, *1992*
Nautilus Pompilius
Pompilius, sterling silver,
18k gold, diamonds,
sapphires, rubies,
emerald, lapis lazuli,
red coral, wedding
coin from 1967
9 x 8
On the occasion of
the Silver Wedding of
Her Majesty the Queen
of Denmark and His
Royal Highness

E.
Bataille, *brooch, 1990*
sterling silver, 18k and
24k gold, opal, amethyst,
diamonds, South Sea pearl
3h
courtesy of the Susie
Elson Collection

Robert Turner:
A Rememberance

By Helen W. Drutt English

A.

In 1755, Samuel Johnson said, "If a man does not make new acquaintances, as he advances through life, he will find himself alone." We are not alone, we belong to a community of individuals who have enriched our existence by giving form to our life through their creative work. Among them was Robert Turner. When I reflect on Bob, I remember a favorite book, *Van Loon's Lives*, by Hendrik van Loon, which established a concept of social and professional dialogue that became an important part of my thinking. The notion of bringing together great minds from different disciplines and periods in history for dinner and conversation was intriguing. Just imagine Spinoza, Mozart, Joan of Arc, and Robert Turner at dinner exchanging ideas. Bob Turner would sit quietly at the table discussing who we are as human beings – his presence always brought back to us an awareness and sensitivity of being one with the natural world. As he wrote in Studio Potter in 1982, "Our identity with the universe is as close as I can get to what we are talking about. What we are, what we can discover from exposing our sensibilities, from being vulnerable, from being quiet and letting things speak back to us. It is not identity in the isolated sense, but identity in its joining sense. One hopes that one doesn't miss entirely the natural world and its order..." We can only imagine the responses from Spinoza, Mozart, and Joan of Arc, and now, perhaps, there is an opportunity for that to actually occur.

•

I first met Robert Turner in the early 1970s, on the opening of my eponymous gallery, in Philadelphia. My immediate response to his work was slow, for the dynamics of his ceramics were internal and I was still in a period of extensive learning. Robert Turner devoted himself to the medium of stoneware; his monochromatic surfaces were sandblasted and incised with subtle alterations in essential symmetry of their wheel-thrown forms.[1] They looked ancient but were contemporary and serene and contemplative, reflecting the peaceful continence of the Robert Turner we all came to know. I remember both Bill Daley and Wayne Higby instructing me as to how I should observe as well as absorb Turner's pots. They weren't high and they weren't low, they weren't soft and they weren't hard – but just right. I was advised to look at simple forms that expressed the reductive spirit of complex thinking. Turner was undergoing a gradual transition from functional work to more

esoteric forms that related to his extensive journeys; works entitled the *Ife*, the *Ashanti*, the *Canyon de Chelly* were coming into their own, and referred to primordial cultures and the geography of western Africa and the American Southwest. I came to understand the Canyon de Chelly form when I visited the actual site with its shaved terra cotta walls that inspired Turner's pots. Growing with the work of an artist is a great privilege in life.

•

Clay and gold are materials central to the craftsman's world. When I think of Bob Turner, I remember Isaiah's cry: "We are the clay, oh Lord, and thou, our potter," – Robert Turner embraced that sense of being in his work with Sue Turner, his wife, beside him for sixty-seven years. It was always Bob and Sue. She was the gold that comes from the dust metaphorically buried in the body for a lifetime on earth; in this sense, gold is a symbol of the soul.[2] Their joint commitment to liberal causes in politics and social justice, their dedication to Quaker beliefs, the delight they took in their family, and friends, and their reserved philanthropic spirit were emblematic of them. As a couple, they shared an extraordinary lifetime.

•

Robert was a gentle and profound intellectual, a visionary whose mystic presence was sometimes masked with humor. Tall, graceful, and quiet, his hands gently stroked the clay when at the wheel, or, when dancing, reached into the air like a magic wand. He honored his peers and took delight in their successes and recognition; he also enjoyed his own successes and savored his recognition. In my role as a go-between, I have been trusted by artists to bring their work into the public forum. The trust bestowed upon me by Robert Turner took me on a journey to places both spiritual and physical that I had never previously known. His artistic legacy as well as his soul will continue to live in his work.

Helen W. Drutt English
Founder/Director, Helen Drutt: Philadelphia
September, 2005

[1] News release, Helen Drutt Gallery, 1989.

[2] Haviva Pedaya, *Beaten Gold*, Eretz Israel Museum, Tel Aviv, 2005, p. 22.

B.

C.

D.

A.
Robert Turner
Ceremonial Tureen, *1975-76*
Glazed and sandblasted
stoneware
12 x 16
private collection
Photo: Steve Myers

B.
Robert Turner
Owerri, *1994*
Glazed and sandblasted
stoneware 11 x 11
Photo: Brian Oglesbee

C.
Robert Turner
Vase, *1993*
Glazed and sandblasted
stoneware
19 x 18
Photo: Brian Oglesbee

D.
Robert Turner
Canyon, *1995*
Glazed and sandblasted
stoneware 10.25h
Photo: Brian Oglesbee

Recalling Bob Turner: Finding the Words

By Wayne Higby

We meet
to part again.
I have no words
to respond
to this double
Inspiration.

Wen Chao
10th century, China

In 1970 Viking Press published the book that accompanied the benchmark exhibition, *Objects USA*. In his introduction, Lee Nordness traces the tradition of the handmade emphasizing twentieth century American contributions. Nordness concentrates, as does the exhibition, on art and artists of major influence during the Post World War II period. He mentions a 1966 interview with Bob Turner and quotes him as follows: "When I got involved, we weren't so much concerned with the object as with a way of life – a result, I think of the War period. We were looking for – the word used then was *integration*."

Integration is a good word. The dictionary states: integration – unified; the state of being whole. Bob Turner exemplified this definition. He projected a gentle confidence that was always reassuring. When I first met him, I thought – does he know something I don't know? Well, of course, he was older, but it was more than that. Eventually Bob and I became colleagues. I learned that this sureness came from his basic spiritual nature and his belief in the good unqualified by corporal constraint. He intuited and believed that he was mind and body part of a meaningful, universal whole. That inspired his courage to create.

Bob said of his work in ceramics: "I do what the clay accepts." Certainly, all ceramic artists must do that, but what he meant was that he didn't need to be in control. He was "OK" to let it be. He was open to discovering the zone where he and the clay became one. I watched him work.

He often found that place. He had great skill and knew when not to use it. His pots are never intentionally impressive. They assert only the agreement he and the clay have come to. I wrote for the dust jacket of Bob's biography, *Shaping Silence:* "Bob Turner is an artist of commanding, gentle presence. His ceramic work offers an inspired, improvisational mapping of the secret rhythms of human awareness." Turner's work always seems to be searching. This is, no doubt, a reflection of the collaborative investigation of meaning undertaken between the material, the process and Bob. "Idea" arrives, generates from his contact with the phenomena of making. There is never a "wow;" that is it. The drama is internal. It manifests. Its intensity is gradual, but firm. It ebbs and reaffirms. Once someone asked me, with doubt in their voice, to point out exactly why Robert Turner's pots were so important. As we looked carefully at a group of them, I said, "You see, they aren't that, nor are they this. You can't box them in. They are certain in their uncertainty. They point to nature, time, change. They are and are becoming. Isn't that the experience of life itself?"

Bob Turner received numerous awards for the excellence of his work as an artist. In 2000 the New York State College of Ceramics at Alfred University presented him with the Charles Fergus Binns Medal of Excellence in Ceramic Art. He received the Gold Medal for Artistic Excellence from the American Craft Council in 1993, as well as an Honorary Doctor of Fine Art from Swarthmore College, 1987. As if to point out that these honors were sure to come, Turner received the Silver Medal from the International Ceramics Exposition at Cannes, France in 1955.

During his distinguished career as a ceramic artist, which began in the late 1940's, Bob Turner made an indelible contribution to education. He initiated the ceramic program at the now legendary Black Mountain College and taught, with distinction, from 1958 until 1979 as a faculty member of the New York State College of Ceramics at Alfred University – serving twice as Chairman of the School of Art and Design. In 1974 he was given the Chancellor's Award for Excellence in Teaching, State University of New York.

In the midst of the late 1950's-1960's East Coast – West Coast discussion/clash/antagonism regarding ceramic art, one ceramic artist at Alfred represented the voice of poetic reason: Robert Turner was an artist who absorbed the tenor of the time. He was able to produce work in touch with the movement, and completely true to his own forceful vision. Early on, perhaps he alone at Alfred

E.

F.

understood Voulkos and the achievement of West Coast ceramics. He was not afraid to appropriate what was revealed to him. The "Alfred Vessel" in his hands took on a vital, sensitive quality of speculation and mystery. Tradition wed the unknown. Voulkos was admiringly aware of Bob Turner's work. They became friends. In 1998, Alfred University presented an Honorary Doctor of Fine Arts to Pete Voulkos. At that time, Bob and Pete worked side by side for a week inspiring and entertaining students. They embraced each other as artists, as friends and visionaries revisiting in nostalgic memory days of their youthful, artistic passion. For that glorious week Alfred became an ark riding above the waves, set free from time, held safe and transfixed by an abiding energy that was ceramic history.

Bob Turner was instrumental in convincing me to join the Alfred University faculty in 1973. We taught together at Alfred until his retirement. I learned a great deal about myself and about teaching. For several years, Bob and I were together working as board members of the

Haystack Mountain School of Crafts as well. Bob was always able to bring accord to conflict. He had a gift for quietly empowering individuals he had confidence in. As a teacher, Bob could bring a touch of harmony, often just by his presence, to a studio full of youthful artistic angst. He had an uncanny ability to encourage the necessary journey of imagination. A few words with Bob would secure an embrace of doubt that permitted one to travel to a place of personal reflection beyond common assumptions. Bob's teaching was all a part of the integration theme – art, life, teaching. In the best sense, Bob Turner was a classic representative of teaching by example. His students respected and admired him. In fact, they were fond of him. Sometime in 1973, Robert Turner acquired a nickname from a student. John Gill, today a Professor of Ceramic Art at Alfred University, conferred the title "Rocket Bob" on a favorite teacher. The name stuck; it seemed right. When I think about Bob Turner, I often see "Rocket Bob." Why, "Rocket?" Well, he was long and lean, but most especially because Bob had an unusual ability to go "out there" – up and away – where few can travel. He brought things back and shared them often in eloquent, poetic words. He told stories that would at first seem a bit unclear but ultimately made a resounding connection. How did he do it? He was "out there" and also so present "here" as well. "Rocket Bob" brought us powerful art, remarkable teaching and rich friendship to those fortunate to know him. Robert Turner stands as a sentinel of excellence beckoning us to recognize in ourselves, in our work and in the everlasting endeavor we call Ceramic Art, all that is remarkable and of great value.

In the end, of course, there are no words to express the deep meaning of another's life and work. However, the effort to do so brings one close. Trying to find the words is a meditation that serves as a vehicle for dwelling in the inspiration that is Bob Turner. Fortunately, we can also simply sit in silence with his pots.

Wayne Higby
Robert C. Turner Chair of Ceramic Art*
Alfred University, Alfred, NY

*The Robert C. Turner Chair of Ceramic Art at Alfred University was established in 2005 by Marlin and Ginger Miller.

E.
Bob Turner, Wayne Higby, Pete Voulkos at Alfred University, 1998

F.
Robert C. Turner Chair Naming Event, Alfred University, April, 2005 (left to right) Sue Turner, Bob Turner, Wayne Higby, Ginger Miller, Marlin Miller

G.
Robert Turner and Sam Maloof, 1996 Photo courtesy of Rosalind and Howard Zuses

G.

August 2, 2005

Sue Turner and the entire Turner Family…

Bob's passing is just plain bad news.

What first came to my mind, when we heard of this, was a memory of Bob and Pete Voulkos holding hands.

The day after the honorary degree convocation for Pete (at which Bob spoke with his passion and calm merged uniquely together), Kymberli and I, along with several others including Wayne Higby, went to Sue and Bob's place for dinner. Bob and Sue were leaving their Alfred home and studio within a few days to move to Maryland, and most of the house was packed. Despite the pressure of the move, they were gracious hosts, and we all gathered around a ping-pong table for good food and fellowship.

After the meal, Bob took Pete through the studio. Along the way, Pete studied Bob's work and from time to time he smiled and nodded approval or familiarity. He seemed calmed by Bob's world and by being together again with his two old friends.

Having circled the studio, the two men stood face to face and Pete reached out and took Bob's hand. He held his hand to Bob's, fingers to fingers, palms to palms and he seemed to be feeling for the shared history in the fingers, touching the hand of a friend and colleague and companion. They stood together gently holding hand seemingly relaxed and refreshed at the same time. These two men standing for that moment became in my mind a gentle mirror image of parallel forces working through clay to create significant lasting art. As they stood together, each man's hand cupped by the other, I saw these two men as key parts of a whole history.

The moment passed, the conversations in the studio came back into focus, and the party continued.

With Bob's passing, one more primary element of contemporary creative ceramic art is now our memory. All of us have been enriched by knowing Bob's great creative energy, by sharing his calm and solid presence, by sensing what complex life decisions were required of Bob and Sue in keeping to the path of their choice, and what treasures Bob left behind as inspirations for us all.

As Dean, I always thought that the first endowed chair in the School of Art and Design should be in the Ceramics Division. That that chair will always carry Bob's name is so wonderful.

Sue, we surely will miss him.

Richard Thompson, professor, School of Art and Design at Alfred University, NY.

Robert Turner's work is represented at SOFA CHICAGO 2005 by Helen Drutt: Philadelphia/ Hurong Lou Gallery, Philadelphia, PA.

Michael Zobel, **Necklace**
sterling silver, pure gold, .88ct diamonds, 16.5 x 1

Aaron Faber Gallery

Thirty years of personalizing jewelry design and style

Staff: Edward Faber; Patricia Kiley Faber; Erika Rosenbaum; Ji-Hae Han

666 Fifth Avenue
New York, NY 10103
voice 212.586.8411
fax 212.582.0205
info@aaronfaber.com
aaronfaber.com

Tod Pardon, **Somerrie** brooch
sterling silver, 14k gold, bone, wood, pigment, glass, 2 x 5

Representing:
Glenda Arentzen
Margaret Barnaby
Marco Borghesi
Wilhelm Buchert
Ute Büge
Claude Chavent
Françoise Chavent
Lina Fanourakis
Michael Good
Bernd Munsteiner
Tom Munsteiner
Tod Pardon
Linda Kindler Priest
Kim Rawdin
Susan Kasson Sloan
Jeff Wise
Susan Wise
Michael Zobel

Kim Rawdin, **Mountains of the Sky People … Cuff,** *2005*
14k and 18k gold, turquoise

Aaron Faber Gallery

Special SOFA CHICAGO Presentation: Signature Style: The jewelry artist's vision expressed through technical mastery

Elena Votsi, **Rings,** *2004*
18k gold, three in one

Emily Kame Kngwarreye, **My Country,** *1994*
acrylic on canvas, 80 x 69

Aboriginal Galleries of Australia

Aboriginal art from the Central Australian Desert
Staff: Maryanne Hollow, director; Natalie Hollow, director

35 Spring Street
Melbourne, Victoria 3000
Australia
voice 61.3.9654.2516
fax 61.3.9654.3534
art@agamelbourne.com
maryanne.hollow@bigpond.com
agamelbourne.com

Johnny Warangkula Tjupurrula, **Water Dreaming Kalipinpa***, 1975*
natural ochres on canvas, 63 x 50

Representing:
Emily Kame Kngwarreye
Makinti Napanangka
Anna Petyarre
Gloria Petyarre
Kathleen Petyarre
Minnie Pwerle
Mick Namerari Tjapaltjarri
Walala Tjapaltjarri
Johnny Warrangkula Tjupurrula
Turkey Tolson Tjupurrula

*Donald Sultan, **Calla Lilies**, 2005*
hand-painted and poured glass bas relief, 15 x 11 x 2.25 each
photo: courtesy of Rosenthal Fine Art

Adamar Fine Arts

A contemporary gallery focusing on sculpture and paintings by recognized national and international artists
Staff: Tamar Erdberg, owner/director; Adam Erdberg, owner

358 San Lorenzo Avenue
Suite 3210
Coral Gables, FL 33146
voice 305.576.1355
fax 305.448.5538
adamargal@aol.com
adamargallery.com

Marlene Rose, **Metallic Birdbath Buddha,** *2005*
sand-cast glass, 44 x 13 x 9
photo: David Monroe

Representing:
Brad Howe
Jeff Koons
Gretchen Minnhaar
Niso
Rene Rietmeyer
Marlene Rose
Donald Sultan
Tolla

51

Salvador Dali, **Surrealist Angel**, *1983*
bronze, 28.75 x 15 x 8.5

Aldo Castillo Gallery

International fine arts — specializing in Latin American art

Staff: Aldo Castillo, director; Christina Maybaum, gallery associate; Rafael Castro, manager

233 West Huron Street
Chicago, IL 60610
voice 312.337.2536
fax 312.337.3627
info@artaldo.com
artaldo.com

Aldo Castillo, **Lost Dynasty**, *2005*
mixed media, 15 x 13 x 10

Representing:
Maria Cristina Arria
Aldo Castillo
Carlos Colombino
Salvador Dali
Magdalena Fernandez
Estuardo Maldonado
Gretchen Minnhaar
Hugo Palma
Veronica Riedel
Jorge Salas
Rosa Segura

Carol Stein, **Endora II**, *2005*
waxed linen, rice paper, sea grass, pastels, Prismacolor pencils, 22 x 20 x 9

Andora Gallery

Emerging and established artists working in clay, fiber, glass, metal, wood and jewelry
Staff: Sue Bass, owner; Erica Kern, gallery director

PO Box 5488
Carefree, AZ 85377
voice 480.595.1039
fax 480.595.1069
info@andoragallery.com
andoragallery.com

Representing:
Jill Baker
Caroline Bartlett
Christian Burchard
Paul Elia
Mark Gardner
Stephen Goetschius
Jeff Goodman
Mark Hancock
Sergey Jivetin
Taliaferro Jones
James Lovera
Hideaki Miyamura
Dennis Nahabetian
Stephen Mark Paulsen
Ron Pessolano
George Peterson
Karen Pierce
Zorine Rinaldi
Axel Russmeyer
Debra Sachs
Carol Stein
Cathy Strokowsky
Jennifer Trask

Taliaferro Jones, **Brim,** *2005*
kiln-cast crystal, 15 x 6 x 3

Jim Rose, **Block Quilt Cupboard,** *2005*
blue steel with colored panels, 74 x 52 x 21

Ann Nathan Gallery

Established and emerging contemporary realist painters, artist-made steel furniture, famed ceramic and bronze sculptors, visionaries and selective African art
Staff: Ann Nathan, director; Victor Armendariz, assistant director

212 West Superior Street
Chicago, IL 60610
voice 312.664.6622
fax 312.664.9392
nathangall@aol.com
annnathangallery.com

Representing:
Mary Bero
Mary Borgman
Gordon Chandler
Cristina Cordova
Gerard Ferrari
Krista Grecco
Michael Gross
Chris Hill
Charlene Nemec-Kessel
Jesus Curia Perez
Jim Rose
John Tuccillo
Jerilyn Virden

Chris Hill, **Crossing Division,** *2005*
welded steel, acrylic paint, 51 x 35 x 8.5

Cristina Cordova, **La Guardian,** *2005*
cermaic, mixed media, 24 x 25 x 10

Mary Borgman, **Portrait of Moises Mayen**
mixed media on Mylar, 42 x 72

Salvador Dali, u Montant l'escalier- homage a Marcel Duchamp, *1973*
original bronze, edition of 8, 82 x 42 x 52

ART+

A new edge in contemporary art surrounded by our representation of reference masters
Staff: Jean Bernard; Debra Arman; Danielle Alvarez; Jamaal Sommers

358 San Lorenzo Avenue
Suite 3135
Miami, FL 33146
voice 786.497.1111
fax 786.497.4104
info@artplusgallery.com
artplusgallery.com

Georges Braque, **Asteria,** *1962*
vermeil, amethyst, amazonite druze, 15.5 x 11

Representing:
Arman
Laurent Ellie Badessi
Rafael Barrios
Georges Braque
Alexander Calder
Salvador Dali
Mark Koven
Rob Stern

Ioan Nemtoi, **Pipes** *detail, 2004*
glass, 48 x 8 each

Art Novell

Introduction of contemporary Romanian and Lithuanian fine art and glass
Staff: Mirela Van Dyke, owner; Barbara Beans, gallery manager, Vail;
Nicole Rieck, Kohler gallery; Victor Van Dyke, gallery manager, Minneapolis

Crossroads of Vail
Meadow Street
Vail, CO
voice 970.479.5171
fax 952.470.0541
artnovell2003@yahoo.com
artnovell.com

Shops at Woodlake
Kohler, WI 53044
voice 920.208.5145

Gaviidae Commons II
Minneapolis, MN 55401
voice 612.332.2305

Representing:
Ioan Nemtoi
Ion Tamaian
Mihai Topescu
Nicu Zeleznicov

Mihai Topescu, **Caterpillar,** *2005*
glass, copper, 16 x 7.5

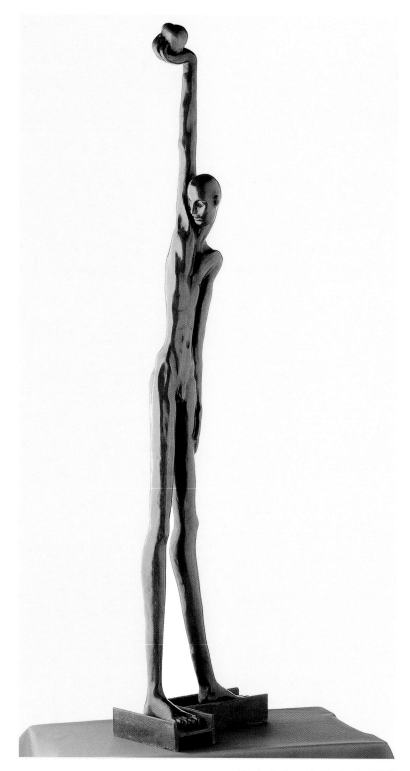

Elizabeth Gavotti, **Big Apple,** *2005*
bronze, 16 x 4 x 2

Artempresa

International contemporary art with special emphasis on Latin American expressions
Staff: Maria Elena Kravetz, director; Raúl Nisman; Matías Alvarez, assistant

San Jerónimo 448
Córdoba 5000
Argentina
voice 54.351.422.1290
fax 54.351.427.1776
artempresa@arnet.com.ar
artempresagallery.org

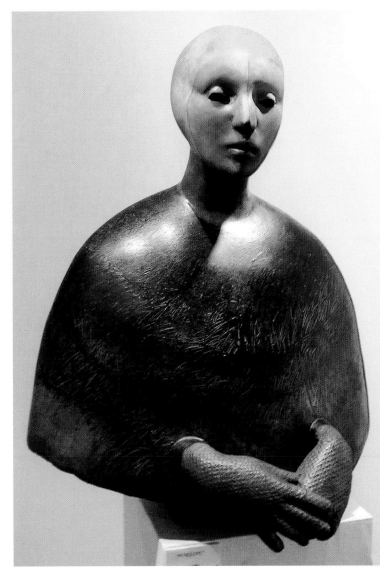

Representing:
Oscar Daga
Elizabeth Gavotti
Sol Halabi
Ana Mazzoni
Cristina Nuñez
María Ester Pañeda
Silvia Parmentier
Gabriela Pérez-Guaita
Daniel Pezzi
Polimnia Sepulveda
Maria Alejandra Tolosa
Elias Toro
Feyona Van Stom

Elias Toro, **Penelope***, 2005*
bronze, oil paint, 26 x 24 x 12

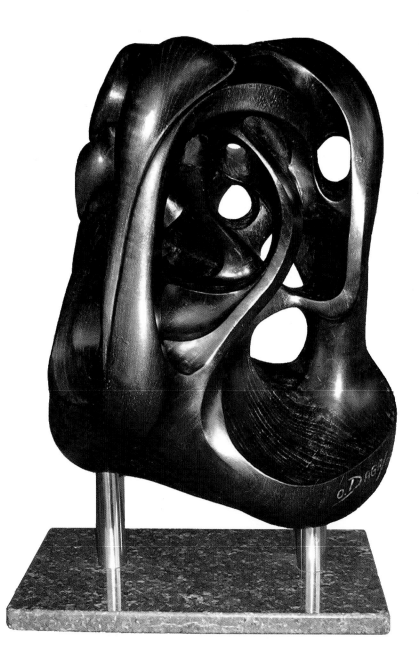

Oscar Daga, **Escape Lines,** *2004*
carved cedar, 22 x 15 x 10

Cristina Nuñez, **The Game,** *2005*
oil and charcoal on canvas, 60 x 58

Gabriella Bisetto, **Inhale,** *2005*
blown glass, 19 x 6 x 8
photo: Grant Hancock

Australian Contemporary

Presenting Australian craft and design to international audiences
Staff: Stephen Bowers, managing director; Pauline Griffin, sales manager

19 Morphett Street
Adelaide, South Australia 5000
Australia
voice 61.8.8410.0727
fax 61.8.8231.0434
contact@jamfactory.com.au
jamfactory.com.au

Representing:
Gabriella Bisetto
Jane Bowden
Mari Funaki
Maureen Williams

Jane Bowden, **Pillow,** *2004*
bonded 22ct. sterling silver; hand-fabricated, 2 x 2 x 1
photo: Grant Hancock

Mari Funaki, **Bracelet,** *2004*
oxidized mild steel

Maureen Williams, Larapinta Series, *2004*
blown glass, 10 x 9 x 6

Richard Slee, **Bananas** *, 2005*
clay, 11.5 x 19 x 11
photo: Philip Sayer

Barrett Marsden Gallery

Staff: Juliana Barrett; Tatjana Marsden

17-18 Great Sutton Street
London EC1V 0DN
England
voice 44.20.7336.6396
info@bmgallery.co.uk
bmgallery.co.uk

Representing:
Gordon Baldwin
Alison Britton
Caroline Broadhead
Tessa Clegg
Ken Eastman
Philip Eglin
Chun Liao
Robert Marsden
Carol McNicoll
Steven Newell
Sara Radstone
Nicholas Rena
Michael Rowe
Richard Slee
Martin Smith
Maria van Kesteren
Emma Woffenden

Martin Smith, **Sound and Silence 5/2**, *2005*
clay, glass, 5 x 16 x 16.5
photo: Martin Smith

Philip Eglin, **Reclining Nude,** *2005*
clay, 12 x 15 x 12.5
photo: Philip Sayer

Gordon Baldwin, **Pierced Bowl III**
clay, 14.5 x 17.5
photo: Philip Sayer

Benjamin Edols and Kathy Elliott, **Orange Curled Leaf,** *2005*
hot-formed and wheel-cut glass, 15.75 x 16 x 5.5
photo: Greg Piper

Beaver Galleries

Contemporary Australian paintings, sculpture, glass, ceramics, jewelry and wood
Staff: Martin Beaver, director

81 Denison Street, Deakin
Canberra, ACT 2600
Australia
voice 61.2.6282.5294
fax 61.2.6281.1315
mail@beavergalleries.com.au
beavergalleries.com.au

Representing:
Clare Belfrage
Benjamin Edols
Kathy Elliott
Avital Sheffer

Clare Belfrage, **Quiet Shifting Group #2***, 2005*
blown glass with cane drawing, acid-etched, 15 x 23.5 x 11
photo: Grant Hancock

77

Silvio Vigliaturo, **Amazzone**, *2005*
fused glass, 102 x 18 x 16
photo: F. Ferruzzi

Berengo Fine Arts

Contemporary art and glass art
Staff: Adriano Berengo, director; Hans van Enckevort, fair manager

Fondamenta Vetrai 109/A
Murano, Venice 30141
Italy
voice 39.041.739453
39.041.527.6364
fax 39.041.527.6588
adberen@berengo.com
berengo.com

Berengo Collection
Calle Larga San Marco 412/413
Venice 30124
Italy
voice 39.041.241.0763
fax 39.041.241.9456

Kortestraat 7
Arnhem 6811 EN
The Netherlands
voice 31.26.370.2114
31.61.707.4402
fax 31.26.370.3362
berengo@hetnet.nl

Representing:
Henrik Allert
Paolo Anselmo
Luigi Benzoni
Dusciana Bravura
Shan Shan Sheng
Silvio Vigliaturo

Henrik Allert, **Faun,** *2005*
Murano glass, 16 x 12 x 11
photo: F. Ferruzzi

Richard Hooper, **Galaxy 2000**
birch ply, aluminum, dyed veneer, 15.75d
photo: Bob Baxter

Bluecoat Display Centre

Inspirational British applied art
Staff: Maureen Bampton, director; Samantha Rhodes, assistant director

Bluecoat Chambers
College Lane
Liverpool L1 3BX
United Kingdom
voice 44.151.709.4014
fax 44.151.707.8106
crafts@bluecoatdisplaycentre.com
bluecoatdisplaycentre.com

Susan May, **Tall Bebop** *ring*
silver, 1.75h
photo: Joël Degen

Representing:
Stephen Dixon
Thomas Hill
Richard Hooper
Gilly Langton
Susan May
Cathy Miles
Junko Mori
Emma Rodgers

Thomas Hill, **Bound Wire Birds,** *2005*
steel, wood, 10 x 6 x 3; 14 x 10 x 7
photo: Jeffrey Goldsmith

Emma Rodgers, **Bronze Horse**
bronze, 15.75 x 21.5
photo: Mills Media

Jin-Sook So, **New York Skyline II,** *2004*
steel mesh, electroplated silver with gold leaf and patinated thread, 27.5 x 27.5 x 2.25
photo: Tom Grotta

browngrotta arts

Focusing on arttextiles and fiber sculpture for 18 years
Staff: Rhonda Brown and Tom Grotta, co-curators; Roberta Condos, associate

Wilton, CT
voice 203.834.0623
fax 203.762.5981
art@browngrotta.com
browngrotta.com

Representing:

Adela Akers	Kyoko Kumai
Dona Anderson	Gyöngy Laky
Jeanine Anderson	Inge Lindqvist
Marijke Arp	Åse Ljønes
Jane Balsgaard	Astrid Løvaas
Jo Barker	Dawn MacNutt
Dorothy Gill Barnes	Ruth Malinowski
Caroline Bartlett	Mary Merkel-Hess
Dail Behennah	Judy Mulford
Nancy Moore Bess	Keiji Nio
Birgit Birkkjaer	Simone Pheulpin
Sara Brennan	Valerie Pragnell
Jan Buckman	Ed Rossbach
Pat Campbell	Scott Rothstein
Chris Drury	Mariette Rousseau-Vermette
Lizzie Farey	
Ceca Georgieva	Debra Sachs
Mary Giles	Toshio Sekiji
Linda Green	Hisako Sekijima
Françoise Grossen	Kay Sekimachi
Norie Hatakeyama	Hiroyuki Shindo
Ane Henricksen	Karyl Sisson
Maggie Henton	Britt Smelvær
Helena Hernmarck	Jin-Sook So
Sheila Hicks	Grethe Sørenson
Marion Hildebrandt	Kari Stiansen
Agneta Hobin	Noriko Takamiya
Kazue Honma	Chiyoko Tanaka
Kate Hunt	Hideho Tanaka
Kristín Jónsdóttir	Tsuroko Tanikawa
Christine Joy	Blair Tate
Glen Kaufman	Lenore Tawney
Ruth Kaufmann	Jun Tomita
Tamiko Kawata	Deborah Valoma
Anda Klancic	Claude Vermette
Lewis Knauss	Ulla-Maija Vikman
Mazakazu Kobayashi	Kristen Wagle
Naomi Kobayashi	Wendy Wahl
Nancy Koenigsberg	Katherine Westphal
Yasuhisa Kohyama	Inge Winqvist
Irina Kolesnikova	Jiro Yonezawa
Markku Kosonen	Masako Yoshida

Norie Hatakeyama, **Seeing Is Believing***, 2004*
plaited, paper fiber strips, 21 x 23 x 20
photo: Tom Grotta

Anonymous, **Table,** *2002*
wood, myrtle and eucalyptus burl inlay, 36 x 42 x 84

Brushings, Ltd.

Unique, high-quality, useful pieces for the home
Staff: Martha Hackett; William Parke; Stuart Meeking

By Appointment Only
Thompson, OH
voice 440.298.1548
fax 440.298.3782
wwp@lightstream.net
brushings.com

Anonymous, **Bench,** *2004*
wood, quilted eucalyptus and blackwood, 14 x 24 x 78

Catharine Newell, **Man in a Pink Shirt,** *2005*
kiln-formed glass, 23.75 x 8 x 1
photo: Paul Foster

Bullseye Connection Gallery

Contemporary works in Bullseye glass by established and emerging artists

Staff: Lani McGregor, executive director, The Bullseye Connection; Dan Schwoerer, CEO, Bullseye Glass Co.; Rebecca Rockom, sales associate; Chris McNelly, office manager

300 NW Thirteenth Avenue
Portland, OR 97209
voice 503.227.0222
fax 503.227.0008
galleryweb@bullseyeglass.com
bullseyeconnectiongallery.com

Representing:
Giles Bettison
Steve Klein
Alicia Lomné
Jessica Loughlin
Catharine Newell
Kirstie Rea
April Surgent

April Surgent, I Thought I Saw You There, *2005*
fused and engraved glass, 19 x 34 x 2
photo: Ryan Watson

Maria Grazia Rosin, **Red Jellyfish Lux,** *2004*
hand-made blown glass by Murano maestro Pino Signoretto, 92 x 31
photo: Franzini

Caterina Tognon Arte Contemporanea

Contemporary glass sculpture by European and American artists
Staff: Caterina Tognon, director; Sergio Gallozzi, assistant

San Marco 2671
Campo San Maurizio
Venice 30124
Italy
voice 39.041.520.7859
fax 39.041.520.7859
info@caterinatognon.com
caterinatognon.com

Representing:
Jaroslava Brychtová
Václav Cigler
Maurizio Donzelli
Silvia Levenson
Stanislav Libenský
Maria Grazia Rosin
Gisela Sabokova

Silvia Levenson, **Red Cactus Bag***, 2005*
fused glass, copper, 10 x 10 x 6
photo: Natalia Saurin

Alex Gabriel Bernstein, **Flower**
cast and cut glass, fused steel, 12 x 9

Chappell Gallery

Contemporary glass sculpture

Staff: Alice M. Chappell, director; Kathleen M. Pullan, manager

526 West 26th Street
Suite 317
New York, NY 10001
voice 212.414.2673
fax 212.414.2678
amchappell@aol.com
chappellgallery.com

Kazumi Ikemoto, **Scene 0205**
painting on blown glass, 30 x 32.5

Representing:
Sean Albert
Mary Ann Babula
Alex Gabriel Bernstein
Emma Camden
Sydney Cash
Christie Cathie
Kathleen Holmes
Toshio Iezumi
Kazumi Ikemoto
Vladimir Kopecký
Anna Matouskova
David Murray
Etsuko Nishi
Kait Rhoads
Takeshi Sano
Youko Sano
Lada Semecka
Benjamin Sewell
Ethan Stern
Sasha Zhitneva

Meiri Ishida, **Brooch**, *2005*
felt, silver
photo: Karen Bell

Charon Kransen Arts

Contemporary innovative jewelry from around the world
Staff: Ciel Bannenberg; Adam Brown; Lisa Granovsky; Charon Kransen

By Appointment Only
456 West 25th Street
New York, NY 10001
voice 212.627.5073
fax 212.633.9026
charon@charonkransenarts.com
charonkransenarts.com

Representing:

Miho Akitomo	Christine Matthias
Efharis Alepedis	Elisabeth McDevitt
Kirsten Bak	Bruce Metcalf
Ralph Bakker	Miguel
Rike Bartels	Naoka Nakamura
Carola Bauer	Martin Niemeijer
Michael Becker	Evert Nijland
Harriete Estel Berman	Daniela Osterrieder
Liv Blavarp	Barbara Paganin
Antje Braeuer	Gundula Papesch
Sebastian Buescher	Anya Pinchuk
Shannon Carney	Natalya Pinchuk
Anton Cepka	Kaire Rannik
Giovanni Corvaja	Jackie Ryan
Simon Cottrell	Lucy Sarneel
Annemie de Corte	Renate Schmid
Peter Frank	Claude Schmitz
Ursula Gnaedinger	Biba Schutz
Sophie Hanagarth	Evelien Sipkes
Valerie Hector	Elena Spano
Mirjam Hiller	Claudia Stebler
Meiri Ishida	Dorothee Striffler
Reiko Ishiyama	Barbara Stutman
Hiroki Iwata	Hye-Young Suh
Hilde Janich	Janna Syvanoja
Mette Jensen	Salima Thakker
Karin Johansson	Ketli Tiitsar
Ike Juenger	Terhi Tolvanen
Martin Kaufmann	Silke Trekel
Ulla Kaufmann	Erik Urbschat
Yoon Jeong Kim	Flora Vagi
Stefanie Klemp	Felieke van der Leest
Yael Krakowski	Ben van Orshaegen
Winfried Krueger	Peter Vermandere
Dongchun Lee	Manuel Vilhena
Peter Machata	Karin Wagner
Stefano Marchetti	Yasunori Watanuki
Lucia Massei	Annamaria Zanella

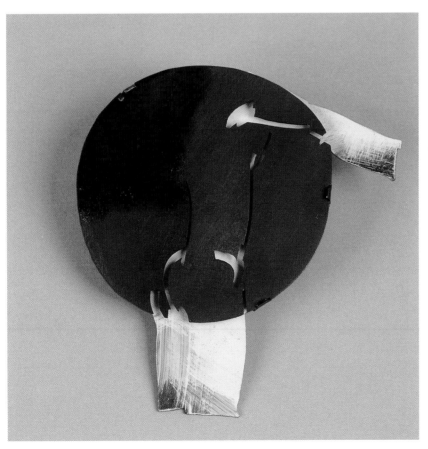

Dongchun Lee, **Brooch***, 2005*
iron, paint
photo: Karen Bell

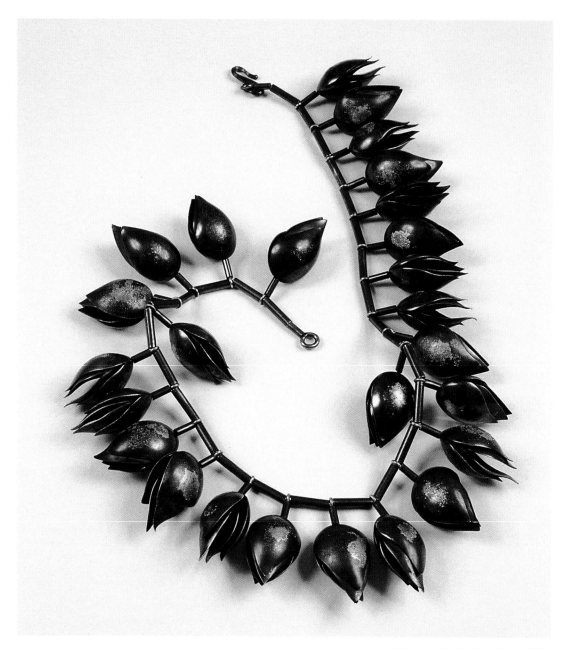

Nina Ehmck, **Pod Necklace,** *2004*
oxidized sterling silver, 22k gold
photo: Karen Bell

The David Collection

International fine arts with a specialty in contemporary studio jewelry
Staff: Jennifer David, director; Yuki Ishi

44 Black Spring Road
Pound Ridge, NY 10576
voice 914.764.4674
fax 914.764.5274
jkdavid@optonline.net
thedavidcollection.com

Representing:
Mikiko Aoki
Sara Basch
Alexander Blank
Beate Brinkmann
Barbara Christie
Joachim Dombrowski
Valerie Dubois
Nina Ehmck
Petronella Eriksson
Kyoko Fukuchi
Tania Gallas
Gill Galloway-
 Whitehead
Ursula Gnaedinger
Michael Good
Ulrike Hamm
Michael Hamma
Masako Hayashibe
Marion Heilig
Lydia Hirte
Mari Ishikawa
Yoko Izawa
Kyung Shin Kim
Heide Kindelmann
Costas Kyriakou
Ingrid Larssen
Wilhelm Tasso Mattar
Martina Mühlfellner
Suzanne Otwell Négre
Lena Olson
Helge Ott
Maria Phillips
Alexandra Pimental
Sabine Reichert
Julia Reymann
Kayo Saito
Mona Wallström
Beate Weiss
Hedvig Westermark

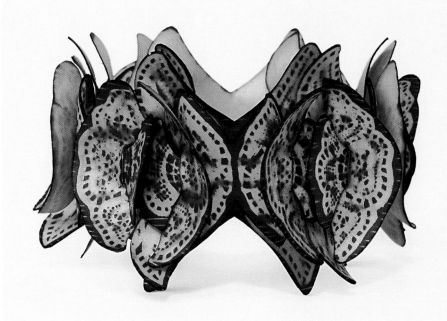

*Ulrike Hamm, **Bracelet**, 2005
parchment*

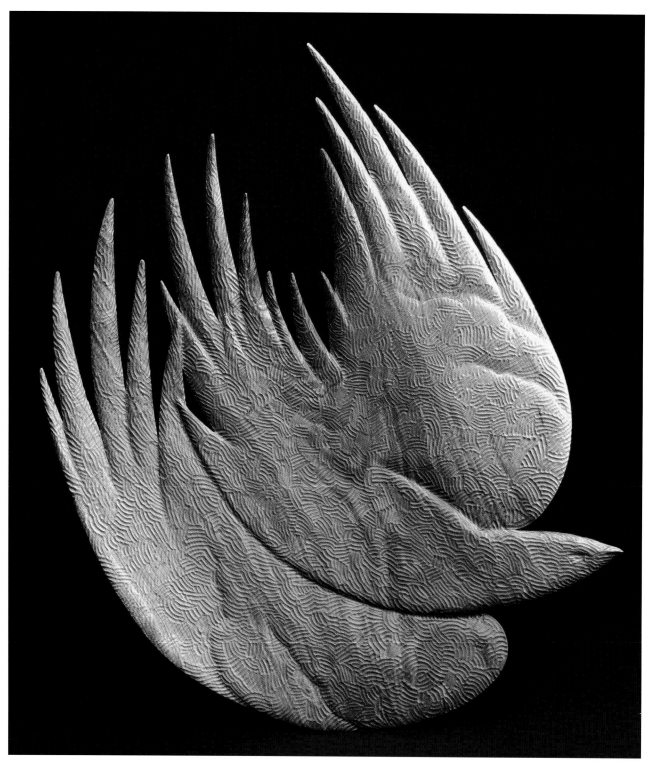

Ron Layport, **Windscape,** *2005*
cherry, 27 x 25 x 4
photo: Chuck Fuhrer

del Mano Gallery

Turned and sculptured wood, fiber, teapots and jewelry
Staff: Ray Leier; Jan Peters; Kirsten Muenster

11981 San Vicente Boulevard
Los Angeles, CA 90049
voice 310.476.8508
fax 310.471.0897
gallery@delmano.com
delmano.com

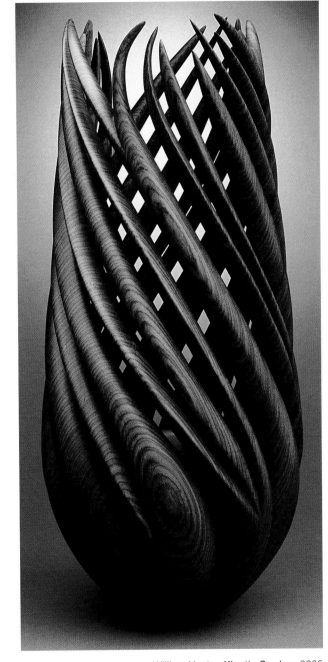

William Hunter, **Kinetic Garden***, 2005*
cocobolo, 17 x 7.75
photo: Alan Shaffer

Representing:

Gianfranco Angelino	Patti Lechman
Michael Bauermeister	Michael Lee
Derek Bencomo	John Macnab
Dixie Biggs	Alain Mailland
Christian Burchard	Ricky Maldonado
David Carlin	Bert Marsh
Dale Chase	Marilyn Moore
Leah Danberg	Matt Moulthrop
J. Kelly Dunn	Philip Moulthrop
David Ellsworth	Dennis Nahabetian
Harvey Fein	David Nittman
J. Paul Fennell	Nikolai Ossipov
Melvyn Firmager	Sarah Parker-Eaton
Ron Fleming	David Peters
Mark Frank	Michael Peterson
Donald E. Frith	Binh Pho
Angie Harbin	Jill Powers
Carrianne Hendrickson	Tania Radda
Louise Hibbert	Vaughn Richmond
Robyn Horn	JoAnne Russo
Todd Hoyer	Joshua Salesin
Peter Hromek	Merryll Saylan
David Huang	Kay Sekimachi
William Hunter	David Sengel
John Jordan	Michael Shuler
Steven Kennard	Steve Sinner
Ron Kent	Karyl Sisson
Ray Key	Hayley Smith
Bonnie Klein	Butch Smuts
Leon Lacoursiere	Ema Tanigaki
Stoney Lamar	Grant Vaughan
Merete Larsen	Jacques Vesery
Bud Latven	Hans Weissflog
Ron Layport	Andi Wolfe

Patrick Hall, **Power Blocks** *detail, 2005*
collected and manipulated books, 48 x 39.5 x 18
photo: Di Allison

Despard Gallery

Sculptural furniture, jewelry, sculpture, and ceramics
Staff: Steven Joyce, director

15 Castray Esplanade
Hobart, Tasmania 7000
Australia
voice 61.3.6223.8266
fax 61.3.6223.6496
steven@despard-gallery.com.au
despard-gallery.com.au

Patricia Bromley Marks, **Noir**
rubber, 18k gold, black diamonds, 1.25
photo: Richard Marks

Representing:
Di Allison
Patricia Bromley Marks
Michael Gather
Patrick Hall
Jenny Orchard
Peter Prasil
John Smith
Penny Smith
Ross Straker
Jim Vaughan
Roger Webb
Marty Wolfhagen

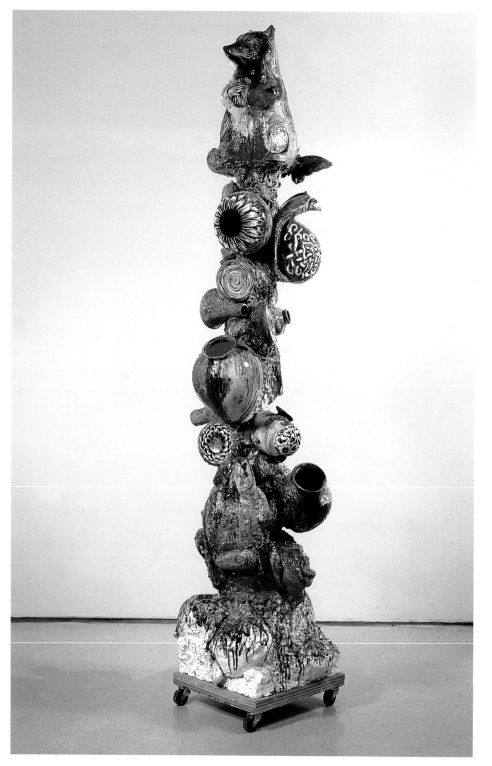

Michael Lucero, **Dust Collector,** *1997*
ceramic with glazes, 85 x 22 x 23
photo: Good Body

Donna Schneier Fine Arts

Modern masters in ceramics, glass, fiber, metal and wood
Staff: Donna Schneier; Leonard Goldberg; Jesse Sadia

By Appointment Only
New York, NY
voice 212.472.9175
fax 212.472.6939
dnnaschneier@mhcable.com

Representing:
Jaroslava Brychtová
Dale Chihuly
Richard DeVore
Rick Dillingham
Viola Frey
Stanislav Libenský
Michael Lucero
Mark Peiser
Stephen Rolfe Powell
Toshiko Takaezu
Bertil Vallien
František Vízner
Peter Voulkos
Beatrice Wood
Betty Woodman

Michael Lucero, **Pair of Skunks,** *2005*
ceramic with yarn and glazes, 26 x 28 x 14 each
photo: Good Body

Scott Rench, **Interactive Ceramics,** *2005*
printed earthenware, wood, 9 x 16 x 5

Dubhe Carreño Gallery

Contemporary ceramics by international artists
Staff: Dubhe Carreño, director; Theresa DeCesare, gallery assistant; Brian Gillham, gallery assistant

1841 South Halsted Street
Chicago, IL 60608
voice 312.666.3150
fax 312.577.0988
info@dubhecarrenogallery.com
dubhecarrenogallery.com

Representing:
Brian Boldon
Cynthia Consentino
Erin Furimsky
Tyler Lotz
Sewon Minn
Dennis Lee Mitchell
Scott Rench
Patricia Rieger
Diana Solis
Karen Swyler
Michaelene Walsh

Brian Boldon, **Eclipse**, *2005*
laser printed decals, slumped glass, aluminum, nylon, vinyl, stainless steel, electricity, 6 x 21 x 9
photo: Amy Baur

Louis Mueller, **Ultraist Sconce,** *2005*
constructed bronze, enamel paint, light bulb, 18 x 5 x 6
photo: Ira Garber

Elliott Brown Gallery

Contemporary glass and other craft media
Staff: Kate Elliott, director; Charlotte Webb

By Appointment Only
Seattle, WA
Mailing Address:
P.O. Box 1489
North Bend, WA 98045
voice 206.660.0923
fax 425.831.3709
kate@elliottbrowngallery.com
elliottbrowngallery.com

Hank Murta Adams, **Gossipbater**, 2005
cast glass, patinated copper, 30 x 17 x 17
photo: Hank Adams

Representing:
Hank Murta Adams
Dale Chihuly
Laura de Santillana
Katherine Gray
Joey Kirkpatrick
Mayme Kratz
Flora C. Mace
Richard Marquis
John McQueen
Louis Mueller
Pike Powers
Toots Zynsky

Marc Petrovic, **Navigator** *detail, 2005*
glass, mixed media, 96 x 72
photo: Marc Petrovic

Ferrin Gallery

Two and three dimensional art, ceramic sculpture and studio pottery
Staff: Leslie Ferrin; Donald Clark; Scott Norris; Michael McCarthy

69 Church Street
Lenox, MA 01240
voice 413.637.4414
fax 914.271.0047
info@ferringallery.com
ferringallery.com

Representing:
Russell Biles
Annette Corcoran
Paul Dresang
Julie Elkins
Lucy Feller
Rain Harris
Sergei Isupov
Karen Karnes
Kathryn McBride
Matthew Metz
Eunjung Park
Marc Petrovic
Karen Portaleo
Mark Shapiro
Micah Sherrill
Michael Sherrill
Michael Simon
Mara Superior
Joan Takayama-Ogawa
Susan Thayer
Sandra Trujillo
Wendy Walgate
Jason Walker
Red Weldon-Sandlin
Irina Zaytceva

Karen Karnes, **Trio,** *2004*
ceramic, 15h
photo: Mark Shapiro

Giampietro Filippetti, **Angolo Rosso,** *2005*
glass mosaic, 48 x 48 x 1

Filippetti

Glass mosaic fine art by Giampietro Filippetti
Staff: Martha Gombas, director

6689 Opera Glass Crescent
Mississauga, Ontario L5W 1R7
Canada
voice 416.566.5072
info@filippetti.ca
filippetti.ca

Representing:
Giampietro Filippetti

Giampietro Filippetti, **Pioggia Colarata,** *2005*
glass mosaic, 33 x 44 x 1

John Cederquist, **Little Waves,** *2005*
various woods and inks, 70 x 54 x 19

Franklin Parrasch Gallery

Contemporary art 20 West 57th Street
Staff: Franklin Parrasch; Chris Churchill; Holly Brown; Bryan Osburn New York, NY 10019
voice 212.246.5360
fax 212.246.5391
franklin@franklinparrasch.com
franklinparrasch.com

Richard DeVore, **Untitled #772**, c. 1994
glazed ceramic, 14.5 x 10 x 8

Representing:
Robert Arneson
John Cederquist
Stephen DeStaebler
Richard DeVore
Viola Frey
John Mason
Irv Tepper
Peter Voulkos

Peter Layton, **Paradiso**, *2004*
glass, 14 x 12

Freed Gallery

Contemporary gallery featuring Northwest, national and international artists
Staff: Lee Freed, owner

6119 SW Highway 101
Lincoln City, OR 97367
voice 541.994.5600
fax 541.994.5606
info@freedgallery.com
freedgallery.com

Representing:
Micajah Bienvenu
Jaye Blackwood
Susan Block
Brian Brenno
Jan Gjaltema
Larry Glickman
Jim Kraft
Yorgos Kypris
Peter Layton
Tracy MacEwan
Brian Mackin
Rick Martin
Rosalie Neilson
Tom Owczarzak
James Shaw
Chris Tedesco

Yorgos Kypris, **Entrapped Fish,** *2005*
bronze, 45 x 51

Rick Martin, **Black Chair,** *2005*
walnut, 70h

Tom Owczarzak, Natalie, *2003*
black onyx, diamonds, gold, pearls, 3.5 x 1.5

David Orth, **Occasional Table 7353**, *2005*
bronze, steel, 57 x 28 x 12

Function + Art/PRISM Contemporary Glass

Excellence in contemporary studio furniture, sculptural objects and studio glass
Staff: D. Scott Patria, director; Amy Hajdas, communications

1046-1048 West Fulton Market
Chicago, IL 60607
voice 312.243.2780
info@functionart.com
info@prismcontemporary.com
functionart.com
prismcontemporary.com

Representing:
Bonnie Bishoff
Afro Celotto
Alex Fekete
Greg Fidler
Janet Kelman
Shayna Leib
Mark Levin
Elizabeth Mears
Robert Mickelsen
Sarah Obrecht
David Orth
Douglas Rich
Martin Rosol
Scott Schroeder
Brent Skidmore
J.M. Syron

Shayna Leib, **Charybdis,** *2005*
glass cane, steel, 14 x 18 x 4

Tyrone Mitchell, **Hiroshima** *detail, 1992*
mixed media sculpture, 55 x 61 x 61
photo: Alejandro Garcia

G.R. N'Namdi Gallery

Contemporary and historic abstract paintings and sculpture by national and international artists
Staff: George N'Namdi; Jumaane N'Namdi

110 North Peoria Street
Chicago, IL 60607
voice 312.563.9240
fax 312.563.9299
contact@grnnamdi.com
grnnamdi.com

Representing:
Chakaia Booker
Carol Ann Carter
Marjorie Guyon
Christine Hagedorn
Adia Millett
Tyrone Mitchell
Charles Searles
Kathleen Spicer

Christine Hagedorn, **Dilate** *detail, 2004*
wood, rice paper, waxed linen thread, 22 x 22 x 36
photo: Alejandro Garcia

Ruth Bloch, **Somewhere Out There**
mixed media, 51 x 30 x 20

Galeria Mundial

An international selection of unique artists
Staff: Mariela Pijem, director

Malva #58 Santa Maria
San Juan, Puerto Rico 00927
voice 787.565.6258
galeriamundial@gmail.com

Markus Pierson, **Ode to Time**
mixed media, 81 x 55 x 23

Representing:
Ruth Bloch
Roxana Jordan
Markus Pierson

Simone Perrotte, **Vase***, 2004*
porcelain, 9h

Galerie Ateliers d'Art de France

Work by contemporary artists in a variety of media
Staff: Marie-Armelle de Bouteiller; Anne-Laure Roussille

4 Passage Roux
Paris 75017
France
voice 33.1.4401.0830
fax 33.1.4401.0835
galerie@ateliersdart.com
ateliersdart.com

Representing:
Catherine Farge
Bernard Gonnet
Louiselio
Géraldine Luttenbacher
Christophe Nancey
Simone Perrotte
Udo Zembok

Catherine Farge, **Rouge en Fleur,** *2005*
blown glass, wood, 15 x 15 x 20

Ewen Henderson, **Large Standing Form,** *c. 1990*
mixed clay, 19h
photo: Alan Tabor

Galerie Besson

International contemporary ceramics
Staff: Anita Besson, owner; Matthew Hall; Louisa Vowles

15 Royal Arcade
28 Old Bond Street
London W1S 4SP
England
voice 44.20.7491.1706
fax 44.20.7495.3203
enquiries@galeriebesson.co.uk
galeriebesson.co.uk

Representing:
Claudi Casanovas
Peter Collingwood
Hans Coper
Ewen Henderson
Mo Jupp
Jennifer Lee
Shozo Michikawa
Lucie Rie
Tatsuzo Shimaoka

Hans Coper, **White Globular Form on Black Base,** *c. 1975*
stoneware, 9.5h
photo: Alan Tabor

Mo Jupp, **Tall Blue Standing Figure,** *2005*
earthenware, 32.25h
photo: Alan Tabor

Jennifer Lee, Olive Dark Haloed Trace Amber Pot and Pale Speckled Granite and Olive Trace Pot, *2004*
hand-built colored stoneware, 5 x 4.25; 8.5 x 6.25
photo: Alan Tabor

Patrick Primeau, **Untitled,** *2004*
blown glass, incalmo, reticello, wheel engravings, 21.5 x 6.75 x 6.75
photo: Michel Dubreuil

Galerie des Métiers d'Art du Québec/Galerie CREA

Promoting excellence in Quebec contemporary fine craft in all media
Staff: France Bernard, gallery director; Margerie Lorrain-Cayer; Jerôme Bleton

Bonsecours Market
350 St. Paul Street East
Montreal, Quebec H2Y 1H2
Canada
voice 514.878.2787, ext. 2
fax 514.861.9191
france.bernard@
metiers-d-art.qc.ca
galeriedesmetiersdart.com

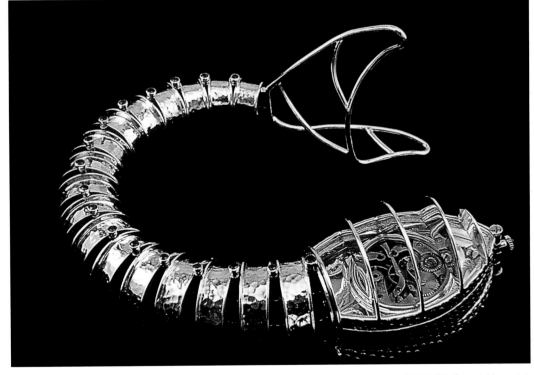

Francesc Peich, **Murène**, *table watch*
sterling silver, 14k and 24k gold, sapphires, 1.5 x 10.5
photo: Francesc Peich

Representing:
Maude Bussières
Annie Cantin
Marie-Andrée Côte
Laurent Craste
Elyse De Lafontaine
Susan Edgerley
Carole Frève
Bruno Gerard
Monique Giard
Chantal Gilbert
Antoine Lamarche
Christine Larochelle
Louise Lemieux Berubé
Caroline Ouellette
Francesc Peich
Claudio Pino
Stephen Pon
Patrick Primeau
John Paul Robinson
Natasha St-Michael
Luci Veilleux

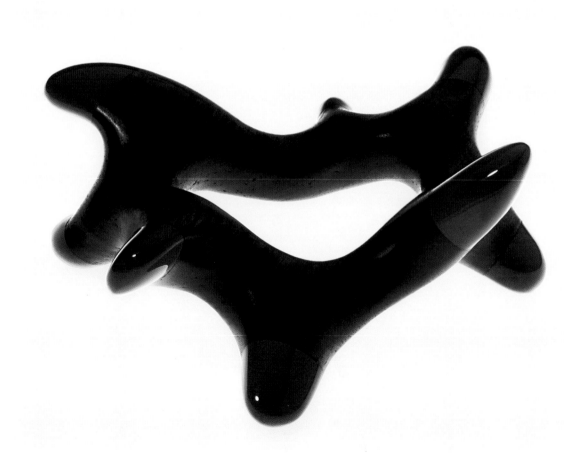

Helle Løvig Espersen, **Bracelet**, *2005*
walnut, aramithe, 5 x 5 x 2.5
photo: Dorthe Krogh

Galerie Metal

Innovative and experimental contemporary jewelry and hollowware of Danish origin
Staff: Nicolai Appel, director; Else Nicolai Hansen and Camilla Prasch, sales managers

Nybrogade 26
Copenhagen 1203
Denmark
voice 45.33.145540
fax 45.33.145540
galeriemetal@mail.dk
galeriemetal.dk

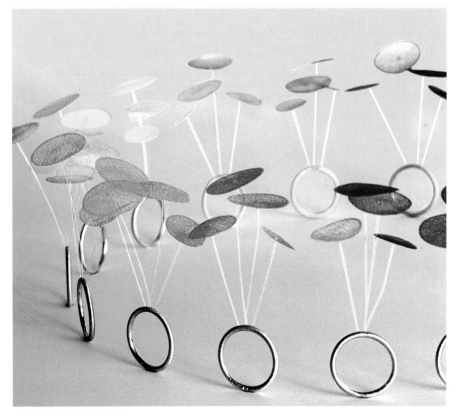

Representing:
Carsten From Andersen
Nicolai Appel
Yvette N.S. Bredsted
Margaret Bridgwater
Helle Løvig Espersen
Else Nicolai Hansen
Mette Laier Henriksen
Louise Hee Lindhardt
Karina Noyons
Camilla Prasch

Margaret Bridgwater, **Floating** *rings, 2004*
silver, nylon, chiffon, 2 x .75 x .75
photo: Thomas Damsgaard

Zora Palova, **Big Bridge,** *2005*
cast and cut glass, 32 x 16 x 5

Galerie Pokorná

To serve art — Jánský Vršek 15
Staff: Jitka Pokorná, director — Prague 1, 11800
Czech Republic
voice 420.222.518635
fax 420.222.518635
office@galeriepokorna.cz
galeriepokorna.cz

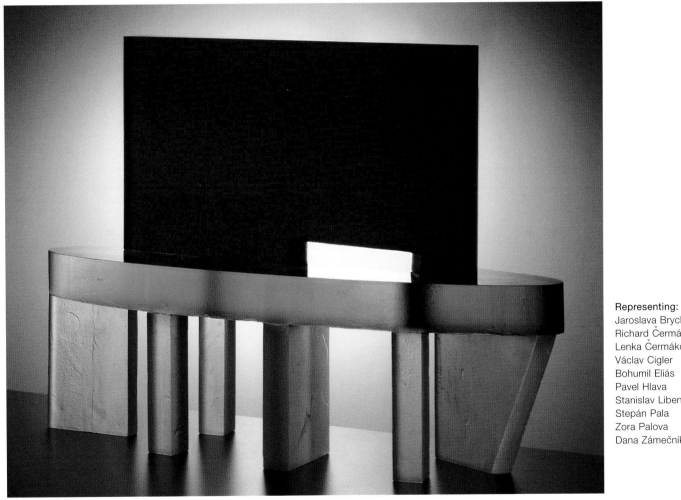

Representing:
Jaroslava Brychtová
Richard Čermák
Lenka Čermáková
Václav Cigler
Bohumil Eliás
Pavel Hlava
Stanislav Libenský
Stepán Pala
Zora Palova
Dana Zámečníková

Richard Čermák, **Boat,** *2005*
cast, cut and laminated glass, 25 x 35 x 12

Kevin O'Dwyer, **Party Teapot: The Mardi Gras Series,** *2004*
hand-forged and colored bronze with Kilkenny limestone base, 28 x 24 x 12
photo: James Fraher

Galerie Tactus

Hollowware and a touch of jewelry
Staff: Lina and Peter Falkesgaard, owners; Freda Lippmann; Sarah Hurtigkarl

By Appointment Only
6 Stavangergade
DK 2110 Copenhagen
Denmark
voice 45.33.933105
fax 45.33.326001
tactus@galerietactus.com
galerietactus.com

Torben Hardenberg, **Deconstruction** *brooch, 2005*
sterling silver, 24k gold, emerald, tourmaline, brown diamond, 2 x 2; 1.5 x 3

Representing:
Claus Bjerring
Sidsel Dorph-Jensen
Jenny Edlund
Lina Falkesgaard
Seamus Gill
Torben Hardenberg
David Huycke
Martin Kaufmann
Ulla Kaufmann
Richard Kirk
Lone Løvschal
Kevin O'Dwyer
Hiroshi Suzuki

Luigi Moro, Testa Su Mano, Tributo a Picasso, *2005*
glass, 26 x 16

Galerie Vivendi

Contemporary art and design with a special accent on bronze material
Staff: Alex Hachem, director; Paola Cancian, assistant; Rachel Pavie, assistant

28 Place des Vosges
Paris 75003
France
voice 33.1.4276.9076
fax 33.1.4276.9547
vivendi@vivendi-gallery.com
vivendi-gallery.com

Representing:
Massimo Boï
Dirk De Keyzer
Luigi Moro
Tolla

Dirk De Keyzer, **Fauteuil**, *2005*
bronze, 20.5 x 14 x 14

Stig Persson, **Holes in the Sea,** *2005*
glass, 16 x 28 each
photo: Ole Akhøj

Galleri Grønlund

Danish glass art created by five young artists among the very best in Denmark
Staff: Anne Merete Grønlund, director; Kirstine Grønlund; Jørgen Grønlund

Birketoften 16a
Copenhagen 3500
Denmark
voice 45.44.442798
fax 45.44.442798
groenlund@get2net.dk
glassart.dk

Representing:
Steffen Dam
Trine Drivsholm
Micha Maria Karlslund
Tobias Møhl
Stig Persson

Steffen Dam, **Black Perforated Bowl**, *2005*
glass, 22d
photo: Sten Ard. Fem

Martin Bodilsen Kaldahl, **Bagatelle I,** *2005*
stoneware, 5.5 x 7.25 x 19.5
photo: Søren Nielsen

Galleri Nørby

Contemporary Danish ceramics
Staff: Bettina Køppe, director; Marie T. Hermann, assistant; Gurli Elbaekgaard, assistant

Vestergade 8
Copenhagen 1456
Denmark
voice 45.33.151920
fax 45.33.151963
info@galleri-noerby.dk
galleri-noerby.dk

Representing:
Morten Løbner Espersen
Michael Geertsen
Bente Hansen
Louise Hindsgavl
Nina Hole
Steen Ipsen
Martin Bodilsen Kaldahl
Sten Lykke Madsen
Bodil Manz
Anders Ruhwald
Bente Skjøttgaard

Bodil Manz, **Untitled***, 2005*
porcelain, 10 x 14 x 9.25
photo: Søren Nielsen

Michael Geertsen, **Blue Wall Object,** *2005*
earthenware, 14 x 52 x 9.25
photo: Søren Nielsen

Bente Skjøttgaard, **Branch,** *2005*
stoneware, 7.25 x 2.5
photo: Søren Nielsen

Mark Chatterley, **3 Levels***, 2005*
hand-built ceramic, 93 x 15 x 27

Gallery 500 Consulting

Promoting excellence and creativity in all media
Staff: Rita Greenfield, owner

3502 Scotts Lane
Philadelphia, PA 19129
voice 215.849.9116
fax 215.849.9116
gallery500@hotmail.com
gallery500.com

Representing:
Carolyn Morris Bach
Mark Chatterley
Christine Federighi
Dale Gottlieb
Philip Soosloff

Carolyn Morris Bach, **Containers***, 2005*
fine silver, sterling, copper, bone, ebony, various sizes

Philip Soosloff, **A Briefcase Full of Blues**, *2005*
painted mixed media construction, 42 x 48 x 13
photo: Steve Pitkin

Christine Federighi, **Dark Dreamer,** *2004*
ceramic, 24 x 8 x 5

Yoshiaki Yuki, **Red Screens**, *2005*
wood, paper, polychrome, 72 x 72
photo: Tamotsu Kawaguchi

gallery gen

A broad spectrum of contemporary art from Japan
Staff: Chizuko Go, manager; Valerie Foley, office manager; Rie Mori, assistant sales manager; Shinya Ueda, coordinator; John Park

158 Franklin Street
New York, NY 10013
voice 212.226.7717
fax 212.226.3722
info@gallerygen.com
gallerygen.com

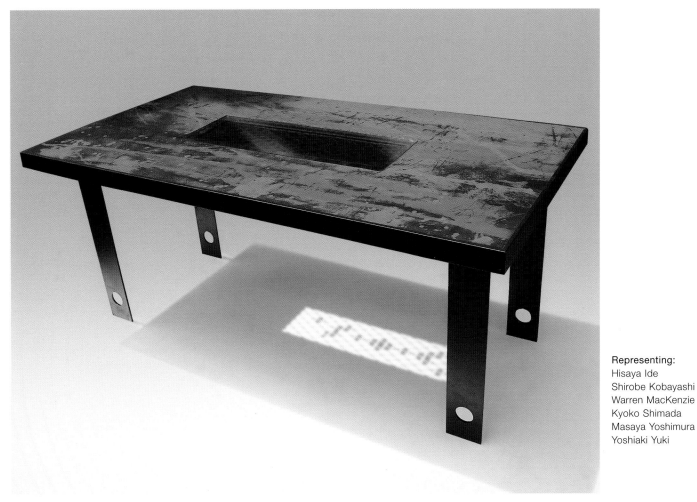

Representing:
Hisaya Ide
Shirobe Kobayashi
Warren MacKenzie
Kyoko Shimada
Masaya Yoshimura
Yoshiaki Yuki

Yoshiaki Yuki, **Red Table***, 2005*
wood, paper, polychrome, glass, 28 x 36 x 72
photo: Tamotsu Kawaguchi

Pamela Rawnsley, **Shadow Vessels,** *2004*
silver, oxide, 12h
photo: Dewi Tannatt Lloyd

The Gallery, Ruthin Craft Centre

Contemporary craft and applied art from Wales
Staff: Philip Hughes, director; Jane Gerrard, deputy director

Park Road
Ruthin, Denbighshire LL15 1BB
Wales, United Kingdom
voice 44.1824.704774
fax 44.1824.702060
thegallery@rccentre.org.uk

Walter Keeler, **Cut Branch Platter,** *2004*
thrown ceramic, Whieldon ware, 12d
photo: Dewi Tannatt Lloyd

Caitlin Jenkins, **Blue Bowl,** *2004*
thrown earthenware, 15 x 13
photo: Caitlin Jenkins

Catrin Howell, Hare Heads, Portents Series, *2005*
terracotta, 12h
photo: Sylvain Deleu

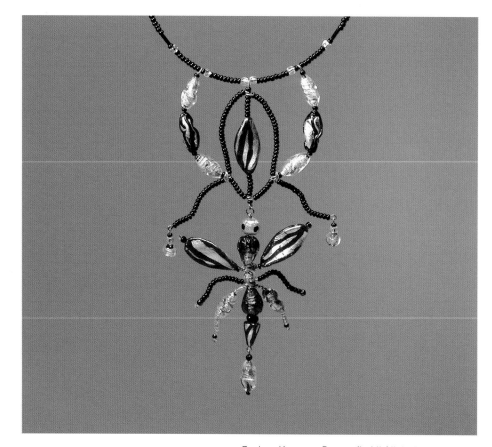

Gudrun Kosmus, **Dragonfly Libèllula Rubino,** *2005*
Murano glass, 11.5 x 4 x 1
photo: Michele Benzoni

Genninger Studio

Specializing in Murano glass jewelry, sculpture and functional glass objects

Staff: Leslie Ann Genninger, owner; Michele Benzoni; Cheryl Mizrachi; Donna Routt; Tali-Grace Diggs; Alan Routt

Dorsoduro 2793/A
Calle del Traghetto
Venice 30123
Italy
voice 39.041.522.5565
fax 39.041.522.5565
leslie@genningerstudio.com
genningerstudio.com

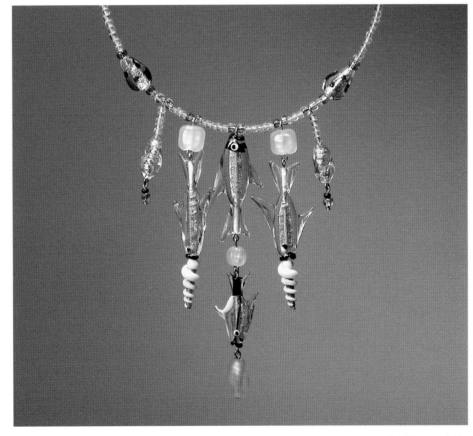

Representing:
Leslie Ann Genninger
Gudrun Kosmus

Leslie Ann Genninger, **Fish Pesce Oro Bianco,** *2005*
Murano glass, 9.5 x 4.5 x .5
photo: Michele Benzoni

157

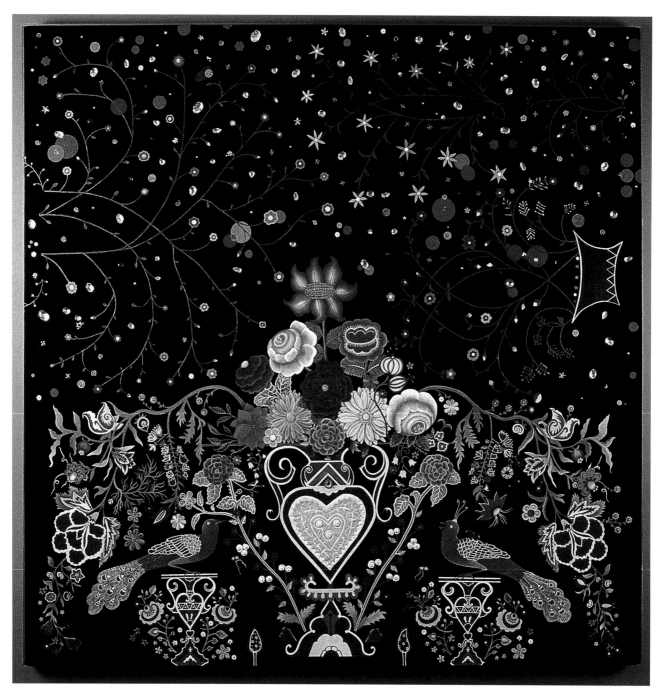

Janet Bloch, This Heart of Mine I Give Entirely to You, *2004*
mixed media on fabric, 60 x 60

gescheidle

Challenging and well-crafted contemporary art by emerging and established artists
Staff: Susan Gescheidle, principal; Jannette Rho, director

118 North Peoria, 4th floor
Chicago, IL 60607
voice 312.226.3500
fax 312.226.6255
susan@gescheidle.com
gescheidle.com

Whitney Lee, **Venus of Urbino by Titian,** *2004*
found latch hook rugs and yarn, 33 x 45

Representing:
Janet Bloch
Susie Brandt
M. Ivan Cherry
Don Fritz
Brooke L. Larsen
Whitney Lee
Darrel Morris
Nnenna Okore
Lorraine Peitz
Erling Sjovold
Tim Vermeulen

Sam Juparulla, **Black and White Ceremony,** *2005*
kiln-formed, infused and hand-painted enamels, 14 x 15 x 5
photo: Ian Beck

Glass Artists' Gallery

Australia's foremost contemporary glass gallery promoting established and emerging artists since 1982
Staff: Maureen Cahill, gallery director

70 Glebe Point Road
Glebe, Sydney, NSW 2037
Australia
voice 61.2.9552.1552
fax 61.2.9552.1552
mail@glassartistsgallery.com.au
glassartistsgallery.com.au

Representing:
Deb Cocks
Rod Coleman
Holly Grace
David Hay
Sam Juparulla
Tim Shaw

Holly Grace, **Leaf Forms**
free-blown glass with glue-chipped detail, 26 x 12 x 6; 18 x 10 x 5
photo: Adrian Lambert

Deanna Clayton, **Red and Amber Net Vessel,** *2005*
pate de verre, electroplated copper, 15 x 24

Habatat Galleries

Presenting the finest works in contemporary glass since 1971
Staff: Linda J. Boone, president; Lindsey Scott, director

608 Banyan Trail
Boca Raton, FL 33431
voice 561.241.4544
fax 561.241.5793
info@habatatgalleries.com
habatatgalleries.com

117 State Road
Great Barrington, MA 01230
voice 413.528.9123
fax 413.644.9981

Representing:
David Bennett
Deanna Clayton
Keith Clayton
Robert Palusky
Peter Powning

David Bennett, **High Kick Dancer,** *2005*
hand-blown glass, bronze, 32 x 12 x 10
photo: Emil Meek

Maria Lugossy, **Balanced Dialogue**, *2005*
cast and cold-worked glass, 19 x 28.25 x 12.5
photo: Doug Schaible

Habatat Galleries

The finest in contemporary glass from around the world

Staff: Ferdinand Hampson; Kathy Hampson; Corey Hampson; John Lawson; Rickey Keulen; Debbie Clason; Robert Bambrough; Robert Shimmell

4400 Fernlee Avenue
Royal Oak, MI 48073
voice 248.554.0590
fax 248.554.0594
info@habatat.com
habatat.com

Representing:
Martin Blank
Pawel Borowski
Stanislaw Borowski
Stanislaw Yan Borowski
Emily Brock
Daniel Clayman
Kimiake Higuchi
Eric Hilton
Tomas Hlavicka
Petr Hora
Maria Lugossy
Laszlo Lukacsi
Margit Toth
Leah Wingfield

Daniel Clayman, **Aperture 5**
bronze, glass matrix, 17 x 17 x 14.5
photo: Doug Schaible

Albert Paley, **Presentation Table,** *2005*
forged and fabricated steel, polychromed with slate top, 49.5 x 35 x 29

Hawk Galleries

Contemporary sculpture by modern masters working in glass, metal and wood
Staff: Tom Hawk, Jr.; Susan Janowicz; Kami Meighan

153 East Main Street
Columbus, OH 43215
voice 614.225.9595
fax 614.225.9550
tom@hawkgalleries.com
hawkgalleries.com

Representing:
Albert Paley
Flo Perkins
Christopher Ries
Paul Schwieder

Christopher Ries, **Sunflower,** *2005*
optic crystal, 40 x 13 x 42.5

Flo Perkins, **Three Graces,** *2005*
glass, steel, 23 x 15 x 15
photo: Addison Doty

Paul Schwieder, **Amber Eddy,** *2005*
sand-blasted blown glass, 16 x 16 x 6

Robert Turner, **Ashanti***, c. 1982*
stoneware, glazed, sand-blasted; wheel-thrown, applied elements; 12.5 x 10.75
private collection, photo: Steve Meyers

Helen Drutt: Philadelphia/Hurong Lou Gallery

In Memoriam: Robert Turner

Staff: Helen W. Drutt English, founder/director, Helen Drutt: Philadelphia; Martha Flood, archivist; Milica Stojancic, assistant
Hurong Lou, director, Hurong Lou Gallery; David Romberg, assistant

Helen Drutt: Philadelphia
By Appointment Only
Postal Address
2220-22 Rittenhouse Square
Philadelphia, PA 19103-5505
215.735.1625
fax 215.732.1382

Hurong Lou Gallery
320 Race Street
Philadelphia, PA 19106
215.238.8860
fax 215.238.8862
info@huronglou.com
huronglou.com

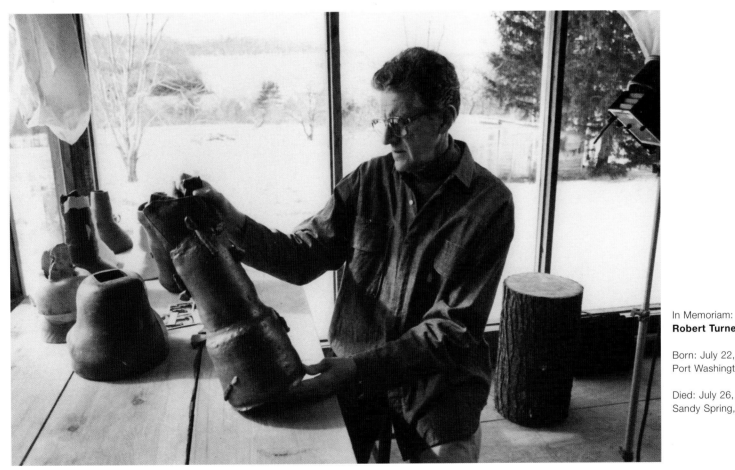

Robert Turner, Alfred Station Studio, NY
1989

In Memoriam:
Robert Turner

Born: July 22, 1913
Port Washington, NY

Died: July 26, 2005
Sandy Spring, MD

171

Tom Patti, **Starphire Four Ringed Echo with Azurlite, Red and Green**
glass, 4.25 x 5.75 x 4.5
photo: George Erml

Heller Gallery

Exhibiting sculpture using glass as a fine art medium since 1973
Staff: Douglas Heller; Michael Heller; Katya Heller

420 West 14th Street
New York, NY 10014
voice 212.414.4014
fax 212.414.2636
info@hellergallery.com
hellergallery.com

Representing:
Nicole Chesney
Susan Taylor Glasgow
Robin Grebe
Ivan Mares
Tom Patti
Ivana Sramkova
Miles Van Rensselaer

Ivan Mares, **On Edge,** *2005*
cast glass, 20.5 x 43.75 x 8.75

Tom Lundberg, **Barbara's Steps,** *2005*
mixed fibers, 8.25 x 8.25
photo: Tom Lundberg

Hibberd McGrath Gallery

Contemporary American fiber, ceramics, glass and jewelry
Staff: Martha Hibberd, partner; Terry McGrath Craig, partner

101 North Main Street
PO Box 7638
Breckenridge, CO 80424
voice 970.453.6391
fax 970.453.6391
terry@hibberdmcgrath.com
hibberdmcgrath.com

Representing:
Mical Aloni
Laurie Hall
Tom Lundberg
Marcia Macdonald
John Nickerson
Beth Nobles
Sang Roberson
Carol Shinn
Missy Stevens

Carol Shinn, **Sitting Room,** *2005*
machine-stitched canvas, 17.25 x 13.25
photo: Carol Shinn

Dale Chihuly, **Orange Hornet and Eelgrass Chandelier,** *2005*
blown glass, 92 x 53 x 54
photo: Scott M. Leen

Holsten Galleries

Contemporary art glass

Staff: Kenn Holsten, owner/director; Jim Schantz, art director; Mary Childs, co-director; Stanley Wooley, associate; Joe Rogers, preparator

3 Elm Street
Stockbridge, MA 01262
voice 413.298.3044
fax 413.298.3275
artglass@holstengalleries.com
holstengalleries.com

Representing:
Dale Chihuly
Lino Tagliapietra

Lino Tagliapietra, **Mandara***, 2005*
blown glass, 25 x 13 x 6.75
photo: Russell Johnson

Louis Durot, **Twister #1,** *2004*
polyurethane, recycled tubing, 35 x 18 x 17
photo: Louis Durot

House of Colors Gallery

Contemporary art

Staff: Woody Woodward, owner; Gisele Person, agent

34 Irby Avenue
Atlanta, GA 30305
voice 404.233.6738
770.918.1182
rougefrenchlips@aol.com

Representing:
Debroeck
Louis Durot
Robin Liles
Françoise Mayeras

Louis Durot, **L'Aspiral***, 1992*
polyurethane resin, 26 x 35 x 31
photo: Louis Durot

Kay Kahn, **The Mumblers,** *2005*
quilted, pieced, layered, appliqued, hand and machine-constructed silk, felt, cotton, 36 x 17 x 6.5
photo: Wendy McEarhern

Jane Sauer Thirteen Moons Gallery

Promoting innovation and excellence in contemporary material based art
Staff: Jane Sauer, owner/director; Karen Hyatt; Wayne Haak

652 Canyon Road
Santa Fe, NM 87501
voice 505.995.8513
fax 505.995.8507
jsauer@thirteenmoonsgallery.com
thirteenmoonsgallery.com

Representing:
Adela Akers
Kate Blacklock
Charissa Brock
Carol Eckert
John Garrett
Lissa Hunter
Kay Khan
Lewis Knauss
John Rais
Lindsay K. Rais
Jon Eric Riis
JoAnne Russo
Goedelle Vanhille
Jiro Yonezawa

Jon Eric Riis, **Night Flight,** *2005*
freshwater pearls, coral, woven metallic thread, 30 x 66
photo: Mike McKelvey

Diane Copper, **Bundles,** *2005*
mixed media, 20 x 11 x 7 each
photo: Tom Van Eynde

Jean Albano Gallery

Contemporary painting, sculpture and construction

Staff: Jean Albano Broday; Sarah Kaliski; Jen Lavender-Thompson; Merry-Beth Noble; Julie Albano Saltzman

215 West Superior Street
Chicago, IL 60610
voice 312.440.0770
fax 312.440.3103
jeanalbano@aol.com
jeanalbanogallery.com

Representing:
Luciana Abait
Greg Constantine
Diane Cooper
Claudia DeMonte
John Geldersma
Robert Walker
Mindy Weisel

*Mindy Weisel, **Spring**, 2005*
kiln-formed fused glass, 10 x 13
photo: John Woo

Emily Wilson, **The Bunting Path,** *2004*
carved/painted wood and steel, 57 x 37 x 9

Jerald Melberg Gallery

Late 20th century and contemporary paintings, sculpture, and objects

Staff: Jerald Melberg, director; Mary Melberg, manager; Gaybe Johnson, senior associate/registrar; Chris Clamp, associate/exhibition designer

625 South Sharon Amity Road
Charlotte, NC 28211
voice 704.365.3000
fax 704.365.3016
gallery@jeraldmelberg.com
jeraldmelberg.com

Representing:
Raul Diaz
Wolf Kahn
Alice Ballard Munn
Albert Paley
Brian Russell
Ramon Urbán
Emily Wilson

Brian Russell, **Continuum I,** *2003*
cast glass, bronze, 26 x 16 x 9

Lisa Clague, **Monkey Business**, *2004*
clay, metal, wax, 74 x 24 x 17
photo: Michael Trask

John Natsoulas Gallery

Contemporary art with and dedicated to art history and education
Staff: John Natsoulas; Steve Rosenzweig

521 First Street
Davis, CA 95616
voice 530.756.3938
fax 530.756.3961
art@natsoulas.com
natsoulas.com

Representing:
Robert Arneson
Judy Chicago
Lisa Clague
Arthur Gonzales
Richard Shaw
Esther Shimazu
Patti Warashina

Richard Shaw, **Standing Figure with Wingtip,** *2003*
glazed porcelain, overglaze decals, 64 x 28.5 x 21.5
photo: Michael Trask

Leslie Emery, **Sustained Emergence,** *2005*
mixed media, 16 x 16 each
photo: Stephen Funk Photography

Katie Gingrass Gallery

Contemporary fine art and crafts

Staff: Katie Gingrass, owner; Shannon Rather, manager; Elaine Hoth, curator; Barbie Blutstein, sales; Jeffrey Kenney, gallery associate; David Schaefer, consultant

241 North Broadway
Milwaukee, WI 53202
voice 414.289.0855
fax 414.289.9255
katieg@execpc.com
gingrassgallery.com

Ellen Kochansky, **Tree Language**, 2005
mixed media, 36 x 42
photo: Tim Barnwell

Representing:
Jackie Abrams
Ken Anderson
Susan Colquitt
Suzanne Donazetti
Patrick Dragon
Leslie Emery
Larry Fielder
Ty Gillespie
Stephen Goetschius
William Jauquet
Ellen Kochansky
Barbara Kohl-Spiro
Linda Leviton
David Lory
Laura Foster Nicholson
Tom Rauschke
Michael Rohde
Jon Michael Route
Colin Schleeh
John Skau
Fraser Smith
Missy Stevens
Polly Adams Sutton
Kaaren Wiken

Simon Maberley, **Contemplation (Clear Blue),** *2005*
blown glass, steel, rubber, aluminum, 35 x 10 x 7

Kirra Galleries

Leaders in the Australian contemporary glass movement supporting established and emerging artists
Staff: Peter Kolliner, gallery director; Suzanne Brett, gallery manager; Vicki Winter, administration manager

The Atrium, Federation Square
Swanston and Flinders Streets
Melbourne, Victoria 3000
Australia
voice 61.3.9639.6388
fax 61.3.9639.8522
kirra@kirra.com
kirra.com

Representing:
Christian Arnold
George Aslanis
Alasdair Gordon
Rish Gordon
Tony Hanning
Niki Harley
Noel Hart
Simon Maberley
Chris Pantano
Crystal Stubbs

Noel Hart, **Adelaide Rosella***, 2005*
blown glass, 15 x 13 x 3

Michael Pugh, **Man of the Moon,** *2005*
ceramic, freshwater pearls, 9 x 5.5
photo: Mike Lee

Kraft Lieberman Gallery

Modern and contemporary art in all media by national and international artists
Staff: Jeffrey Kraft and Paul Lieberman, directors; Galya Kraft; Laurie Lieberman

835 West Washington Boulevard
Chicago, IL 60607
voice 312.948.0555
fax 312.948.0333
klfinearts@aol.com
klfinearts.com

Representing:
Pearl Dick
Daniel N. Marder
Michael Pugh
Philip Soosloff
Ron Starr
Donald Sultan

Ron Starr, **Big Drip**, *2005*
ceramic, glass, 14 x 30

Pearl Dick, **Head to Head,** *2005*
glass, metal, 18 x 5 x 12.5
photo: Andrew Thomas

Daniel N. Marder, **Love Pocket, Love Rocket,** *2005*
cut and polished glass, 6 x 9.25 x 4.25; 6 x 8.25 x 4.25
photo: Daniel N. Marder

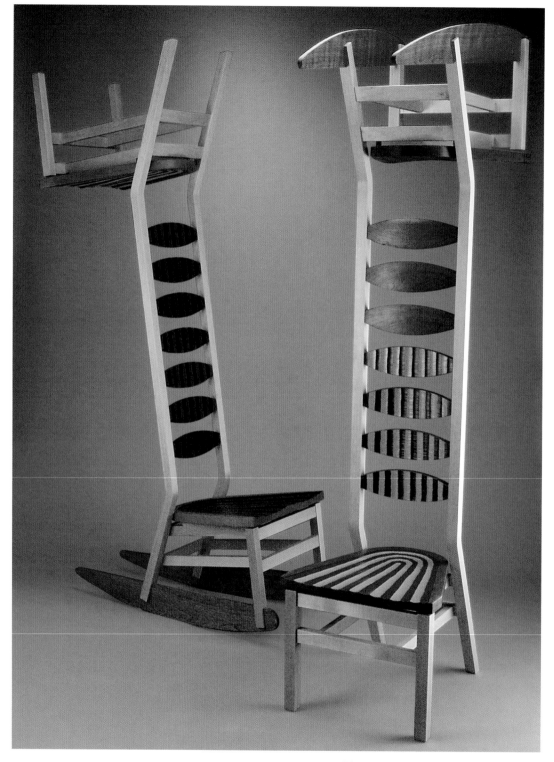

Thomas Loeser, **Ladderback Chairs,** *2005*
wood, paint, 87 x 21 x 41 each

Leo Kaplan Modern

Established artists in contemporary glass sculpture and studio art furniture
Staff: Scott Jacobson; Terry Davidson; Lynn Leff; Dawn Russell

41 East 57th Street
7th floor
New York, NY 10022
voice 212.872.1616
fax 212.872.1617
lkm@lkmodern.com
lkmodern.com

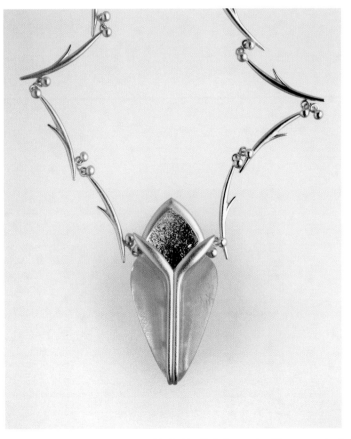

Representing:
Garry Knox Bennett
Greg Bloomfield
Yves Boucard
William Carlson
José Chardiet
Scott Chaseling
Kéké Cribbs
Dan Dailey
David Huchthausen
Richard Jolley
Kreg Kallenberger
John Lewis
Thomas Loeser
Linda MacNeil
Paul Seide
Tommy Simpson
Jay Stanger
Michael Taylor
Cappy Thompson
Gianni Toso
Mary Van Cline
Steven Weinberg
Ed Zucca

Linda MacNeil, **Lavender Charm** *pendant
glass, 24k gold-plated brass, 2.75 x 2.75 x 1*

Martha Croasdale, **Dream River,** *2002*
cast glass, 20 x 80 x 2

Lost Angel Glass

Cultivating an appreciation for the medium of sculptural glass
Staff: Meghan D. Bunnell, director; Ashley E. Hupe, assistant

79 West Market Street
Corning, NY 14830
voice 877.937.3578
fax 607.937.3578
meghan@lostangelglass.com
lostangelglass.com

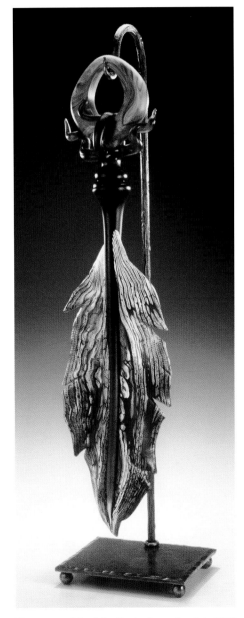

Stephen Rolf Gartner and Danielle Blade, **Sage Amulet,** *2004*
hot-sculpted glass, 34 x 17 x 9
photo: Jonathan Wallen

Representing:
Danielle Blade
Martha Croasdale
Barry Entner
Stephen Rolf Gartner
Martin Kremer
Joel O'Dorisio

Joel O'Dorisio, **Birch Curl in Ruby,** *2004*
cast glass, 14 x 12 x 8
photo: Frank Borkowski

Martin Kremer, **Tenement***, 2004*
fused glass, 20 x 11.5 x 46.25
photo: Kari Lonning

Bertil Vallien, **Untitled Head**
cast glass

Marx-Saunders Gallery, Ltd.

Contemporary glass sculpture created by prominent international artists
Staff: Bonnie Marx; Ken Saunders; Donna Davies; Dan Miller; James Geisen; Jo-Nell Koelsch

230 West Superior Street
Chicago, IL 60610
voice 312.573.1400
fax 312.573.0575
marxsaunders@earthlink.net
marxsaunders.com

Paul Stankard, **Floating Bouquet Orb**, *2005*
lamp-worked glass, 8.5d
photo: Douglas Schaible

Representing:
Rick Beck
Lene Bodker
William Carlson
José Chardiet
Sidney Hutter
Jon Kuhn
Dante Marioni
Joel Philip Myers
Stephen Rolfe Powell
Richard Ritter
David Schwarz
Thomas Scoon
Paul Stankard
Lisabeth Sterling
Bertil Vallien
Janusz Walentynowicz
Steven Weinberg
Richard Whiteley
Hiroshi Yamano

Brian Rust, **West by Nonwest,** *2003*
wood and steel sculpture, 90 x 18 x 18
photo: Brian Rust

Mary Pauline Gallery

Augusta's only preeminent contemporary gallery specializing in museum-quality artwork
Staff: Molly McDowell, director; Heather Neal, gallery assistant/registrar

982 Broad Street
Augusta, GA 30901
voice 706.724.9542
fax 706.724.9543
molly@marypaulinegallery.com
marypaulinegallery.com

Representing:
Kathy Girdler-Engler
Richard Jolley
Philip Morsberger
Brian Rust

Philip Morsberger, **Reaching the Top,** *2004-05*
oil on canvas, 48 x 36
photo: Brian Rust

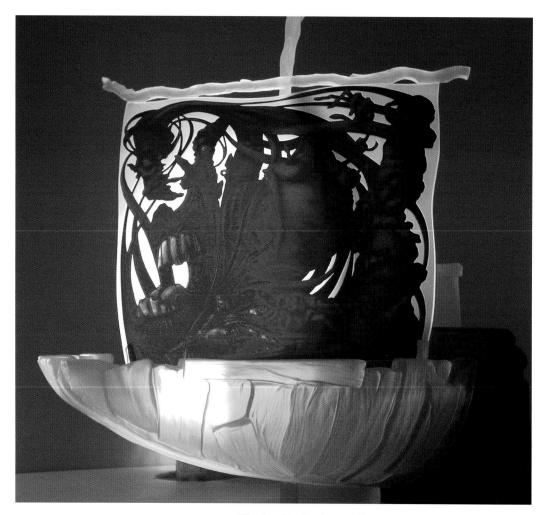

Miroslaw Stankiewicz and Rafal Galazka, **Mermaids Song,** *2002*
glass, 12 x 8 x 12

Mattson's Fine Art

Contemporary Polish glass
Staff: Greg Mattson, director; Walter Mattson; Skippy Mattson

2579 Cove Circle NE
Atlanta, GA 30319
voice 404.636.0342
fax 404.636.0342
sundew@mindspring.com
mattsonsfineart.com

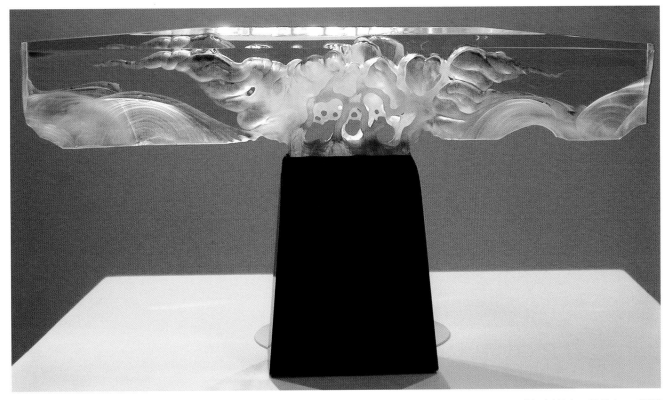

Representing:
Rafal Galazka
Miroslaw Stankiewicz
Maciej Zaborski

Maciej Zaborski, **Totem,** *2000*
crystal, 14 x 3 x 7

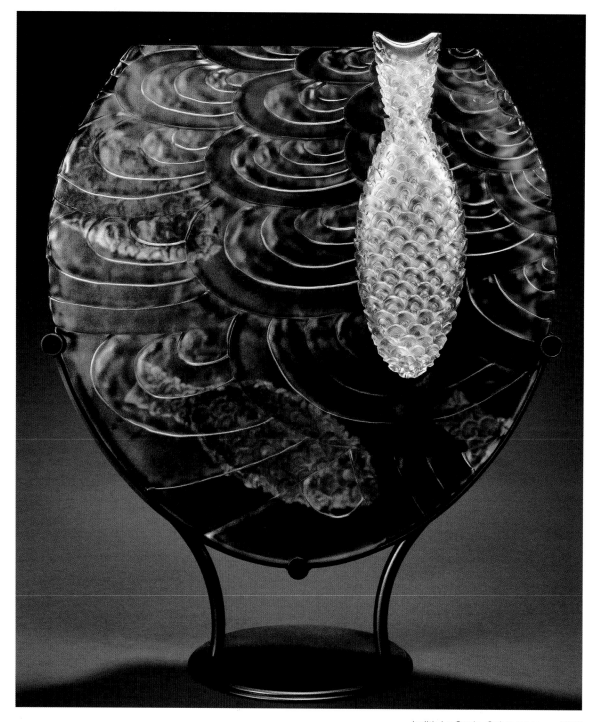

Judith La Scola, **Submergence,** *2005*
glass, 22 x 18.5 x 6
photo: Rob Vinnedge

Maurine Littleton Gallery

Sculptural work of contemporary masters in glass and ceramics
Staff: Maurine Littleton, director; Seth Campbell; Zach Vaughn

1667 Wisconsin Avenue NW
Washington, DC 20007
voice 202.333.9307
fax 202.342.2004
info@littletongallery.com
littletongallery.com

John Littleton and Kate Vogel, **Lotus Circle**, 2005
hot-worked, cut and polished cast glass, 16.25 x 9 x 3.25
photo: John Littleton

Representing:
Mark Bokesch-Parsons
Judith La Scola
Harvey K. Littleton
John Littleton
Colin Reid
Don Reitz
Therman Statom
James Tanner
Kate Vogel

Harriete Estel Berman, **California Dream,** *2005*
mixed media, 22 x 20 x 7.25
photo: Philip Cohen

Mobilia Gallery

Contemporary decorative arts and studio jewelry
Staff: Libby Cooper; JoAnne Cooper

358 Huron Avenue
Cambridge, MA 02138
voice 617.876.2109
fax 617.876.2110
mobiliaart@aol.com
mobilia-gallery.com

Renie Breskin Adams, **A Battle of Wills,** *2005*
cotton embroidery, 6.75 x 5.5
photo: Renie Breskin Adams

Representing:

Jeanette Ahlgren	Jan Hopkins	Sarah Perkins
Tomomi Arata	Michael Hosaluk	Gugger Petter
Donna Barry	Mary Lee Hu	Janet Prip
Kim Bass	Dan Jocz	Giovanna Quadri
Linda Behar	Rosita Johanson	Robin Quigley
Hanne Behrens	Deb Karash	Annette Rack
Harriete Estel Berman	Hannah Keefe	Wendy Ramshaw,
Flora Book	Jutta Klingebiel	OBE RDI
Michael Boyd	Annette Kraen	Suzan Rezac
Renie Breskin Adams	Okinari Kurakawa	Scott Rothstein
Klaus Burgel	Mariko Kusumoto	Caroline Rugge
Dorothy Caldwell	Birgit Laken	Yuka Saito
David K. Chatt	Jan Lohman	Marjorie Schick
Kirsten Clausager	Tom Lundberg	Joyce Scott
Kevin Coates	Asagi Maeda	Richard Shaw
Lia Cook	Jennifer Maestre	Yoko Shimizu
Jack Da Silva	Fritz Maierhofer	Christina Smith
Marilyn Da Silva	Donna Rhae Marder	Etsuko Sonobe
Linda Dolack	Tomomi Maruyama	Brandon Sullivan
Tom Eckert	Alphonse Mattia	Cynthia Toops
Dorothy Feibleman	John McQueen	Jennifer Trask
Arline Fisch	Nancy Michel	Wim Vandershoot
Gerda Flockinger, CBE	Kazuko Mitsushima	Grazianna Visintin
Nora Fok	Yoko Miyaji-Zeltserman	Sylvia Walz
David Freda	Kazumi Nagano	Alexandra Watkins
Elizabeth Fritsch CBE	Harold O'Connor	Mizuko Yamada
Emi Fujita	Brigid O'Hanrahan	Yoshiko Yamamoto
Lydia Gerbig-Fast	Joan Parcher	Annamaria Zanella
Margit Hart	Miel-Margarita Paredes	
Nick Hollibaugh	Karen Paust	

Loni Kreuder, **La Rumeur,** *2000*
bronze, 65 x 44 x 40

Modus Art Gallery

Emphasis on painting, bronze and glass sculpture, excellence of execution and genuineness of style and content
Staff: Karl Yeya, owner; Mana Asselli, director; Sophie Montcarat, assistant; Oscar Seran; Stan Mink; Richard Elmir

23 Place des Vosges
Paris 75003
France
voice 33.1.4278.1010
fax 33.1.4278.1400
modus@galerie-modus.com
galerie-modus.com

Representing:
Françoise Abraham
Jacques Chereau
Dominique Dardek
Loni Kreuder
Lolek
Vincent Magni
Alain Salomon
Jean-Pierre
 Umbdenstock

Françoise Abraham, **Rebecca,** *2005*
bronze, 35 x 13 x 11

Gerry King, **Tartessos Vase MG,** *2003*
kiln-formed glass with stainless steel base, 41 x 12.5 x 11.5
photo: Grant Hancock

Mostly Glass Gallery

Unique and technically challenging art

Staff: Sami Harawi; Charles Reinhardt; Marcia LePore

34 Hidden Ledge Road
Englewood, NJ 07631
voice 201.816.1222
fax 201.503.9522
info@mostlyglass.com
mostlyglass.com

Representing:
Miriam Di Fiore
Vlastislav Janacek
Gerry King
Madelyn Ricks
Alison Ruzsa
Julius Weiland

Julius Weiland, **Bath***, 2005*
fused borosilicate glass tubes, 9 x 30 x 9
photo: Hanns Joosten

David Kuraoka, **P.T.**, *2001*
bronze, 32 x 13 x 13

Mowen Solinsky Gallery

A sophisticated mix of contemporary fine objects of art
Staff: John Mowen, owner; Steve Solinsky, owner; Franceska Alexander, manager

225 Broad Street
Nevada City, CA 95959
voice 530.265.4682
fax 530.265.8469
info@mowensolinskygallery.com
mowensolinskygallery.com

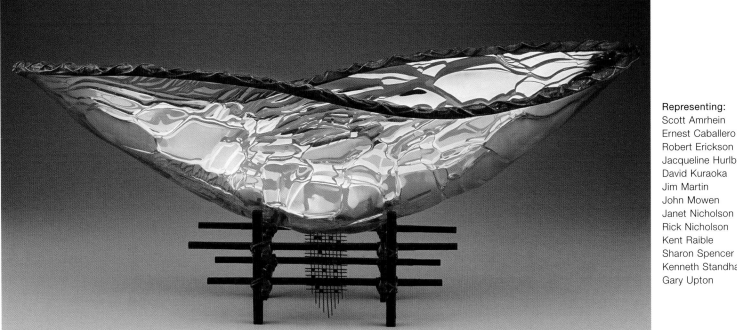

Scott Amrhein, **Oval Feather Bowl with Pedestal**, _27.75 x 9 x 10.5_
glass, copper, charred wood

Representing:
Scott Amrhein
Ernest Caballero
Robert Erickson
Jacqueline Hurlbert
David Kuraoka
Jim Martin
John Mowen
Janet Nicholson
Rick Nicholson
Kent Raible
Sharon Spencer
Kenneth Standhardt
Gary Upton

Kaiser Suidan, Ceramic Cube Installation
clay, 6 x 6 x 6 each
photo: Beth Singer

Next Step Studio and Gallery

Promoting young, emerging talent; artists with a vision for the future
Staff: Kaiser Suidan, director; Rebecca Myers, sales

530 Hilton Road
Ferndale, MI 48220
voice 248.342.5074
fax 248.414.7050
nextstepstudio@aol.com
nextstepstudio.com

Representing:
John Gargano
Rebecca Myers
Tom Phardel
Theresa Pierzchala
Michael J. Schunke
Adam Shirley
Scott Strickstein
Kaiser Suidan
Gregory Tom

Michael J. Schunke, **18 Goblets**
glass, 7-14h

Fritz Olsen, **Sunflower**, *2002*
Vermont white marble, 108 x 60 x 30

Niemi Sculpture Gallery & Garden

Contemporary sculpture
Staff: Bruce A. Niemi, owner; Susan Niemi, director

13300 116th Street
Kenosha, WI 53142
voice 262.857.3456
fax 262.857.4567
gallery@bruceniemi.com
bruceniemi.com

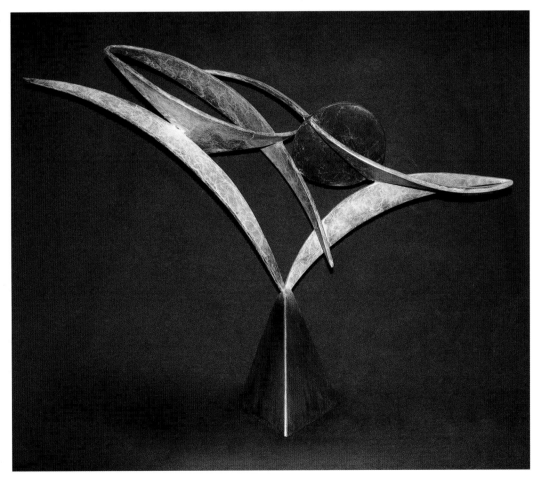

Representing:
Theodore Gall
Bruce A. Niemi
Fritz Olsen

Bruce A. Niemi, **Maui Sunset***, 2005*
fabricated bronze, 20.5 x 28 x 7

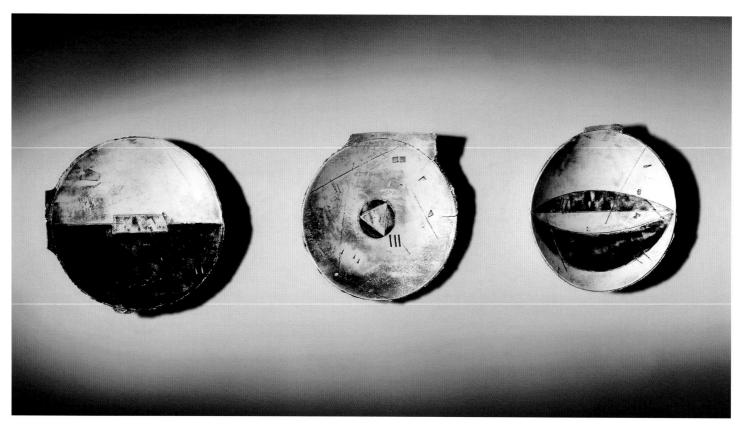

Gilbert Poissant, **Variations 3D**, *2005*
porcelain with colored slips, glazes, 24 x 24 x 6 each

Option Art

Excellence in Canadian contemporary wood, ceramics, jewelry and mixed media sculpture
Staff: Barbara Silverberg, director; Philip Silverberg, assistant; Arin Wahed, assistant

4216 de Maisonneuve Blvd. West
Suite 302
Montréal, Québec H3Z 1K4
Canada
voice 514.932.3987
fax 514.932.6182
info@option-art.ca
option-art.ca

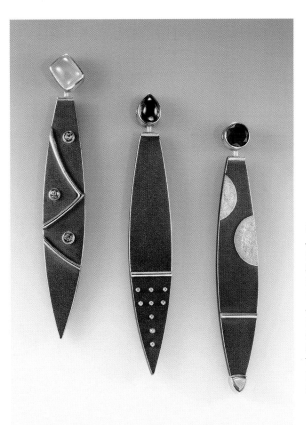

Representing:
Jorge Aguilar
Bruno Andrus
Sophie DeFrancesca
Dawn Detarando
Rosie Godbout
Janis Kerman
Brian McArthur
Gilbert Poissant
Susan Rankin
Tiana Roebuk
David Samplonius
Colin Schleeh

Janis Kerman, **Brooches,** *2005*
oxidized sterling silver, 18k gold, assorted gems

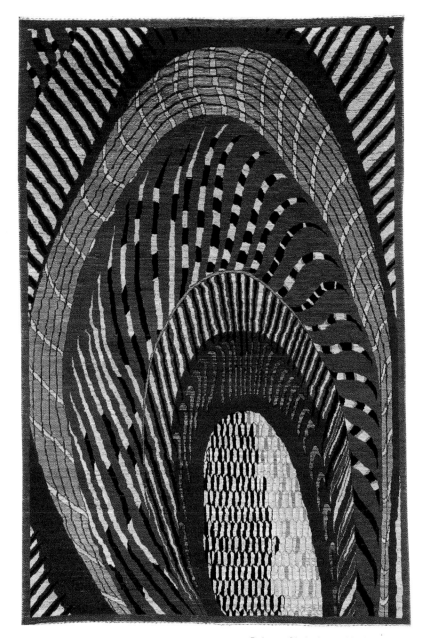

Bahram Shabahang, **Medusa,** *2005*
wool pile carpet, 48 x 72

Orley & Shabahang

Contemporary Persian carpets
Staff: Geoffrey A. Orley; Bahram Shabahang; Mehran Iravani

5841 Wing Lake Road
Bloomfield Hills, MI 48301
voice 586.996.5800
fax 248.524.2909
geoffreyorley@aol.com
shabahangcarpets.com

240 South County Road
Palm Beach, FL 33480
voice 561.655.3371
fax 561.655.0037
shabahangorley@adelphia.net

223 East Silver Spring Drive
Whitefish Bay, WI 53217
voice 414.332.2486
fax 414.332.9121
shabahangcarpets@gmail.com

Bahram Shabahang, **Martinique,** *2005*
wool pile carpet, 144 x 216

Representing:
Bahram Shabahang

Gerd Rothmann, **Friends, Acquaintances and Relatives** *necklace, 2003*
silver, gold, 8.25d
photo: Wilfried Petzi

Ornamentum

Contemporary international jewelry
Staff: Laura Lapachin; Stefan Friedemann

506.5 Warren Street
Hudson, NY 12534
voice 518.671.6770
fax 518.822.9819
info@ornamentumgallery.com
ornamentumgallery.com

Representing:
Iris Bodemer
Juliane Brandes
Johanna Dahm
Sam Tho Duong
Maria Rosa Franzin
Thomas Gentille
Rebecca Hannon
Sabine Hauss
Elisabeth Heine
Sergey Jivetin
Jiro Kamata
Hwa-Jin Kim
Jutta Klingebiel
Wolli Lieglein
Ruudt Peters
Mary Preston
Gerd Rothmann
Silke Spitzer
Julia Turner
Barbara Vischer-Wolfinger
Luzia Vogt
Beate Weiss

Ruudt Peters, **Azoth Pyriet** *brooches, 2004*
silver, polyester, 1.75 x 2.75 x 1
photo: Rob Versluys

Toshiko Takaezu, **Purple Moon - Mursaki Homage 2,** *1994*
ceramic, 22 x 22

Perimeter Gallery, Inc.

Painting, drawing and master works in ceramic and fiber
Staff: Frank Paluch; Scott Ashley; Holly Sabin; Scott Enders

210 West Superior Street
Chicago, IL 60610
voice 312.266.9473
fax 312.266.7984
perimeterchicago@
 perimetergallery.com
perimetergallery.com

Jay Strommen, **Earth Smile** *plate, 2005*
ceramic, 19.5 x 2.5
photo: Tom Van Eynde

Representing:
Lia Cook
Jack Earl
Edward Eberle
Kiyomi Iwata
Dona Look
John Mason
Karen Thuesen
 Massaro
Beverly Mayeri
John McQueen
Jeffrey Mongrain
Jay Strommen
Toshiko Takaezu

Susan Thiel, **Early Plastics** *necklace*
Vigorite (similar to Bakelite from 1920s), sterling silver

Pistachios

Contemporary jewelry and glass
Staff: Yann Woolley, director; Sione LaPointe, manager; Alexandra Jamroz

55 East Grand Avenue
Chicago, IL 60611
voice 312.595.9437
fax 312.595.9439
pistach@ameritech.net
pistachiosonline.com

Representing:
Michael Anis
Petra Class
Barbara Galazzo
Gellner
Barbara Heinrich
Gudrun Meyer
Norbert Muerrle
Niessing
Susan Thiel
Michael Zobel

Norbert Muerrle, **Classic Jewelry Series**
18k gold, platinum, diamonds

Karen Halt, **Nest on My Arms,** *2005*
aplicated and painted cotton with beeswax and resin, 32 x 32 x 14
photo: Fred Fischer

Portals Ltd.

Contemporary art of diverse media by national and international artists
Staff: William and Nancy McIlvaine, gallery owners; Claudia Kleiner, gallery director;
Maria Antonieta Oquendo, gallery shows coordinator

742 North Wells Street
Chicago, IL 60610
voice 312.642.1066
fax 312.642.2991
artisnow@aol.com
portalsgallery.com

Constance Roberts, **Russian Tea**, 2005
carved and painted wood, 16 x 21 x 5
photo: Gary Henderson

Representing:
Wendy Ellis-Smith
Karen Halt
Toni Putnam
Constance Roberts
Kraft Stuart

Debora Moore, **Tree Series I,** *2005*
glass, 38.5 x 20 x 4
photo: Russell Johnson

R. Duane Reed Gallery

Contemporary painting, sculpture, ceramics, glass and fiber by internationally recognized artists
Staff: R. Duane Reed; Glenn Scrivner; Merrill Strauss; Kate Anderson; Gaby Schaefer; Dara Metz

7513 Forsyth Boulevard
St. Louis, MO 63105
voice 314.862.2333
fax 314.862.8557
reedart@primary.net
rduanereedgallery.com

529 West 20th Street
New York, NY 10011
voice 212.462.2600
fax 212.462.2510
reedartnyc@primary.net

James Tyler, **Three Marshals,** *2005*
ceramic, 36 x 32 each

Representing:
Rudy Autio
Cassandria Blackmore
Crooks and Beers
Laura Donefer
Michael Eastman
Mary Giles
Sabrina Knowles
Curt LaCross
Marvin Lipofsky
Mari Meszaros
Debora Moore
Danny Perkins
Jenny Pohlman
Ross Richmond
Ginny Ruffner
James Tyler
Michal Zehavi

Cassandria Blackmore, **Beautiful Orphan**, *2005*
reverse painted glass mosaic, 51.75 x 19.75 x 2.5

Crooks and Beers, **Mamam and Gamin,** *2005*
reverse pate de verre painting, 62.5 x 20 x .5; 36 x 16 x .5
photo: Frank Borkowski

Turiya Orme, **To Have and To Hold 7**
hand-blown, lathe and carved glass, 8 x 6 x 3.5

Raglan Gallery

Australia's leading and emerging artists working in ceramics, glass, sculpture and textiles
Staff: Jan Karras, director

5-7 Raglan Street
Manly, Sydney, NSW 2095
Australia
voice 61.2.9977.0906
fax 61.2.9977.0906
jankarras@hotmail.com
raglangallery.com.au

Representing:
Sandra Black
Victor Greenaway
Virginia Kaiser
Warren Langley
Jeff Mincham
Turiya Orme
Sallie Portnoy
Amanda Shelsher
Mark Thiele
Robert Wynne

Jeff Mincham, **Nebula**
ceramic, 5.5 x 4.25
photo: G. Hancock

Rami G. Abboud, **Coup de Foudre** *necklace*
opals, sapphires, diamonds

Rami G. Abboud Jewelers

Exceptionally crafted jewelry
Staff: Zi Doll, manager

44 Rue des Tournelles
Paris 75004
France
voice 832.794.4913
fax 213.891.0661
info@ramiabboud.com
ramiabboud.com

550 South Hill Street
Los Angeles, CA 90013

Representing:
Rami G. Abboud

Rami G. Abboud, **Rock Me Baby**
sapphires, diamonds

Lina Fanourakis, **Disques** *bracelet*
22k yellow gold, diamonds

Sabbia

Elegant and imaginative jewelry; a blend of modern designs with classic motifs
Staff: Deborah Friedmann; Tina Vasiliauskaite

66 East Walton Street
2nd floor
Chicago, IL 60611
voice 312.440.0044
fax 312.440.0007
sabbiafinejewelry@hotmail.com

Alex Sepkus, **Orchard diamond ring**
18k yellow gold, diamonds

Representing:
Pedro Boregaard
Lina Fanourakis
Yossi Harari
Alex Sepkus
Catherine M. Zadeh

Thomas Hoadley, **#762 Medium Bowl,** *2005*
colored porcelain, gold leaf, 6 x 8.75 x 8

Sherrie Gallerie

Contemporary ceramic sculpture and art jewelry
Staff: Sherrie Hawk; Tyler Steele; Pamela Beeler

937 North High Street
Columbus, OH 43201
voice 614.298.8580
fax 614.298.8570
info@sherriegallerie.com
sherriegallerie.com

Representing:
Curtis Benzle
Karen Gilbert
Thomas Hoadley
Marc Leuthold
Jeanne Otis
Janis Mars Wunderlich

Curtis Benzle, **40 Keys,** *2004*
porcelain, 8 x 18 x 4
photo: Curtis Benzle

Judy Onofrio, **Meow**, *2005*
mixed media, 47 x 37 x 22
photo: Jeremy Kilkus

Sherry Leedy Contemporary Art

Contemporary art in all media by nationally and internationally recognized artists
Staff: Sherry Leedy; Jennifer Bowerman; Shellie Bender

2004 Baltimore Avenue
Kansas City, MO 64108
voice 816.221.2626
fax 816.221.8689
sherryleedy@sherryleedy.com
sherryleedy.com

Jun Kaneko, Dango #04-07-07, *2004*
ceramic, 29.5 x 20.5 x 13
photo: Dirk Bakker

Representing:
Ruth Borgenicht
Jason Briggs
Charlotte Cain
Richard Chung
Michael Eastman
Yoshiro Ikeda
Jun Kaneko
Judy Onofrio
Jennifer Onofrio-Fornes
Doug Owen
Charles Timm-Ballard

Melanie Bilenker, **Dishes,** *2005*
silver, gold, ebony, resin, pigment, hair, 3.75 x 3 x .5

Sienna Gallery

International contemporary jewelry and objects
Staff: Sienna Patti, director; Raissa Bump

80 Main Street
Lenox, MA 01240
voice 413.637.8386
sienna@siennagallery.com
siennagallery.com

Barbara Seidenath, **Ring***, 2005*
crystal, enamel, gold, 1.5 x .5 x 1.75

Representing:
Giampaolo Babetto
Jamie Bennett
Melanie Bilenker
Lola Brooks
Raissa Bump
Noam Elyashiv
Vered Kaminski
Esther Knobel
Daniel Kruger
Seung-Hea Lee
Jacqueline Lillie
Mary Pearse
Tina Rath
Barbara Seidenath
Alessia Semeraro
Sondra Sherman
Bettina Speckner
Johan van Aswegen

Lanny Bergner, **Fruititious,** *2005*
stainless steel screen wire, glass frit, 48 x 19.5 x 19.5
photo: Lanny Bergner

250

Snyderman-Works Galleries

Finest in contemporary fiber, ceramic, glass, jewelry, studio furniture, wood, painting and sculpture
Staff: Rick and Ruth Snyderman, owners; Bruce Hoffman, director, Snyderman-Works; Francis Hopson, director, Works Gallery; Colleen Barry, assistant director; Lynn Schuberth, associate

303 Cherry Street
Philadelphia, PA 19106
voice 215.238.9576
fax 215.238.9351
bruce@snyderman-works.com
snyderman-works.com

Bob Ebendorf, **Bird in the Box,** *2005*
mixed media, 8.75 x 6.75 x 1.5

Representing:

Dan Anderson	Ron Isaacs
Kate Anderson	Ferne Jacobs
Pamela Becker	Michael James
Lanny Bergner	Judith James
Karin Birch	Kerry Jameson
Yvonne Bobrowicz	Kim Kamens
Ruth Borgenicht	Jonathan Kline
Jacek Byczewski	Nancy Koenigsberg
Dorothy Caldwell	Ed Bing Lee
Barbara Cohen	Ruth McCorrison
Mardi Jo Cohen	Milissa Montini
Joyce Crain	Marilyn Pappas
Nancy Crow	Huib Petersen
Daniel Cutrone	Rowland Rickets, III
Lisa Cylinder	Michelle Sales
Scott Cylinder	Jonathan Schmuck
Ellen Dickinson	Warren Seelig
Marcia Docter	Karen Shapiro
Robert Ebendorf	Barbara Lee Smith
Tammy Echols-Howell	Emiko Suo
Deb Fleck-Stabley	Anna Torma
John Ford	Claire Verkoyen
David Forlano	Kiwon Wang
Danielle Gori-	Emily Watson
Montanelli	Dave Williamson
	Roberta Williamson
Judith Hoyt	Yoko Yagi

Ueno Masao, Rotation of Ellipse Makes Two Transparent Drums, *2004*
bamboo, 20 x 20
photo: Carolyn Wright

Tai Gallery/Textile Arts

Japanese bamboo arts and museum quality textiles from Africa, India, Indonesia and Japan
Staff: Robert T. Coffland; Pamela Osborn; Trina Hall; Steve Halvorsen

616 1/2 Canyon Road
Santa Fe, NM 87501
voice 505.984.1387
fax 505.989.7770
gallery@textilearts.com
textilearts.com

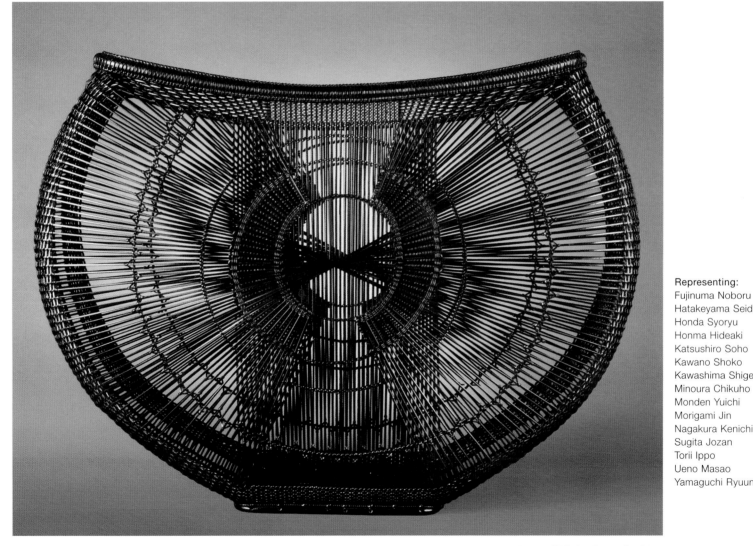

Representing:
Fujinuma Noboru
Hatakeyama Seido
Honda Syoryu
Honma Hideaki
Katsushiro Soho
Kawano Shoko
Kawashima Shigeo
Minoura Chikuho
Monden Yuichi
Morigami Jin
Nagakura Kenichi
Sugita Jozan
Torii Ippo
Ueno Masao
Yamaguchi Ryuun

Minoura Chikuho, **Butterfly,** *2005*
bamboo, 16 x 22 x 9
photo: Carolyn Wright

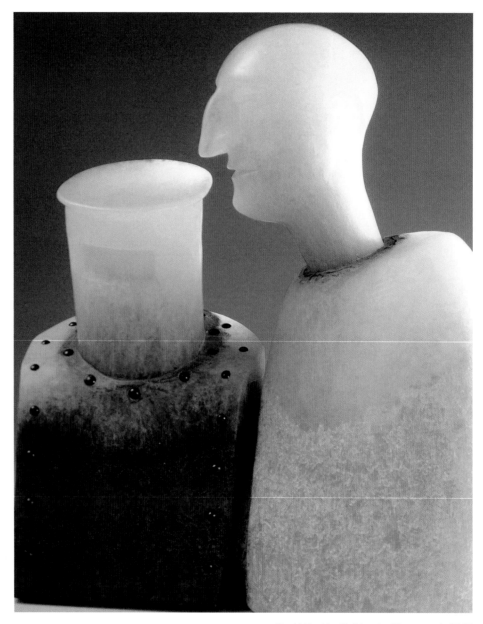

David Reekie, **Talking to Strangers I,** *2005*
lost wax cast glass with enamel

Thomas R. Riley Galleries

Timeless forms by established masters and emerging artists
Staff: Thomas R. Riley and Cindy L. Riley, owners; Cheri Discenzo, director

28699 Chagrin Boulevards
Cleveland, OH 44122
voice 216.765.1711
fax 216.765.1311
trr@rileygalleries.com
rileygalleries.com

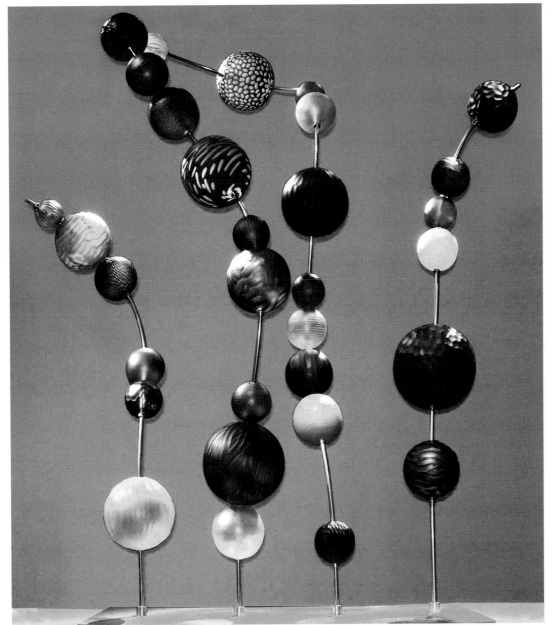

Representing:
Rik Allen
Shelley Muzylowski Allen
Ron Artman
Philip Baldwin
Peter Bremers
Don Charles
Donald Derry
Matt Eskuche
Kyohei Fujita
Monica Guggisberg
Mark Harris
Jeremy Lepisto
Lucy Lyon
Mark Mathews
Duncan McClellan
Sharon Meyer
John Miller
William Morris
Ralph Mossman
Nick Mount
Jeremy Neuman
Seth Randal
Mel Rea
David Reekie
Joseph Rossano
Milon Townsend
Stephanie Trenchard
Karen Willenbrink-Johnsen

Philip Baldwin and Monica Guggisberg, **Hedgerow,** *2005*
Swedish overlay, Italian cold cutting over blown glass, stainless steel, 64 x 55 x 32

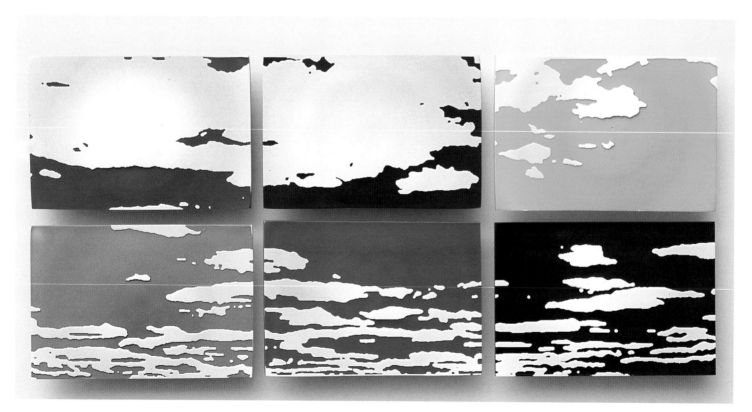

Moshe Bursuker, **Sky Scape***, 2005*
blown and sand-carved glass, 8 x 18
photo: James Dee

UrbanGlass

An international center for new art made from glass

Staff: Dawn Bennett, executive director; Andrew Page, editor, *Glass: The UrbanGlass Art Quarterly*; Leanne Ng, development officer

647 Fulton Street
Brooklyn, NY 11217-1112
voice 718.625.3685
fax 718.625.3889
info@urbanglass.org
urbanglass.org

Laurie Korowitz-Coutu, **Faceted** brooch, 2005
fused and polished glass, sterling silver, 1.5 x 2.5
photo: Kerry Coutu

Representing:
Moshe Bursuker
Laurie Korowitz-Coutu
Becki Melchione
Erica Rosenfeld
Helene Safire
Noriko Tsuji
Melanie Ungvarsky

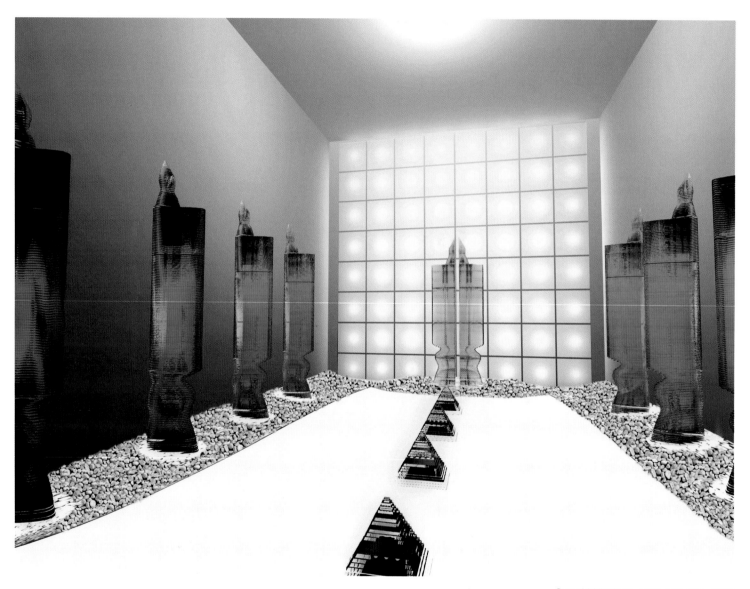

Satoshi Nishizaki, **Ishin-Denshin,** *2005*
glass, installation view

WEISSPOLLACK Galleries

Contemporary glass work and fine art
Staff: Jeffrey Weiss; David Pollack

521-531 West 25th Street
Ground floor #9
New York, NY 10001
voice 212.989.3708
fax 212.989.6392
info@weisspollack.com
weisspollack.com

2938 Fairfield Avenue
Bridgeport, CT 06605
voice 203.333.7733
fax 203.362.2628

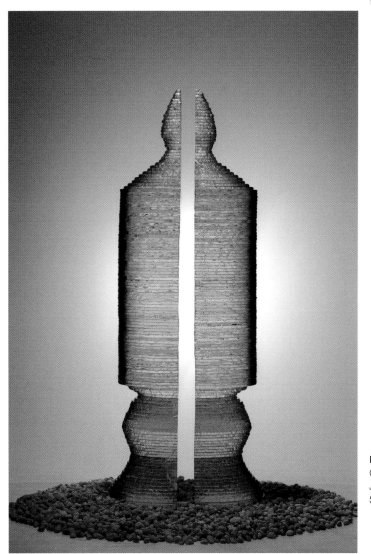

Representing:
Christopher Cantwell
James McLeod
Satoshi Nishizaki

Satoshi Nishizaki, **Shogun,** *2005*
glass, installation detail

Dan Dailey, **Coffee Man,** *1996*
blown glass, sand-blasted and acid-etched, 6 x 6 x 6

Wexler Gallery

201 North 3rd Street
Philadelphia, PA 19106
voice 215.923.7030
fax 215.923.7031
info@wexlergallery.com
wexlergallery.com

The finest in secondary market contemporary glass and new works by artists in the fields of studio art furniture, metalwork, ceramic and design

Staff: Lewis Wexler; Vesna Todorovic

Representing:
Hank Murta Adams
Philip Baldwin
Howard Ben Tre
Giles Bettison
Wendell Castle
José Chardiet
Dale Chihuly
Tessa Clegg
Carol Cohen
Dan Dailey
Laura de Santillana
Robin Grebe
Monica Guggisberg
Ulrica Hydman-Vallien
Jon Kuhn
Dominic Labino
Marvin Lipofsky
Harvey K. Littleton
Richard Marquis
Concetta Mason
Massimo Micheluzzi
William Morris
Joel Philip Myers
Yoichi Ohira
Tom Patti
Mark Peiser
Flo Perkins
Silvano Rubino
Paul Stankard
Lino Tagliapietra
Tomas Tisch
Bertil Vallien
František Vízner

František Vízner, **Round Vase and Green Vase***, c. 1970*
cut glass with sand-blasted matte surface, 5 x 5.5 x 5.5; 10.5 x 2.25 x 4.5
photo: John Carlano

Wounaan People, **Hösig Di Baskets,** *2005*
palm fibers, vegetal dyes, various sizes
photo: Lorran Meares

William Siegal Galleries

Ancient and historic textiles and objects from Aymara, Pre-Columbian, African and Asian cultures
Staff: Bill Siegal, owner; Norberto Zamudio, director

135 West Palace Avenue
Suite101
Santa Fe, NM 87501
voice 505.820.3300
info@williamsiegalgalleries.com
williamsiegalgalleries.com

Chorrera Culture (Ecuador), **Puma Stone Mortar,** *1100-300 B.C.*
stone, 4.5 x 3 x 8.75
photo: Herbert Lotz

John Dodd, **Bench**, *2005*
reclaimed Douglas Fir, ebonized cherry, 18 x 68 x 24

William Zimmer Gallery

Fine and decorative arts

Staff: William and Lynette Zimmer, owners; Pamela Wilson, associate; Barbara Hobbs, associate

10481 Lansing Street
Mendocino, CA 95460
voice 707.937.5121
fax 707.937.2405
wzg@mcn.org
williamzimmergallery.com

Noi Volkov, Hello to Mr. Rembrandt
earthenware, engobes, glazes, oxides, 25 x 16 x 6

Representing:
Abrasha
Jeff Brown
John Dodd
Peter Hayes
Barbara Heinrich
Archie Held
Tai Lake
Sydney Lynch
Guy Michaels
Hiroki Morinoue
Paula Murray
Paul Rieber
Emma Rodgers
Tim Rose
Cheryl Rydmark
Richard Satava
Kent Townsend
Noi Volkov
Rusty Wolfe

Susan Hoge, **Untitled**, *2005*
jewelry, 10 x 5
photo: R.H. Hensleigh

Yaw Gallery

National and international goldsmiths and silversmiths
Special Presentation: Examining the Bead Juried Exhibition
Staff: Nancy Yaw; Jim Yaw; Edith Robertson

550 North Old Woodward
Birmingham, MI 48009
voice 248.647.5470
fax 248.647.3715
yawgallery@msn.com
yawgallery.com

Ion Ionesco, **Untitled,** *2005*
jewelry, 1.25 x .75 x .5
photo: R.H. Hensleigh

Representing:
Chieko Akagi
Maria Beaulieau
Myron Bikakis
Falk Burger
Harlan Butt
Susan Hoge
Ion Ionesco
John Iversen
Shay Lahover
Cornelia Roethel

Alison Kinnaird, MBE, **Horseman,** *2005*
engraved crystal, 18.5 x 64.5
photo: Robin Morton

ZeST Contemporary Glass Gallery

Contemporary British and European glass
Staff: Naomi Hall; Sue Baker

Roxby Place
London SW6 1RS
England
voice 44.20.7610.1900
fax 44.20.7610.3355
naomi@zestgallery.com
zestgallery.com

Representing:
Adam Aaronson
Alison Kinnaird, MBE
Anne-Lise Riond-Sibony
Naoko Sato
Hong Sung-Hwan

Adam Aaronson, **Blue Reeds** *detail, 2005*
blown glass, stainless steel, 46 x 60 x 14
photo: Stephen Brayne

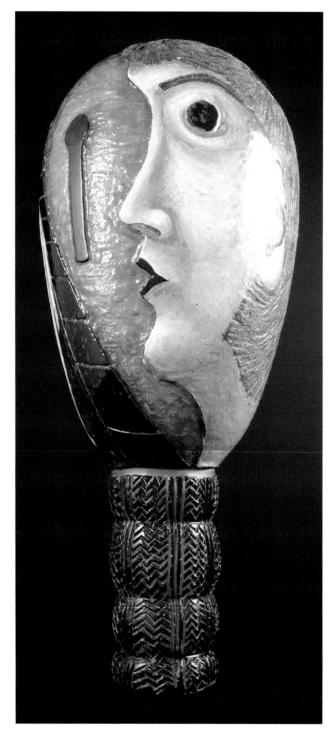

Anne-Lise Riond Sibony, **Venise**, *2005*
blown and painted glass, 10 x 6 x 6
photo: Olivier Sibony

Hong Sung-Hwan, **Bara**, *2004*
blown glass, 8 x 5 x 2.5

Res

ources

AMERICAN **CRAFT**

APR/MAY 05

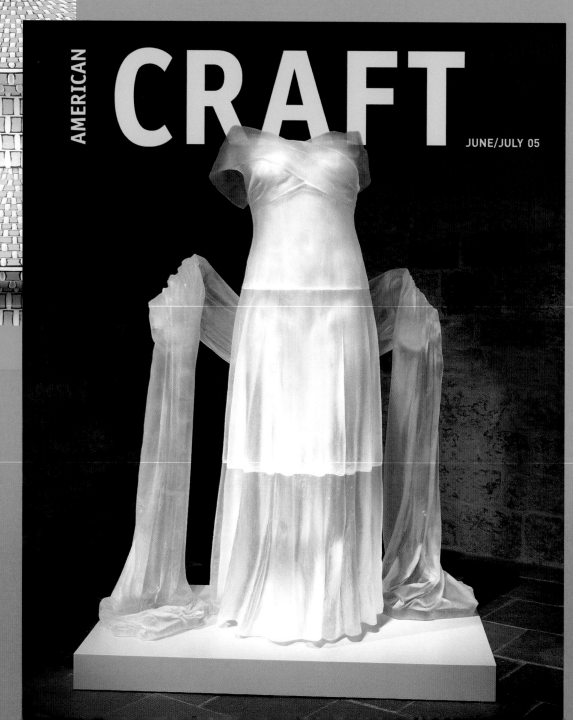

AMERICAN **CRAFT**

JUNE/JULY 05

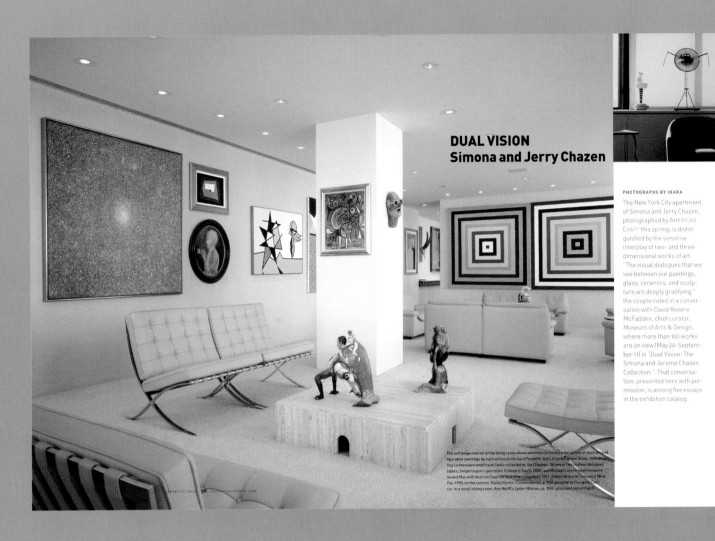

DUAL VISION
Simona and Jerry Chazen

PHOTOGRAPHS BY IHARA

The New York City apartment of Simona and Jerry Chazen, photographed by AMERICAN CRAFT this spring, is distinguished by the sensitive interplay of two- and three-dimensional works of art. "The visual dialogues that we see between our paintings, glass, ceramics, and sculpture are deeply gratifying," the couple noted in a conversation with David Revere McFadden, chief curator, Museum of Arts & Design, where more than 100 works are on view (May 26–September 11) in "Dual Vision: The Simona and Jerome Chazen Collection." That conversation, presented here with permission, is among five essays in the exhibition catalog.

The soft beige interior of the living room allows attention to focus on the variety of abstract and figurative paintings by such artists as Richard Pousette-Dart, Charles Green Shaw, John Willis, Roy Lichtenstein and Frank Stella collected by the Chazens. On one of two custom-designed tables, Sergei Isupov's porcelain *To Keep in Touch*, 2008, and Michael Lucero's earthenware *Seated Man with Heart on Face/Old Man (New Geologies)*, 1991. Robert Arneson's ceramic *Wine Toe*, 1990, on the column, Ranks Farms *Transcendental*, a 1950 gouache by Pousette-Dart for. In a smaller sitting room, Ann Wolff's *Spider Woman*, ca. 1989, glass and metal (right).

AMERICAN CRAFT **36** AUGUST/SEPTEMBER 2009

PUBLISHED BIMONTHLY BY THE AMERICAN CRAFT COUNCIL, **AMERICAN CRAFT** IS THE PREEMINENT MAGAZINE OF CONTEMPORARY CRAFT. ANNUAL MEMBERSHIP IN THE COUNCIL, INCLUDING A SUBSCRIPTION TO THE MAGAZINE, IS $40. CONTACT: 888.313.5527 OR **WWW.CRAFTCOUNCIL.ORG**

Ceramic Review

THE INTERNATIONAL MAGAZINE OF CERAMIC ART AND CRAFT

CERAMIC REVIEW The leading British magazine of studio pottery, is read by all those engaged with contemporary ceramic art and craft around the world

CRITICAL CR offers current and historical overviews, surveys and reviews from potters, critics, curators and commentators

PRACTICAL Artists describe their inspirations, ambitions and experiences. Step-by-step sequences and technical articles cover methods, materials and equipment

INFORMATIVE Leading figures give insights into the framework of contemporary craft, from directors of national institutions to individual collectors

INCLUSIVE Subscribers play a vital role in CR's debates and surveys through the Letters, Gallery, Reports and Review pages

SOFA SUBSCRIPTIONS

Take out a subscription at SOFA Chicago and receive TWO FREE COPIES
Eight issues for the price of six: $69.
Ceramic Review is a full colour, 76-page bimonthly publication. (Offer applies to subscriptions taken at SOFA CHICAGO 2005, or by faxing our office, quoting 'SOFA', between October 28-30.
Fax +44 20 7287 9954)

Kate Malone – *Clover Flower*, crystalline-glazed stoneware, H19cm. Featured in CR215

Ceramic Review
THE INTERNATIONAL MAGAZINE OF CERAMIC ART AND CRAFT
www.ceramicreview.com

PRACTICE
Glaze Fit on Porcelain
The Female Figure
Zelli Porcelain Award
Denby Pottery

PROFILES
Jennifer Hall
Peter Simpson
Nick Chapman
Ruth Duckworth

Vivienne Foley

Ceramic Review
THE INTERNATIONAL MAGAZINE OF CERAMIC ART AND CRAFT

FREE INSIDE
GALLERY MAP

PROFILES
Pippin Drysdale
Edward King
Claire West
Angela Mellor
Joanna Still

PRACTICE
Jonathan Keep
Michael Eden
Glaze Surprises
Setting Out

Halima Cassell

Ceramic Review
THE INTERNATIONAL MAGAZINE OF CERAMIC ART AND CRAFT
www.ceramicreview.com

Jane Muir

PRACTICE
Andrew Wicks
Anagama Kilns
German Cer
Fibres in

Ceramic Review
THE INTERNATIONAL MAGAZINE OF CERAMIC ART AND CRAFT
www.ceramicreview.com

PROFILES
Christopher Dresser
Jim Malone
Nicola Tassie
Andy Shaw

PRACTICE
Artists' Communities
South Wales Potters
Ash Glazes

Stephen Dixon

Ceramic Review
THE INTERNATIONAL MAGAZINE OF CERAMIC ART AND CRAFT
www.ceramicreview.com

PRACTICE
Glazes and Bodies
Virtually Ceramic
Joe Finch Kiln
David Ogle

PROFILES
Lubna Chowdhary
William Plumptre
Les Blakebrough
Toronto Potters

Rupert Spira

Cer

Martin Lungl

Ceramic Review
THE INTERNATIONAL MAGAZINE OF CERAMIC ART AND CRAFT
www.ceramicreview.com

PRACTICE
Feldspar Facts
Alistair Young
Bengali Temples
Pink Glazes

PROFILES
Simon Olding
Stephen Parry
Christoph Zellweger
Jitka Palmer
Walter Keeler

Gwyn Hanssen Pigott

Cera

PRACTICE
Soda Kiln School
Ashley Howard
Israeli Report
David Jones
Paperglaze

PRO
Tina Vla
Carol McN
Mark Jones

www.ceramicreview.com

Johnny Heath – Untitled figure, H49cm. Featured in CR212

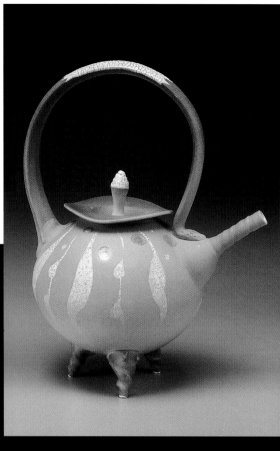

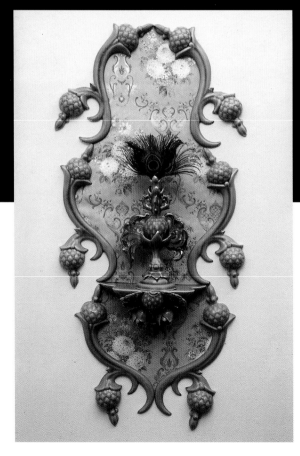

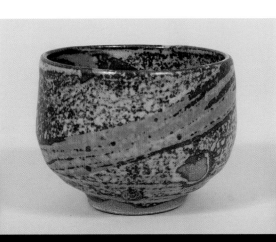

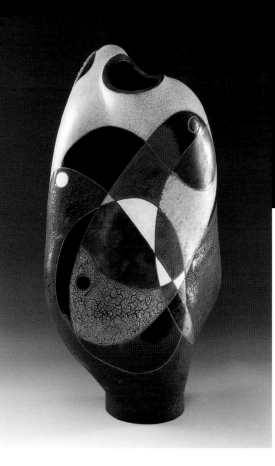

Chicago Artists' Coalition Celebrates 30 Years of Supporting Visual Artists and 30 Years of Chicago Artists' News,

The Most-Read Artists' Newspaper in the Midwest

Published monthly, *Chicago Artists' News* includes features on current events in the regional, national and international art worlds; profiles of artists and galleries; informative reviews of art exhibitions; advice on how to market art; book reviews; and more.

The newspaper's extensive classified section lists exhibition opportunities, jobs, studio space, gallery openings, art events, classes and workshops, member announcements, and more, useful to artists all over the country.

Chicago Artists' News is a great resource to keep artists in touch with the art scene and provide career-development information.

The **Chicago Artists' Coalition** (CAC) offers many other services, including our web site, www.caconline.org, showcasing the works of member artists, some of which are available for sale. In addition, our **New Online Discussion Board for Visual Artists**, www.cacdiscussion.org, provides a variety of forums where artists worldwide can ponder and debate visual art topics.

Join the **Chicago Artists' Coalition** today, start receiving your subscription to *Chicago Artists' News* and become more active in the visual art community. As a member, you can also take advantage of CAC's job referral service, our programs and monthly artists' salons, discounts at art supply and framing stores, plus gain access to health insurance and a credit union.

Call, write or print up the membership form from our web site: www.caconline.org

Chicago Artists' Coalition
11 E. Hubbard Street, 7th Floor, Chicago, IL 60611
Phone: 312-670-2060; Fax: 312-670-2521
Web: www.caconline.org
Discussion Board: www.cacdiscussion.org
E-mail: info@caconline.org

The most comprehensive guide
to Chicago's art galleries and services

Chicago Gallery News is an unequalled resource for gallery listings, art-related services, maps, schedules of opening night receptions and city-wide events.

Published three times a year: January, April and September
Subscriptions: $15 per year

chicagogallerynews

730 N. Franklin, Chicago, IL 60610
312.649.0064 phone
312.649.0255 fax
cgnchicago@aol.com email
www.chicagogallerynews.com

www.**chicagogallerynews**.com

chicago**gallery**news

JIM DINE
at RICHARD GRAY GALLERY

chicago**gallery**news

DOUGLAS DAWSON GALLERY
A DESTINATION FOR ETHNOGRAPHIC ART

now**completely**online

Chicago Gallery News, 730 N. Franklin, Chicago, IL 60610, 312.649.0064, 312.649.0255 fax, info@chicagogallerynews.com

Environmental Sculpture by Neil Dawson (NZ)

AUSTRALIA $13.75 (incl. GST)
US $13, UK £7
NZ $18.50 (incl. GST)
JAPAN ¥1680

ISSN 1038-846X

craft arts INTERNATIONAL

NEW CONCEPTS IN BASKETRY BY JAN HOPKINS
ENVIRONMENTAL SCULPTURE OF NEIL DAWSON, GLASS BY
RICHARD WHITELEY, STEPHEN SKILLITZI & JULIO SANTOS
NEW BIOMORPHIC CERAMICS OF BELA KOTAI

58

Painted Wooden Forms by Binh Pho (USA)

AUSTRALIA $13.75 (incl. GST)
US $13, UK £7
NZ $18.50 (incl. GST)
JAPAN ¥1680

ISSN 1038-846X

craft arts INTERNATIONAL

PAINTED WOODEN ZEN FORMS OF BINH PHO
HOT & COLD-WORKED GLASS BY NICK WIRDNAM,
MEL DOUGLAS AND MARI MÉSZÁROS.
METAL & ENAMEL ARTIST HARLAN W. BUTT

59

Wood Sculpture by Michael Peterson (USA)

AUSTRALIA $13.75 (incl. GST)
US $13, UK £7
NZ $18.50 (incl. GST)
JAPAN ¥1680

craft arts INTERNATIONAL

ISSN 1038-846X

SCULPTURE BY WENDY TEAKEL & ANDREW ROGERS
GLASS BY DAVID MURRAY, NOEL HART & SIMON BUTLER
WOOD BY MICHAEL PETERSON & ALBERT KONERMANN
ENAMELLING BY JENNY GORE

60

Mould-blown glass by Marvin Lipofsky (USA)

AUSTRALIA $16.50 (incl. GST)
US $15, UK £8
NZ $22.50 (incl. GST)
JAPAN ¥1680

craft arts INTERNATIONAL

ALEX DICKSON
& TIM SHAW

62

The cutting edge of expression in contemporary art mediums

CRAFT ARTS INTERNATIONAL is one of the oldest and most respected periodicals in its field. It has attracted worldwide acclaim for its "international scope" of the variety of contemporary visual and applied arts it documents in a lucid editorial style and graphic format. In 2005 the magazine is celebrating 21 years of continuous publishing and to mark this milestone, we have updated our on-line index to include every article and artist that has appeared in the magazine since it was launched in 1984. And access to this remarkable resource, one of the most comprehensive available on the Internet, is totally free.

Each issue of *Craft Arts International* contains 128 pages in full colour, with over 400 color images of innovative concepts and new work by leading artists and designer/makers, supported by authoritative and comprehensive texts, that is essential reading for anyone interested in the contemporary visual and applied arts.

Subscriptions: subs@craftarts.com.au
Advertising: info@craftarts.com.au

crafts

FROM THE CUTTING EDGE TO CLASSIC COLLECTOR'S PIECES

Crafts magazine is the UK'S leading authority on decorative and applied arts. Published every two months by the Crafts Council, we report on quality work from within the UK and beyond. Supplying in-depth coverage and debate across the full spectrum of crafts disciplines, *Crafts* is dedicated to showcasing the best work in ceramics, textiles, jewellery, wood, furniture, glass, fashion and architecture. If you're looking for inspiration and vital information, *Crafts* is the only resource you need.

Subscribe to *Crafts* magazine today and receive **2 issues absolutely free** – that's 8 issues for the price of 6, and also means that your subscription will last for 16 months. A one year subscription costs $69.

To take advantage of this special offer, contact us by quoting 'SOFA 2005' when you order by calling our hotline: +44 (0) 2078062542, fax: +44 (0) 2078370858, visit our website: www.craftscouncil.org.uk, email your details to: subscriptions@craftscouncil.org.uk or write to us at:
Crafts magazine
44a Pentonville Road
London N1 9BY
United Kingdom

30TH ANNIVERSARY ISSUE

SEP|OCT 2005

*Fiber*ARTS

CONTEMPORARY
TEXTILE ART
AND CRAFT

LOOKING FORWARD
looking back

DIGITAL TEXTILES

CREATIVITY
in midlife

contemporary
WEAVING

SHOWCASING
FIBER ART
AND ARTISTS

SHARING INSPIRATION
AND INNOVATIONS

PROVIDING RESOURCES
AND INFORMATION

URBAN GLASS

UrbanGlass is a not-for-profit international center for the creation and appreciation of new art made from glass. Programs include artist-access studio, classes and workshops, on- and off-site exhibitions, Visiting Artist Fellowships, GLASS Quarterly, The Bead Project™, The Store at UrbanGlass and The Bead Expo.

647 FULTON STREET
BROOKLYN, NY 11217-1112
TEL: 718.625.3685
FAX: 718.625.3889
EMAIL: INFO@URBANGLASS.ORG
WWW.URBANGLASS.ORG

GLASS Quarterly is the premiere international showcase of the best contemporary art made from glass. Putting the work of emerging and established artists into critical context, **GLASS Quarterly's** contributors—museum curators, art historians, and critics—are your expert guides to this dynamic field.

Published four times a year with award-winning design and the highest production values, **GLASS Quarterly** is the leading source for all things glass. Your passport to international exhibitions, exclusive studio visits, gallery tours, and breaking news from the worlds of art, architecture and design, **GLASS Quarterly** has provided serious critical discourse on glass as a medium for contemporary art for over 25 years.

Subscribe Today 1.800.607.4410

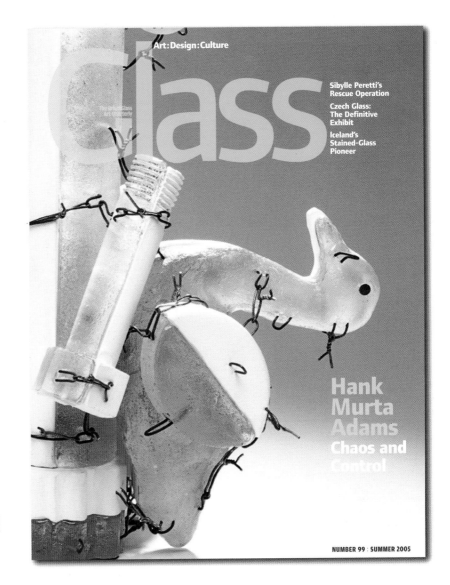

Art:Design:Culture

glass

Sibylle Peretti's
Rescue Operation

Czech Glass:
The Definitive
Exhibit

Iceland's
Stained-Glass
Pioneer

Hank
Murta
Adams
Chaos and
Control

NUMBER 99 : SUMMER 2005

THE INTUIT SHOW OF FOLK AND OUTSIDER ART

Bill Traylor, *Black Bull*, c. 1939-43, 11.25" x 17.25", Courtesy Carl Hammer Gallery

September 30 – October 2, 2005
847 West Jackson Blvd.
Chicago, Illinois

Dealers from around the country feature
a wide variety of folk, outsider, and ethnographic
art in addition to Americana and antiques.

For more information call:

**Intuit: The Center for Intuitive
and Outsider Art**
312-243-9088
or visit our web site at www.art.org

ANNOUNCEMENT

In its 18 years of existence,

kerameiki techni *International Ceramic Art Review*
published since 1987 in Greece, English language, three times a year

This year, our publication on the threshold of its 50th edition, is changing.

We are extending the boundaries of our magazine by combining the medium of print with the possibilities offered by digital technology and the internet.
A pioneering step that will upgrade our publication by transforming it into a multifaceted model for art, communication and information.

The new complex format entitled

will be composed of two parts

CLAY ART INTERNATIONAL

The printed part: **CLAY IN ART** INTERNATIONAL YEARBOOK
which will be published at the end of each year - December

The digital part: **WEBSITE JOURNAL**
online news, updates, information

CLAY IN ART INTERNATIONAL YEARBOOK

-Review of the most important international events and exhibitions of the current year
-Announcements and preview presentations of events scheduled for the year ahead
-Presentations on world-renowned and lesser-known artists
-Introductions to up-and-coming new talents
-Important lectures, exclusive interviews, opinions and criticism
-Recommendations and reviews of books, videos and catalogues

Luxurious hardcover volume, more than 200 pages boasting high production standards, superb full-color illustrations and fold-outs with the main articles

WEBSITE JOURNAL currently under construction

-Major scheduled events and exhibitions
-International Symposiums
-Conferences
-Forums
-International exchanges
-International competitions
-International residencies
-Recommendations and reviews of books, videos and catalogues

ONLINE PANORAMA special section

It will constitute a unique visual document by featuring images from group
and solo shows, important anthological and retrospective exhibitions.
It will be updated regularly throughout the year

ANNUAL PANORAMA CD -ROM

All the ONLINE PANORAMA updates will be collected on the ANNUAL
PANORAMA CD-Rom which will be sent to all subscribers inserted in the Yearbook

We offer our individual subscribers at no extra charge, 12 months of free access
to the WEBSITE JOURNAL, starting from the moment the site comes online.

CLAY ART INTERNATIONAL P.O. Box 76009, NEA SMYRNI 17110, GREECE
Tel/Fax: ++ 30 - 210 - 6752766
kerameiki@otenet.gr - www.kerameikitechni.gr

Now also available entirely in English!
Published 6 times a year!

KeramikMagazin — CeramicsMagazine
Würdigung: Eine Schau zum Werk von Gertraud Möhwald
Fabelhafter Blumenflor: Jugendstilfliesen in Zons
Vitaler Norden. Neues aus Schweden

KeramikMagazin — CeramicsMagazine
Der Tänzer. Neue Stücke von Karl Fulle
Symbole der Stille: Jens Erland
Auf der Überholspur: Ein Mega-Projekt in Fuping

KeramikMagazin — CeramicsMagazine
Im Verborgenen. Über Bert Walter
Erstaunliches aus Kiel
Schönheit im Ebenmaß. Gefäße von Thomas Bohle

KeramikMagazin — CeramicsMagazine
Gegen die Konvention: Michael Geertsen
Hauptstadtkeramik: Die Sonderschau in Pankow
Sammeln als Wissenschaft: Das Ehepaar Crueger im Gespräch

KeramikMagazin — CeramicsMagazine
Erfolgreiche Wiederauflage: 11. Westerwaldpreis
Aus einem Guss: Lothar-Fischer-Museum eröffnet
Starke Stimme aus der Stille: Nicolas Arroyave-Portela

KeramikMagazin — CeramicsMagazine
Lekker Decadent! Wechselbad der Gefühle in Holland
Hingehauchtes. Keramik von Aino Nebel
Die Puristin. Neues von Judith Rataitz

METALSMITH

JEWELRY ▪ DESIGN ▪ METAL ARTS SUMMER 2005

25
YEARS

volume 25 number 3
www.snagmetalsmith.org

Intuitive Vision

Digital Makeover

Redemption and Reverie

Museum of Contemporary Art

M/CA

220 East Chicago Avenue
312.280.2660
www.mcachicago.org

Don't miss our extraordinary exhibitions, innovative
performances, free daily tours, contemporary design
store, and exquisite restaurant. Surprises await
you inside.

www.kunstwelt-online.de

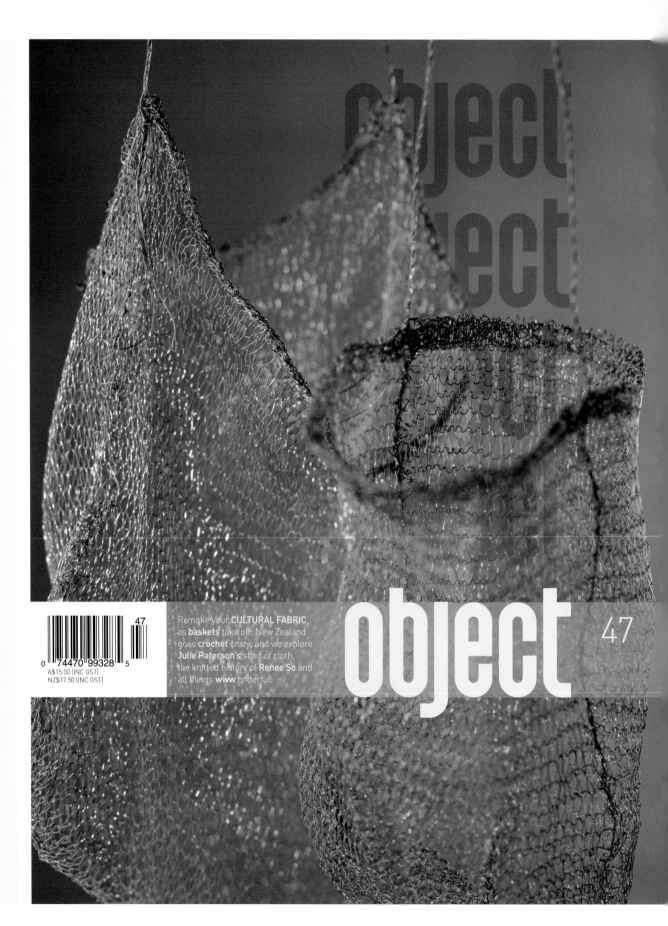

OBJECT MAGAZINE

For a fresh perspective on craft and design.

Australia's leading craft and design magazine brings you inspiration, innovation and information from Australia, New Zealand and across the globe.

A$15.00 (INC GST)
NZ$17.50 (INC GST)

0 74470 99328 5

47

Remake your **CULTURAL FABRIC**, as **baskets** take off; New Zealand goes **crochet** crazy, and we explore **Julie Paterson's** shed of cloth, the knitted history of **Renee So** and all things **www**.onderful.

object 47

SUBSCRIBE

⊳ **one issue free**

⊳ **free delivery to you door**

⊳ **your copy before it hits the stores**

⊳ **great gift idea**

Australia $45.00 (incl. GST)
New Zealand/Asia A$72.00
USA/Europe A$85.00

Simply copy this form and
fax to: + 61 2 9361 4533,
or telephone: + 61 2 9361 4555,
email object@object.com.au
or visit www.object.com.au

☐ Yes, I would like a four-issue subscription
delivered to my door, starting with issue no: _____
Australia $45.00 (inc. GST) / New Zealand & Asia A$72.00 / USA & Europe A$85.00

OR

☐ Yes, I would like to become an Object Supporter, to receive additional benefits
to my subscription, such as invitations to exhibition opening nights and discounts
at Object's store Collect.
A$75.00 (inc. GST)

☐ Yes, I would like to stay up-to-date with Object exhibitions and events.
Please email me the free Object e-flier

☐ Yes, this is a gift subscription for:

Name _____

Address _____

Please complete the form below, then either:

Fax to: +61 2 9361 4533
Mail to: Object: Australian Centre for Craft and Design
415 Bourke Street Surry Hills NSW 2010 Australia
or email to: object@object.com.au
Telephone: +61 2 9361 4555

Your Details:

Name _____

Address _____

Telephone _____

Email _____

Payment Details:

TOTAL $ _____

☐ Cheque (in A$) payable to: Object: Australian Centre for Craft and Design

☐ Please charge my card: ☐ Bankcard ☐ MasterCard ☐ Visa ☐ Amex ☐ Diners

Card no: | | | | | | | | | | | | | | | | Card expiry: | | | | |

Name on card: _____

Cardholder signature: _____

Conditions: Subscription and Supporter rates are valid until 31 December 2005.
Object is committed to handling your personal information in accordance with the Australian Privacy Act.

selvedge...

ISSUE 04 JAN/FEB 05

Celebrate!
Your rites of passage

Missoni
American quilts
Cirque du Soleil

THE FABRIC OF YOUR LIFE: **TEXTILES IN FINE ART, FASHION, INTERIORS, TRAVEL AND SHOPPING**

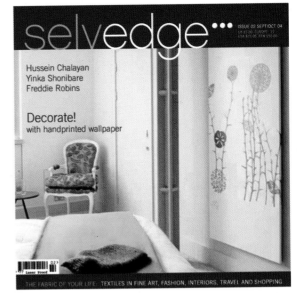
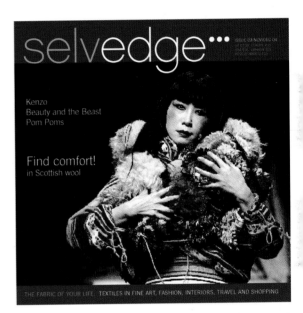
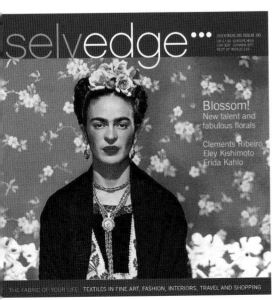
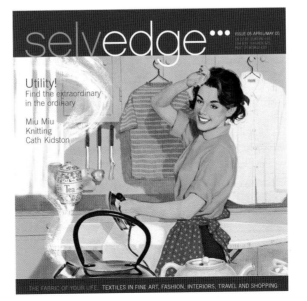

Definition:

Surface Design encompasses the coloring, patterning, and structuring of fiber and fabric.

This involves the creative exploration of processes such as dyeing, painting, printing, stitching, embellishing, quilting, weaving, knitting, felting, and papermaking.

Mission:

The mission of Surface Design Association is to increase awareness, understanding, and appreciation of textiles in the art and design communities as well as the general public.

We inspire creativity and encourage innovation and further the rich tradition of textile arts through publications, exhibitions, conferences, and educational opportunities.

Member Benefits:

- **Four issues of the *Surface Design Journal***
 - **Four issues of the *SDA Newsletter***
 - **National and regional conferences**
 - **Networking opportunities**
 - **Inclusion in SDA Slide Library**
 - **SDA Instructors Registry**
 - **Avenues for promotion of your work**
 - **Opportunities for professional development**
 - **Free 30-word non-commercial classified ad in the newsletter**
 - **Exhibition opportunities**

Member Services:

- **Access to fabric sample library and slide library**
- **Access to instructor directory**
- **Resource recommendations**

For membership information, visit our web site www.surfacedesign.org

**Surface Design Association
PO Box 360
Sebastopol CA 95473
707.829.3110
surfacedesign@mail.com**

www.surfacedesign.org

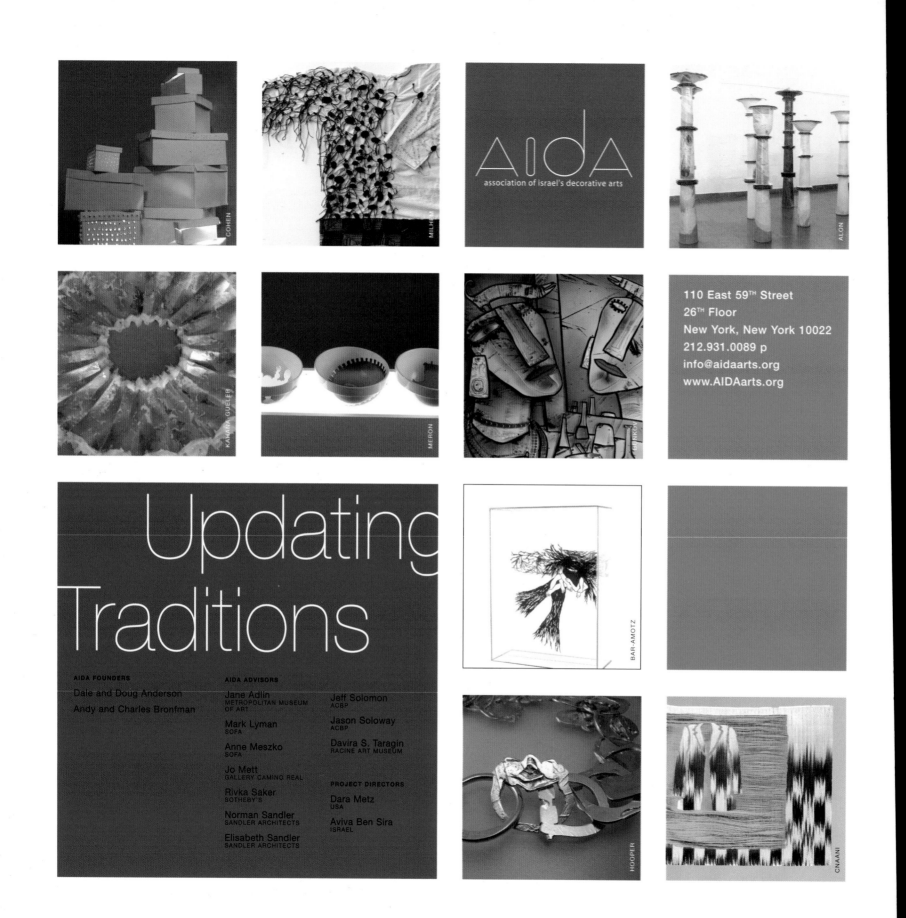

AIDA
association of israel's decorative arts

110 East 59TH Street
26TH Floor
New York, New York 10022
212.931.0089 p
info@aidaarts.org
www.AIDAarts.org

Updating Traditions

AIDA FOUNDERS

Dale and Doug Anderson

Andy and Charles Bronfman

AIDA ADVISORS

Jane Adlin
METROPOLITAN MUSEUM
OF ART

Mark Lyman
SOFA

Anne Meszko
SOFA

Jo Mett
GALLERY CAMINO REAL

Rivka Saker
SOTHEBY'S

Norman Sandler
SANDLER ARCHITECTS

Elisabeth Sandler
SANDLER ARCHITECTS

Jeff Solomon
ACBP

Jason Soloway
ACBP

Davira S. Taragin
RACINE ART MUSEUM

PROJECT DIRECTORS

Dara Metz
USA

Aviva Ben Sira
ISRAEL

Art Alliance for Contemporary Glass

The Art Alliance for Contemporary Glass
is a not–for–profit organization whose mission is to further the development and appreciation of art made from glass. The Alliance informs collectors, critics and curators by encouraging and supporting museum exhibitions, university glass departments and specialized teaching programs, regional collector groups, visits to private collections, and public seminars.

Support Glass

Membership $65
Your membership entitles you to a subscription to "Glass Focus", the AACG newsletter, and opportunities to attend private events at studios, galleries, collectors homes, Glass Weekend and SOFA. For more information visit our web site at www.ContempGlass.org, email at admin@contempglass.org or call at 847-869-2018.

art&antiques

The world's most widely read* and
subscribed-to** art collectors' magazine.

Art & Antiques is proud
to once again support
SOFA CHICAGO.

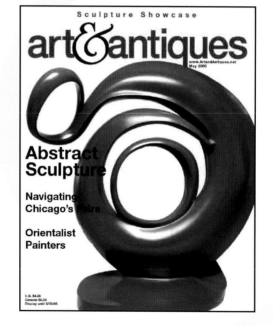

For advertising or subscription details, visit us at
SOFA CHICAGO, online at **www.ArtandAntiques.net**,
or call us at 770-955-5656.

* 2004 Ardisson & Associates Subscriber Survey ** December 2004 ABC Statement

We invite you to join the Art Jewelry Forum

and participate with other collectors who share
your enthusiasm for contemporary art jewelry.

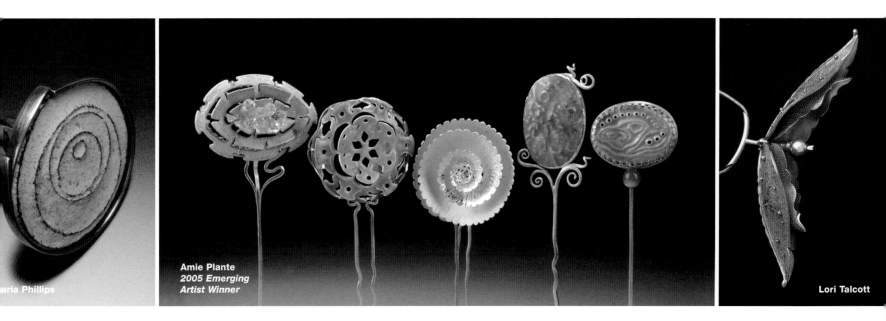

aria Phillips

Amie Plante
*2005 Emerging
Artist Winner*

Lori Talcott

OUR MISSION To promote education, appreciation,
and support for contemporary art jewelry.

OUR GOALS To sponsor educational programs,
panel discussions, and lectures about national and
international art jewelry.

To encourage and support exhibitions, publications,
and programs which feature art jewelry.

To organize trips with visits to private collections,
educational institutions, exhibitions, and artists' studios.

Join the Art Jewelry Forum today!

E-mail: **info@artjewelryforum.org**
Call: **415.522.2924**
Website: **www.artjewelryforum.org**
Write us at: **Art Jewelry Forum,
P.O. Box 590216, San Francisco, CA
94159-0216**

artnet . . . A Global View

Acquavella Galleries, New York | Alice Adam Ltd., Chicago | Thomas Ammann Fine Art AG, Zurich | Greenberg-Van Doren, New York | Galerie de Bellefeuille, Montreal | John Berggruen Gallery, San Francisco | Galerie Beyeler, Basel | Peter Blum, New York | Tanya Bonakdar Gallery, New York | Gavin Brown's enterprise, New York | C&M Arts, New York | Carl Solway Gallery, Cincinnati | Charles Cowles Gallery, New York | Cheim & Read, New York | Paula Cooper Gallery, New York | Danese Gallery, New York | Galerie Daniel Templon, Paris | Dover Street Gallery, London | Richard L. Feigen & Co., New York | Ronald Feldman Fine Arts, New York | Fraenkel Gallery, San Francisco | Gagosian Gallery, New York /London/ LA | Barbara Gladstone Gallery, New York | Galerie Gmurzynska, Cologne/Zug | James Goodman Gallery, New York | Marian Goodman Gallery, New York | Galeria Elvira Gonzalez, Madrid | Richard Gray Gallery, Chicago | Galerie Karsten Greve, Cologne/Milan/Paris/St. Moritz | Cristina Guerra, Lisbon | Galería Enrique Guerrero, Mexico City | Haunch of Venison, London | Hauser & Wirth, London/Zurich | Galería Helga de Alvear, Madrid | Galerie Max Hetzler, Berlin | Hirschl & Adler Galleries, New York | Jablonka Galerie, Cologne | Xavier Hufkens, Brussels | Alan Koppel Gallery, Chicago | Barbara Krakow Gallery, Boston | Galerie Krinzinger, Vienna | Kukje Gallery, Seoul | L.A. Louver Gallery, Los Angeles | Margo Leavin Gallery, Los Angeles | Lefevre Fine Art, London | Galerie Lelong, New York/Paris/Zurich | Lisson Gallery, London | Locks Gallery, Philadelphia | Matthew Marks Gallery, New York | Marlborough Fine Art, London | Galerie Hans Mayer, Dusseldorf | The Mayor Gallery, London | Victoria Miro Gallery, London | Robert Miller Gallery, New York | Mitchell-Innes & Nash, New York | Galerie Nordenhake, Berlin/Stockholm | Pace Wildenstein, New York | Sable-Castelli Gallery, Toronto | Galerie Thomas, Munich | Sonnabend, New York | Sperone Westwater,New York | Galeria Luisa Strina, San Paolo | Stux Gallery, New York | Taka Ishii Gallery, Tokyo | Galerie Thaddaeus Ropac, Salzburg/Paris | Sprüth Magers Lee, London/ Cologne/Munich | Galerie Thomas, Munich | Waddington Galleries, London | Michael Werner, New York/ Cologne | Wooster Projects, New York | Zabriskie Gallery, New York | David Zwirner, New York

And over 1,000 more in 250 cities worldwide.

The Online Gallery Network
Over 150,000 Works
Over 25,000 Artists
The Largest of Its Kind

artnet®
The Art World Online

www.artnet.com
+1-212-497-9700

www.artnet.de
+49-(0)30-209-1780

Bonhams [1793]

20th Century Furniture and Decorative Arts
Tuesday December 6
New York
Glass/Ceramics/Wood/Metal/Fiber

Our upcoming December auction of 20th
Century Decorative Art in New York will feature
a section devoted to Contemporary Works of
Art and we are actively seeking consignments.
Contemporary Art is alive and well at Bonhams.

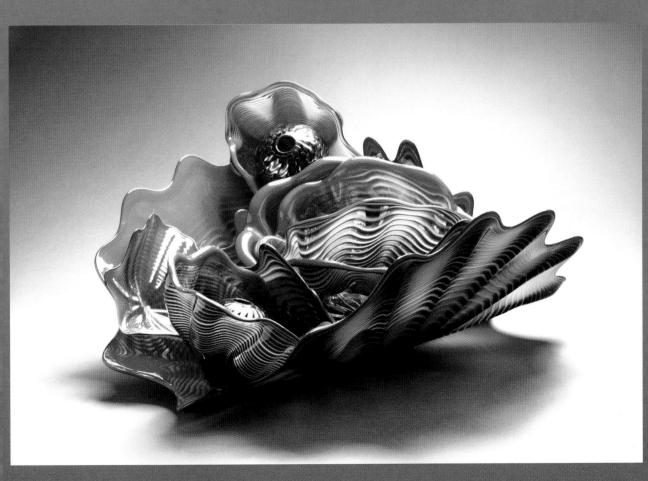

Inquiries
New York
Frank Maraschiello
+1 (212) 644 9059
frank.maraschiello@bonhams.com
Los Angeles
Jason Stein
+1 (323) 436 5422
jason.stein@bonhams.com
San Francisco
Gary Espinosa
+1 (415) 503 3249
gary.espinosa@bonhams.com

For further information, complimentary
auction estimates or to view and order
catalogs, visit www.bonhams.com/us
or call +1 (800) 223 2854

Dale Chihuly (American, born 1941)
Nine piece orange Persian glass set, 1989
Sold for $29,375

Bonhams
595 Madison Avenue, Sixth Floor
New York, New York 10022
+1 (212) 644 9001
+1 (212) 644 9009 fax
www.bonhams.com/us
© 2005, Bonhams & Butterfields Auctioneers Corp.
All rights reserved. Bond No. 57BSBBZ3253
Principal Auctioneer: Malcolm Barber NYC License No. 1183017

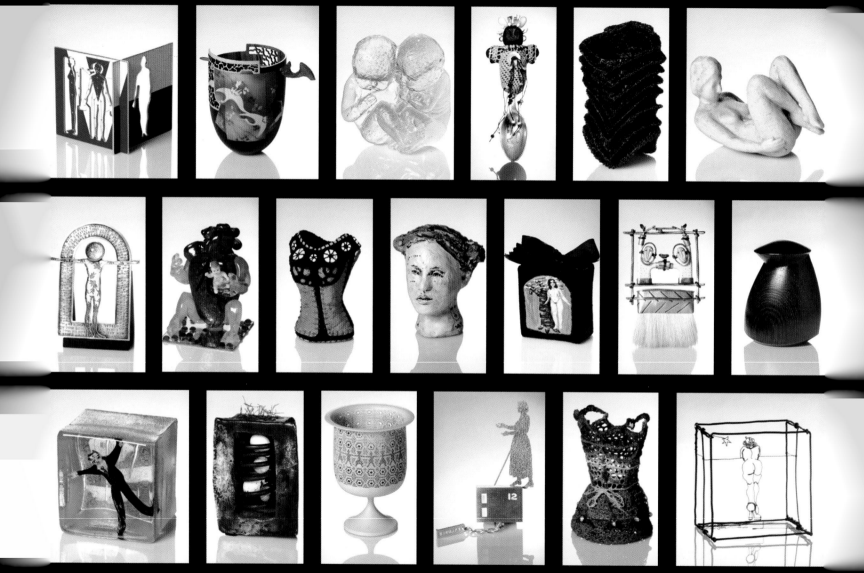

*every*BODY celebrate the *20th* anniversary
of the Craft Emergency Relief Fund

Top row: Boris Bally, Binh Pho, Christina Bothwell, Judy Mulford, Donna Kaplan, Holly Curcio, Norma Minkowitz.
Middle row: Karen Krieger, Einar & Jamex de la Torre, Jan Hopkins, Debra W. Fritts, Mark Sfirri, Carolyn Morris Bach, Beth Nobles, Steve Sinner.
Bottom row: Stephanie Trenchard & Jeremy Popelka, Leslie Rosdol, Christina Y. Smith, Diane Komater.
Also included: Martin Blank, Mark Chatterley, Mark Del Guidice, Joyce J. Scott, Janis Mars Wunderlich.

Come view CERF's collection of miniatures and special exhibition at the **SOFA CHICAGO** Resource Center

The mission of CERF is to strengthen and sustain the careers of craft artists across the United States

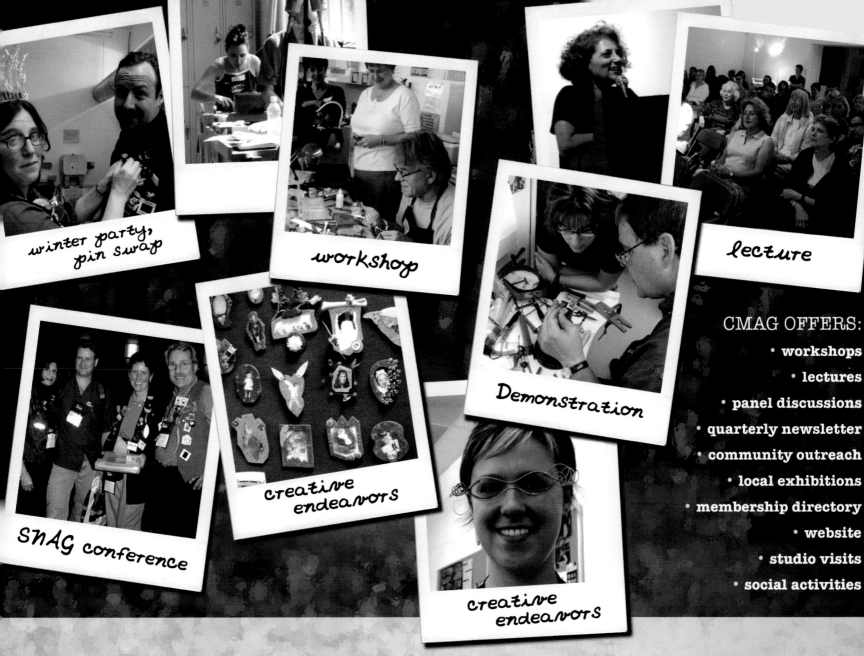

winter party, pin swap

workshop

lecture

SNAG conference

creative endeavors

Demonstration

creative endeavors

CMAG OFFERS:
- **workshops**
- **lectures**
- **panel discussions**
- **quarterly newsletter**
- **community outreach**
- **local exhibitions**
- **membership directory**
- **website**
- **studio visits**
- **social activities**

Chicago Metal Arts Guild (CMAG) offers anyone interested in the metal arts, from students to professionals, the opportunity to become a part of a strong metalsmithing community. This dynamic community enriches the careers of its members, strengthens public perceptions about the field, and advances the place of metal artists in the Chicago art community. It is a forum for sharing business practices and tips, getting artistic feedback from peers, learning new skills in sponsored workshops, gaining exposure to new work and ideas through visiting artists' lectures, providing exhibition opportunities, and promoting our field through educational outreach programs. The Chicago Metal Arts Guild has been recognized as a significant and reliable organization; we've been chosen to host the SNAG (Society of North American Goldsmiths) conference in 2006.

A non-profit organization, we have a nine member volunteer board of directors. We host our events primarily in the Chicago area, but welcome members from all parts of the Midwest. We are four years old and have over 150 members! Join us in creating a vibrant and active organization that will promote and enhance the Chicago area metals community!

CHICAGO METAL ARTS GUILD

For more information write to:

Chicago Metal Arts Guild
4401 N. Ravenswood, Suite 304M
Chicago, IL 60640
Phone: 847-724-7570
www.chicagometalartsguild.org

The international art fair for contemporary objects
Presented by the British Crafts Council

9 – 13 February 2006
At the V&A, London
www.craftscouncil.org.uk/collect

co[]ect®

Venue
Victoria and Albert Museum
South Kensington
London SW7 2RL, UK

Organisers
Crafts Council
44a Pentonville Road
London N1 9BY, UK

For visitor information
+44 (0)20 7806 2512
collect@craftscouncil.org.uk
www.craftscouncil.org.uk/collect

ArtReview
In Association with ArtReview

Registered Charity Number 280956
The Crafts Council is committed to equal opportunities

COLLECT 2006 Exhibitors include:

AIDA – Association of Israel's Decorative Arts
Alpha House Gallery, Dorset
Alternatives Gallery, Italy
Australian Contemporary, Australia
Barrett Marsden Gallery, London
Bishopsland Educational Trust, Reading
blås&knåda, Sweden
Bluecoat Display Centre, Liverpool
Bullseye Connection Gallery, USA
Clare Beck at Adrian Sassoon, London
Collectief Amsterdam, The Netherlands
Contemporary Applied Art, London
Contemporary Art Centre, The Netherlands
Contemporary Ceramics, London
Corman Arts, London
Cosa, London
Cultural Connections CC, Buckinghamshire
Danish Silversmiths, Denmark
Design-Nation, London
Flow, London

Galerie Carla Koch, The Netherlands
Galerie für Angewandte Kunst, Germany
Galerie Louise Smit, The Netherlands
Galerie Marianne Heller, Germany
Galerie Marzee, The Netherlands
Galerie Ra, The Netherlands
Galerie Rosemarie Jaeger, Germany
Galerie S O, Switzerland
Galleri Nørby, Denmark
Galleria Blanchaert, Italy
Gallery Terra Delft, The Netherlands
Hannah Peschar Sculpture Garden, Surrey
Joanna Bird Pottery, London
Katie Jones, London
Lesley Craze Gallery, London
Narek Galleries, Australia
Plateaux Gallery, London
Raglan Gallery, Australia
Sarah Myerscough Fine Art, London
Thea Burger Fine Arts, USA
The Gallery, Ruthin Craft Centre, North Wales
The Scottish Gallery, Edinburgh

Collectors of Wood Art

David Ellsworth Elliptical bowl, 1983, in spalted sugar maple, 6-5/8 x 10". Arizona State University Art Museum collection, gift of Edward Jacobson. Photo courtesy of the ASU Art Museum.

Honors
Edward "Bud" Jacobson
2005 Recipient
Lifetime Achievement Award

Bud Jacobson, 1922 -2005, was a prominent Arizona attorney and arts advocate. This award recognizes his impact on contemporary wood art through inspiring artists and collectors and by providing the opportunity to address the aesthetic of wood vessels in the broader art community. In 1985 his wood art collection toured the nation as a Smithsonian exhibit which led to the publication of *The Art of Turned-Wood Bowls*. His collection was subsequently donated to Arizona State University.

As a truly passionate collector and arts benefactor, he did not keep track of his donations. "I've never thought about the dollar value of what I've given away. ...Giving away art opens up a space on my wall for something else."

Collectors of Wood Art is proud to sponsor a talk by
Heather S. Lineberry
Senior Curator of Arizona State University Art Museum
"Turning Point: The Inspiration of the Edward Jacobson Collection of Turned Wood Bowls."
SOFA Chicago, Friday, October 28, 2005
10:00 to 11:00 am

Collectors of Wood Art is committed to the development and appreciation of studio wood art, including turned objects, sculpture, and furniture. Find out more about CWA — and join! Register at our website: **www.CollectorsOfWoodArt.org**
phone: **888.393.8332** email: **CWA@NYCAP.RR.com**
or mail inquiries to: Collectors of Wood Art, P.O. Box 402
Saratoga Springs, NY 12866

Tapestry woven by Jon Eric Riis titled *Icarus No. 1*

Sculpture stuffed and quilted by Margaret Cusack titled *Hands*

Drawing embroidered by B.J. Adams titled *Hands Drawing Hands*

Sculpture crocheted by Norma Minkowtiz titled *Sandy G*

WALL WORKS AND SOFT SCULPTURE will complement the glass, clay, metal and wooden objects now adorning your home. Discover the impressive range of works being produced today by a talented bevy of artists who employ countless techniques to construct enviable art works of natural and man-made flexible materials.

SEE PRIVATE COLLECTIONS OF FIBER ART on tours organized by Friends of Fiber Art. Generous collector members show you how handsome fiber art looks in their elegant homes. Many were listed among the "100 Top Collectors in America" published by *Art & Antiques* magazine.

NETWORK WITH THE MOVERS AND SHAKERS who share ideas with the buyers and makers at all programs sponsored by Friends of Fiber Art, the only organization that fosters communication among collectors, curators, critics, dealers and artists.

LEARN WHERE FIBER ART IS ON VIEW by reading the outspoken newsletter for members of Friends of Fiber Art. It notes developments in the museum world and features the achievements of its members.

OUR MISSION is to inform and inspire the art-appreciative public about the "collectability" of contemporary art made of flexible materials.

CONTACT US by phone, fax or mail. Learn about scheduled programs at www.friendsoffiberart.org our developing Web site.

friends of fiberArt International™

Post Office Box 468
Western Springs, IL 60558
Phone/Fax 708-246-9466

The Furniture Society
at SOFA Chicago, Oct. 28-30

CONVERGENCE:

CROSSING THE DIVIDE
THE STUDIO FURNITURE OF TASMANIA AND AMERICA

John Smith
Errol and Essie – Dancing Drawers
Photograph by Peter Whyte

Jon Brooks
Picton River Chairs
Photograph by Dean Powell

**AN EXHIBITION OF SIXTEEN
FURNITURE MAKERS**

**ORGANIZED BY
OCEANSIDE MUSEUM OF ART**

SPONSORED BY AN ANONYMOUS DONER

CATALOG AVAILABLE

| MEMBERSHIP | EXHIBITIONS | PUBLICATIONS | CONFERENCES |

The Furniture Society
111 Grovewood Rd., Asheville, NC 28804

ph: 828.255.1949 | fax: 828.255.1950
www.furnituresociety.org

Glass Art Society

The Glass Art Society is an international non-profit organization founded in 1971 whose purpose is to encourage excellence, to advance education, to promote the appreciation and development of the glass arts, and to support the worldwide community of artists who work with glass.

GAS members are artists, students, educators, collectors, gallery and museum personnel, writers, and critics, among others. Membership is open to anyone interested in glass art.

For more information or to join GAS:

Glass Art Society
3131 Western Ave., Suite 414
Seattle, WA 98121

Tel: 206.382.1305
Fax: 206.382.2630
info@glassart.org

www.glassart.org

Glass Gateways: Meet in the Middle
36th Annual Conference
St. Louis, Missouri

June 15-17, 2006

GLASS ART
SOCIETY

Demonstrations, Lectures, Panel Discussions, Tours, Exhibitions, Technical Display, Auction, Parties, and more!

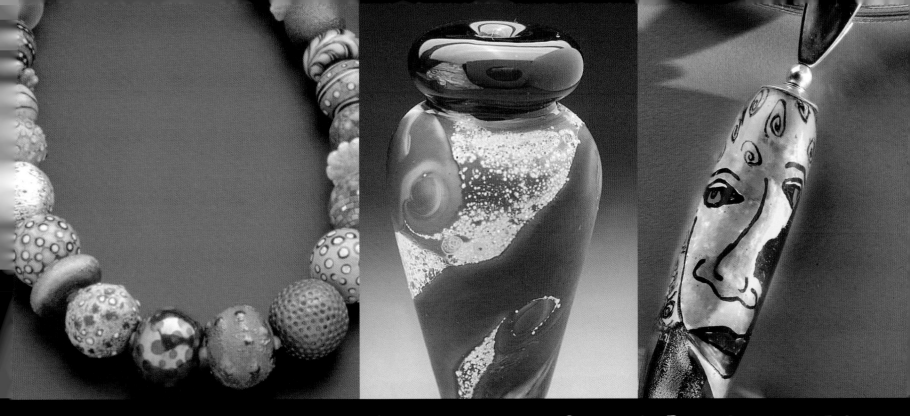

THE INTERNATIONAL SOCIETY OF GLASS BEADMAKERS
EDUCATING, PROMOTING, AND PRESERVING FOR THE NEXT 4,000 YEARS.

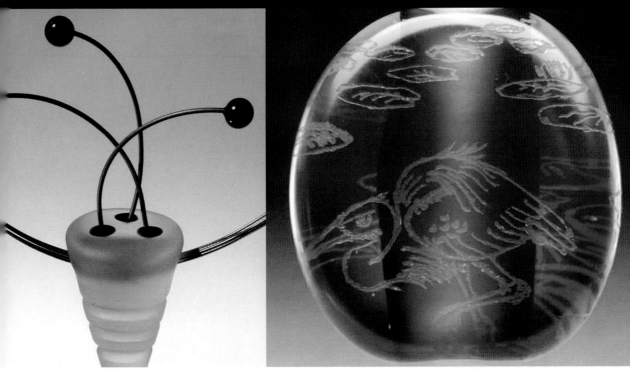

For close to 4,000 years, glass beads have been used for adornment, trade, currency, and religious ritual in cultures all over the world. The International Society of Glass Beadmakers provides the resources to fuel the continuing renaissance of glass beadmaking.

ISGB
International Society of Glass Beadmakers

International Society of Glass Beadmakers • 1120 Chester Ave. #470 • Cleveland, OH 44114 USA • 888 742-0242 • www.isgb.org

CELEBRATE AMERICAN CRAFT ART AND ARTISTS
JOIN THE JAMES RENWICK ALLIANCE.

LEARN
about contemporary crafts at our seminars,

SHARE
in the creative vision of craft artists at workshops,

REACH OUT
by supporting our programs for school children,

INCREASE
your skills as a connoisseur,

ENJOY
the comaraderie of fellow craft enthusiasts,

PARTICIPATE
in Craft Weekend including symposium and auction, and

TRAVEL
with fellow members on our craft study tours.

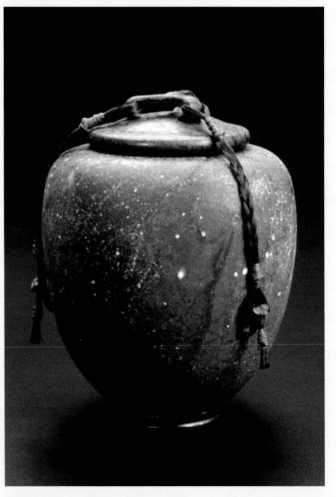

"Cinerary Urn", 2002, by William Morris, was sold at our 2005 Craft Weekend Auction. Photo by Rob Vinnedge.

As a member you will help build our nation's premiere collection of contemporary American craft art at the Renwick Gallery.

The James Renwick Alliance, founded in 1982, is the exclusive support group of the Renwick Gallery of the Smithsonian American Art Museum.

For more information: Call 301-907-3888. Or visit our website: www.jra.org

MATT METZ

LINDA SIKORA

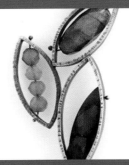

CHRISTINE SIMPSON

SARAH BUSEN

KRISTEN HOLUB

Exhibiting the best in contemporary clay, fiber and metals, since 1975.

October 22-November 20, 2005

Matt Metz and Linda Sikora

Simply Brilliant: Sarah Busen, Kristen Holub and Christine Simpson

CLASSES ★ GALLERY ★ STUDIOS

PROGRAMS FOR CHILDREN AND ADULTS IN:

Ceramic Arts

Jewelry and Metalsmithing

Fiber Arts

Painting and Drawing

LILLSTREET

Founders' Circle

THE NATIONAL SUPPORT AFFILIATE FOR THE *Mint Museum of Craft + Design*

Kawano Shoko
Japan

Robert Ebendorf
United States

Vladimir Bachorik
Czech Republic

The Mint Museums

Founders' Circle
Mint Museum of Craft + Design

www.founderscircle.org

ARTS & SCIENCE COUNCIL
Advancing Arts, Science & History

The Founders' Circle partners with the Mint Museum of Craft +
Design to promote appreciation of contemporary craft and design.

EXHIBITIONS:

Don Reitz: Clay, Fire, Salt and Wood
October 8-December 21, 2005

Thirties Glamour and the Allure of Bakelite
October 29, 2005-April 2, 2006

Crosscurrents: Art, Craft and Design in North Carolina
January 28-August 6, 2006

SAVE THE DATE!

Founders' Circle Weekend
October 6-11, 2005
and
Mint Condition Gala
October 7, 2006

220 N. Tryon Street | Charlotte, NC | 28202 | 704.337.2008

Changing Hands: Art Without Reservation, Part 2
Contemporary Native North American Art from the West, Northwest and Pacific

September 22, 2005 — January 22, 2006

Followed by national tour through 2007

The second exhibition in MAD's internationally acclaimed series
Featuring works by 190 Native artists

Susan Point, *Return*, 2003, Cast glass, red cedar, 29 x 32 x 36" Collection of the Museum of Arts & Design Photo: Mike Zens

Museum of Arts & Design
40 West 53rd Street
New York, NY 10019
212.956.3535

www.madmuseum.org

If you're in New York,

please visit us on 53rd Street.

Museum of Arts & Design

Upcoming exhibitions

Nature Transformed:
Wood from the Bohlen Collection
May 18 – September 3, 2006

The Eames Lounge Chair:
The Evolution of a Modernist Icon
May 18 – September 3, 2006

simply droog
10 + 2 years of creating
innovation and discussion
September 14, 2006 – January 14, 2007

work provided by Erin Furminsky

NATIONAL COUNCIL ON EDUCATION FOR THE CERAMIC ARTS 1966–2006

40 NCECA

N·C·E·C·A

the Resonance of Place

Explorations + Navigations:

> March 8-11, 2006 | Portland, Oregon

for registration, conference information, and membership

www.nceca.net | 866 266 2322

Experimentation
Collaboration
Inspiration

Find them all in Pilchuck Glass School's 2006 Summer Program or during our fall, winter or spring residencies.

PILCHUCK
GLASS
SCHOOL

For more information, write:
Registrar, Pilchuck Glass School
PO Box 95, PMB #527
Stanwood, WA 98292
Call: (360) 445-3111, extension 29
Or visit: www.pilchuck.com

R|A|M

A home for Contemporary Crafts on Main Street, USA

See

John Garrett @ RAM/The Windows Project
Through August 6, 2006

See the Work Evolve – November 9 – 12, 2005
An installation for RAM's Windows on Fifth Gallery, oriented to the street. Garrett will change this twice during the run of the show.

Toshiko Takaezu: Heaven and Earth
Through January 8, 2006
The debut of her gift of the *Star Series* to RAM, placed in the context of her career in ceramics with loans from major American museums.

Material Response: Michael James at RAM
Coming in Winter 2006

Racine Art Museum

441 Main Street
Racine, Wisconsin
262.638.8300

www.ramart.org

Images
Clockwise from top left

Racine Art Museum, Photo: Christopher Barrett © Hedrich-Blessing, Chicago

Toshiko Takaezu, *Star Series* (detail), 1999-2001
14 stoneware sculptures ranging in height from 46 to 68 inches, Gift of Toshiko Takaezu, Photo: Michael Tropea, Chicago

Toshiko Takaezu, *Unas* from the *Star Series*, 1999-2000
Stoneware, 63 1/2 x 25 x 25 inches, Gift of Toshiko Takaezu, Photo: Michael Tropea, Chicago

John Garrett, *The Windows Project* (two details), 2005
Steel wire, painted aluminum, plastic, wood, and tin, 6 x 70 x 1 feet, Photo: Margot Geist

These exhibitions have been supported in part by grants from the Institute of Museum and Library Services (IMLS); from the Wisconsin Arts Board, with funds from the State of Wisconsin; and with gifts from the RAM Society and other donors to the Racine Art Museum. *Toshiko Takaezu: Heaven and Earth* has also been supported in part by an award from the National Endowment for the Arts, which believes that a great nation deserves great art; by a grant from the Friends of Contemporary Ceramics; and through the sponsorship of SC Johnson & Son, Inc and Twin Disc, Inc.

Beyond the Pour:

Pairing Art and the Wine Label

October 21, 2005 - January 29, 2006

SAN FRANCISCO MUSEUM OF CRAFT+DESIGN

550 Sutter Street San Francisco CA 415.773.0303 www.sfmcd.org

Dominic DiMare Untitled (Self-Portrait) Pastel on paper 2003

Visit the Sculpture
Objects and Functional Art
website for in-depth
information on SOFA.
View works of art and
enjoy feature articles
on theory, criticism and
practice of contemporary
decorative and fine art.

SOFAEXPO.COM

**Online Exposition
of Sculpture Objects
& Functional Art**

sofaexpo.com

Wood Turning Center

Wood and Other Lathe-Turned Art

- International not-for-profit arts organization
- Promotes art from wood and other materials - turned and carved
- Gallery exhibitions, publications and Museum Store
- Research library with books, images and artist information

Membership Benefits

- Turning Points magazine, 4 issues a year
- Invitations to Center exhibitions
- 10% discount on books, CD's and videos
- New members receive 250 Japanese turned toothpicks
- Discounted registration to Center conferences and events
- Use of Center's research library

Join today and experience the thrills of the wood art community!

Visit the website for more information www.woodturningcenter.org

Education

Preservation

Promotion

Turning Points
Wood Turning Center

Jack Larimore, *Natural Desire*, 2003

Wood Turning Center
501 Vine Street, Philadelphia, PA 19106
tel: 215.923.8000
fax: 215.923.4403
turnon@woodturningcenter.org
www.woodturningcenter.org

Hours:
Tuesday – Friday 10am – 5pm
Saturday 12pm – 5pm

Turning Points
International news,
articles, images on art
from wood and
other materials from
the historic to the
most avant-garde.

Museums

Icheon World Ceramic Center | Gwangju Joseon Royal Kiln Museum | Yeoju World Ceramic Livingware Gallery

Icheon World Ceramic Center International Competition 2001 - 2005 | Masterpieces of Korean Ceramics 2005

Gwangju Joseon Royal Kiln Museum WOCEF Collection | Hall of Ceramic Culture | Korean Ceramics: Ceramics in Nature

Yeoju World Ceramic Livingware Gallery Ceramic House II | Teapots of the World | World Ceramic Souvenirs

Ceramic Special Library, DoJaManGwonDang

Ceramic Special Library is very pleased to accept donations of world ceramic artists' catalogues, thesis, publication and others.

World

Ceramic

Exposition

Foundation

재단법인세계도자기엑스포
WORLD CERAMIC EXPOSITION FOUNDATION 세계속의 경기도 GYEONGGI PROVINCE A Global Initiative **World Ceramic Exposition Foundation** | Mt. 69-1 Gwango-dong Icheon-si, Gyeonggi-do, Korea 467-020 | Tel: +82-31-631-6509 | Fax: +82-31-631-6648 | www.wocef.com | webmaster@wocef.or.kr

Winter classes begin on January 2, 2006

Chicago Bauhaus Academy

Woodworking & furniture design

A comprehensive program in fundamental and advanced woodworking

ChicagoBauhaus
Chicago Bauhaus Academy, NFP

contact:
Berthold Schwaiger

6525 North Clark Street
Chicago, Illinois 60626

telephone: (773) 338-1746
email: bhai2000@aol.com

www.chicagobauhaus.org
www.lf.org/bhai2000

Chris Nissen, *Chicago Night*, oil on canvas, 103 x 65"
Northwestern Memorial Hospital art collection, Galter Pavilion, third floor

Healing Through Art

Northwestern Memorial Hospital is in the building stages for a new women's hospital that will become the premier facility for women's health care in the nation. Art will be an important component in the development of a healing and welcoming environment for the facility. The Arts Program is made possible through the generosity of our friends and supporters. We welcome the opportunity to discuss ways that you can make a difference at the hospital through philanthropy. For more information, contact the Office of the Vice President of Northwestern Memorial Foundation at 312-926-7066.

SOUL-STIRRING WORKS®

Clay Foster

Temple Bowl, 32 inches high, elm column, pecan bowl

Wabi Sabi brooch, 18k granulation, S/S, spectrolite

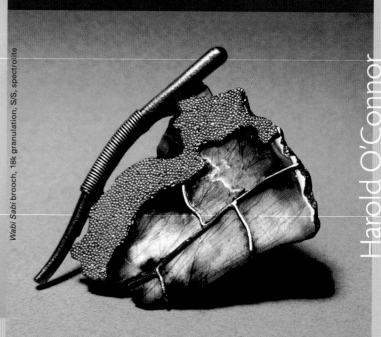

Harold O'Connor

CONTEMPORARY FINE CRAFT PATINA GALLERY™

131 West Palace Avenue, Santa Fe, NM 87501

505.986.3432

patina-gallery.com

PRIVATE AIR MAGAZINE
LIFE AT THE SPEED OF LUXURY

Personality
Travel
Weekend Getaways
Yachting
Automotive
Aviation
Real Estate Development
Luxury Lifestyle
Hotels
Cuisine
Fashion

0 KIDS

1 KID

2 KIDS

3 KIDS

2 KIDS

1 KID

▶ 0 KIDS

To us, where you are is every bit as important as where you're going. We create individually tailored strategies designed to keep your finances running smoothly, today, tomorrow and 20 years from now. And we use our extensive knowledge of investments and securities to help you choose the ones that are right for you. But what we really pride ourselves in knowing is people. We learn what's important to you. And we plan accordingly. So even though you don't know what the future will bring, you can take comfort in knowing you'll be ready for it. For a private consultation, contact Mary Jo Herseth, Group Senior Vice President, at (312) 904-1600.

Wealth Management: *Private Banking* *Investments* *Trusts* *Financial Planning* *Securities*

Making more possible **LaSalle Bank**
ABN AMRO

Index of Exhibitors

A

Aaron Faber Gallery
666 Fifth Avenue
New York, NY 10103
212.586.8411
fax 212.582.0205
info@aaronfaber.com
aaronfaber.com

**Aboriginal Galleries
of Australia**
35 Spring Street
Melbourne, Victoria 3000
Australia
61.3.9.654.2516
fax 61.3.9.654.3534
art@agamelbourne.com
maryanne.hollow@bigpond.com
agamelbourne.com

Adamar Fine Arts
358 San Lorenzo Avenue
Suite 3210
Coral Gables, FL 33146
305.576.1355
fax 305.448.5538
adamargal@aol.com
adamargallery.com

Aldo Castillo Gallery
233 West Huron Street
Chicago, IL 60610
312.337.2536
fax 312.337.3627
info@artaldo.com
artaldo.com

Andora Gallery
PO Box 5488
Carefree, AZ 85377
480.595.1039
fax 480.595.1069
info@andoragallery.com
andoragallery.com

Ann Nathan Gallery
212 West Superior Street
Chicago, IL 60610
312.664.6622
fax 312.664.9392
nathangall@aol.com
annnathangallery.com

ART+
358 San Lorenzo Avenue
Suite 3135
Miami, FL 33146
786.497.1111
fax 786.497.4104
info@artplusgallery.com
artplusgallery.com

Art Novell
Crossroads of Vail
Meadow Street
Vail, CO
970.479.5171
fax 952.470.0541
artnovell2003@yahoo.com
artnovell.com

Shops at Woodlake
Kohler, WI 53044
920.208.5145

Gaviidae Commons II
Minneapolis, MN 55401
612.332.2305

Artempresa
San Jeronimo 448
Cordoba 5000
Argentina
54.351.422.1290
fax 54.351.427.1776
artempresa@arnet.com.ar
artempresagallery.org

Australian Contemporary
19 Morphett Street
Adelaide 5000
Australia
61.8.8410.0727
fax 61.8.8231.0434
contact@jamfactory.com.au
jamfactory.com.au

Ann Nathan Gallery

Barrett Marsden Gallery
17-18 Great Sutton Street
London EC1V 0DN
England
44.20.7336.6396
info@bmgallery.co.uk
bmgallery.co.uk

Beaver Galleries
81 Denison Street, Deakin
Canberra, ACT 2600
Australia
61.2.6282.5294
fax 61.2.6281.1315
mail@beavergalleries.com.au
beavergalleries.com.au

Berengo Fine Arts
Fondamenta Vetrai 109/A
Murano, Venice 30141
Italy
39.041.739453
39.041.527.6364
fax 39.041.527.6588
adberen@berengo.com
berengo.com

Berengo Collection
Calle San Larga San Marco
412/413
Venice 30124
Italy
39.041.241.0763
fax 39.041.241.9456

Kortestraat 7
Arnhem 6811 EN
The Netherlands
31.26.370.2114
31.61.707.4402
fax 31.26.370.3362
berengo@hetnet.nl

Bluecoat Display Centre
Bluecoat Chambers
College Lane
Liverpool L1 3BX
United Kingdom
44.151.709.4014
fax 44.151.707.8106
crafts@bluecoatdisplaycentre.com
bluecoatdisplaycentre.com

browngrotta arts
Wilton, CT
203.834.0623
fax 203.762.5981
art@browngrotta.com
browngrotta.com

Brushings, Ltd.
By Appointment Only
Thompson, OH
440.298.1548
fax 440.298.3782
wwp@lightstream.net
brushings.com

Bullseye Connection Gallery
300 NW Thirteenth Avenue
Portland, OR 97209
503.227.0222
fax 503.227.0008
galleryweb@bullseyeglass.com
bullseyeconnectiongallery.com

**Caterina Tognon Arte
Contemporanea**
San Marco 2671
Campo San Maurizio
Venice 30124
Italy
39.041.520.7859
fax 39.041.520.7859
info@caterinatognon.com
caterinatognon.com

Chappell Gallery
526 West 26th Street
Suite 317
New York, NY 10001
212.414.2673
fax 212.414.2678
amchappell@aol.com
chappellgallery.com

Charon Kransen Arts
By Appointment Only
456 West 25th Street
New York, NY 10001
212.627.5073
fax 212.633.9026
charon@charonkransenarts.com
charonkransenarts.com

The David Collection
44 Black Spring Road
Pound Ridge, NY 10576
914.764.4674
fax 914.764.5274
jkdavid@optonline.net
thedavidcollection.com

del Mano Gallery
11981 San Vicente Boulevard
Los Angeles, CA 90049
310.476.8508
fax 310.471.0897
gallery@delmano.com
delmano.com

Despard Gallery
15 Castray Esplanade
Hobart, Tasmania 7000
Australia
61.36.223.8266
fax 61.36.223.6496
steven@despard-gallery.com.au
despard-gallery.com.au

Donna Schneier Fine Arts
By Appointment Only
New York, NY
212.472.9175
fax 212.472.6939
dnnaschneier@mhcable.com

Dubhe Carreño Gallery
1841 South Halsted Street
Chicago, IL 60608
312.666.3150
fax 312.577.0988
info@dubhecarrenogallery.com
dubhecarrenogallery.com

Elliott Brown Gallery
By Appointment Only
Seattle, WA
Mailing Address
PO Box 1489
North Bend, WA 98045
206.660.0923
fax 425.831.3709
kate@elliottbrowngallery.com
elliottbrowngallery.com

Ferrin Gallery
69 Church Street
Lenox, MA 01240
413.637.4414
fax 914.271.0047
info@ferringallery.com
ferringallery.com

Filippetti
6689 Opera Glass Crescent
Mississauga, Ontario L5W 1R7
Canada
416.566.5072
info@filippetti.ca
filippetti.ca

Franklin Parrasch Gallery
20 West 57th Street
New York, NY 10019
212.246.5360
fax 212.246.5391
franklin@franklinparrasch.com
franklinparrasch.com

Freed Gallery
6119 SW Highway 101
Lincoln City, OR 97367
541.994.5600
fax 541.994.5606
info@freedgallery.com
freedgallery.com

**Function + Art/PRISM
Contemporary Glass**
1046-1048 West Fulton Market
Chicago, IL 60607
312.243.2780
info@functionart.com
info@prismcontemporary.com
functionart.com
prismcontemporary.com

G.R. N'Namdi Gallery
110 North Peoria Street
Chicago, IL 60607
312.563.9240
fax 312.563.9299
contact@grnnamdi.com
grnnamdi.com

Galeria Mundial
Malva #58 Santa Maria
San Juan, Puerto Rico 00927
787.565.6258
galeriamundial@gmail.com

**Galerie Ateliers
d'Art de France**
4 Passage Roux
Paris 75017
France
33.1.4401.0830
fax 33.1.4401.0835
galerie@ateliersdart.com
ateliersdart.com

Galerie Besson
15 Royal Arcade
28 Old Bond Street
London W1S 4SP
England
44.20.7491.1706
fax 44.20.7495.3203
enquiries@galeriebesson.co.uk
galeriebesson.co.uk

**Galerie des Métiers
d'Art du Québec/
Galerie CREA**
Bonsecours Market
350 St. Paul Street East
Montreal, Quebec H2Y 1H2
Canada
514.878.2787, ext. 2
fax 514.861.9191
france.bernard@
 metiers-d-art.qc.ca
galeriedesmetiersdart.com

Galerie Metal
Nybrogade 26
Copenhagen 1203
Denmark
45.33.145540
fax 45.33.145540
galeriemetal@mail.dk
galeriemetal.dk

Galerie Pokorná
Janský Vršek 15
Prague 1, 11800
Czech Republic
420.222.518635
fax 420.222.518635
office@galeriepokorna.cz
galeriepokorna.cz

Galerie Tactus
By Appointment Only
6 Stavangergade
DK 2100 Copenhagen
Denmark
45.33.933105
fax 45.33.326001
tactus@galerietactus.com
galerietactus.com

Galerie Vivendi
28 Place des Vosges
Paris 75003
France
33.1.4276.9076
fax 33.1.4276.9547
vivendi@vivendi-gallery.com
vivendi-gallery.com

Galleri Grønlund
Birketoften 16a
Copenhagen 3500
Denmark
45.44.442798
fax 45.44.442798
groenlund@get2net.dk
glassart.dk

Galleri Nørby
Vestergade 8
Copenhagen 1456
Denmark
45.33.151920
fax 45.33.151963
info@galleri-noerby.dk
galleri-noerby.dk

Gallery 500 Consulting
3502 Scotts Lane
Philadelphia, PA 19129
215.849.9116
fax 215.849.9116
gallery500@hotmail.com
gallery500.com

gallery gen
158 Franklin Street
New York, NY 10013
212.226.7717
fax 212.226.3722
info@gallerygen.com
gallerygen.com

**The Gallery, Ruthin
Craft Centre**
Park Road
Ruthin, Denbighshire LL15 1BB
Wales, United Kingdom
44.1824.704774
fax 44.1824.702060
thegallery@rccentre.org.uk

Genninger Studio
2793/A Dorsoduro
Calle del Traghetto
Venice 30123
Italy
39.041.522.5565
fax 39.041.522.5565
leslie@genningerstudio.com
genningerstudio.com

gescheidle
118 North Peoria, 4th floor
Chicago, IL 60607
312.226.3500
fax 312.226.6255
susan@gescheidle.com
gescheidle.com

Glass Artists' Gallery
70 Glebe Point Road
Glebe, Sydney, NSW 2037
Australia
61.2.9552.1552
fax 61.2.9552.1552
mail@glassartistsgallery.com.au
glassartistsgallery.com.au

Habatat Galleries
608 Banyan Trail
Boca Raton, FL 33431
561.241.4544
fax 561.241.5793
info@habatatgalleries.com
habatatgalleries.com

117 State Road
Great Barrington, MA 01230
413.528.9123
fax 413.644.9981

Habatat Galleries
4400 Fernlee Avenue
Royal Oak, MI 48073
248.554.0590
fax 248.554.0594
info@habatat.com
habatat.com

Hawk Galleries
153 East Main Street
Columbus, OH 43215
614.225.9595
fax 614.225.9550
tom@hawkgalleries.com
hawkgalleries.com

**Helen Drutt: Philadelphia/
Hurong Lou Gallery**
Helen Drutt: Philadelphia
By Appointment Only
Postal Address
2220-22 Rittenhouse Square
Philadelphia, PA 19103-5505
215.735.1625
fax 215.732.1382

Hurong Lou Gallery
320 Race Street
Philadelphia, PA 19106
215.238.8860
fax 215.238.8862
info@huronglou.com
huronglou.com

Heller Gallery
420 West 14th Street
New York, NY 10014
212.414.4014
fax 212.414.2636
info@hellergallery.com
hellergallery.com

Hibberd McGrath Gallery
101 North Main Street
PO Box 7638
Breckenridge, CO 80424
970.453.6391
fax 970.453.6391
terry@hibberdmcgrath.com
hibberdmcgrath.com

Holsten Galleries
3 Elm Street
Stockbridge, MA 01262
413.298.3044
fax 413.298.3275
artglass@holstengalleries.com
holstengalleries.com

House of Colors Gallery
34 Irby Avenue
Atlanta, GA 30305
404.233.6738
770.918.1182
rougefrenchlips@aol.com

**Jane Sauer Thirteen
Moons Gallery**
652 Canyon Road
Santa Fe, NM 87501
505.995.8513
fax 505.995.8507
jsauer@thirteenmoonsgallery.com
thirteenmoonsgallery.com

Jean Albano Gallery
215 West Superior Street
Chicago, IL 60610
312.440.0770
fax 312.440.3103
jeanalbano@aol.com
jeanalbanogallery.com

Jerald Melberg Gallery
625 South Sharon Amity Road
Charlotte, NC 28211
704.365.3000
fax 704.365.3016
gallery@jeraldmelberg.com
jeraldmelberg.com

John Natsoulas Gallery
521 First Street
Davis, CA 95616
530.756.3938
fax 530.756.3961
art@natsoulas.com
natsoulas.com

Katie Gingrass Gallery
241 North Broadway
Milwaukee, WI 53202
414.289.0855
fax 414.289.9255
katieg@execpc.com
gingrassgallery.com

Kirra Galleries
The Atrium, Federation Square
Swanston and Flinders Streets
Melbourne, Victoria 3000
Australia
61.3.9639.6388
fax 61.3.96398522
kirra@kirra.com
kirra.com

Kraft Lieberman Gallery
835 West Washington Boulevard
Chicago, IL 60607
312.948.0555
fax 312.948.0333
klfinearts@aol.com
klfinearts.com

Leo Kaplan Modern
41 East 57th Street
7th floor
New York, NY 10022
212.872.1616
fax 212.872.1617
lkm@lkmodern.com
lkmodern.com

Lost Angel Glass
79 West Market Street
Corning, NY 14830
877.937.3578
fax 607.937.3578
meghan@lostangelglass.com
lostangelglass.com

Marx-Saunders Gallery, Ltd.
230 West Superior Street
Chicago, IL 60610
312.573.1400
fax 312.573.0575
marxsaunders@earthlink.net
marxsaunders.com

Mary Pauline Gallery
982 Broad Street
Augusta, GA 30901
706.724.9542
fax 706.724.9543
molly@marypaulinegallery.com
marypaulinegallery.com

Mattson's Fine Art
2579 Cove Circle NE
Atlanta, GA 30319
404.636.0342
fax 404.636.0342
sundew@mindspring.com
mattsonsfineart.com

Maurine Littleton Gallery
1667 Wisconsin Avenue NW
Washington, DC 20007
202.333.9307
fax 202.342.2004
info@littletongallery.com
littletongallery.com

Mobilia Gallery
358 Huron Avenue
Cambridge, MA 02138
617.876.2109
fax 617.876.2110
mobiliaart@aol.com
mobilia-gallery.com

Modus Art Gallery
23 Place des Vosges
Paris 75003
France
33.1.4278.1010
fax 33.1.4278.1400
modus@galerie-modus.com
galerie-modus.com

Mostly Glass Gallery
34 Hidden Ledge Road
Englewood, NJ 07631
201.816.1222
fax 201.503.9522
info@mostlyglass.com
mostlyglass.com

Mowen Solinsky Gallery
225 Broad Street
Nevada City, CA 95959
530.265.4682
fax 530.265.8469
info@mowensolinskygallery.com
mowensolinskygallery.com

**Next Step Studio
and Gallery**
530 Hilton Road
Ferndale, MI 48220
248.342.5074
fax 248.414.7050
nextstepstudio@aol.com
nextstepstudio.com

**Niemi Sculpture
Gallery & Garden**
13300 116th Street
Kenosha, WI 53142
262.857.3456
fax 262.857.4567
gallery@bruceniemi.com
bruceniemi.com

Option Art
4216 de Maisonneuve Blvd. West
Suite 302
Montreal, Quebec H3Z 1K4
Canada
514.932.3987
fax 514.932.6182
info@option-art.ca
option-art.ca

Orley & Shabahang
5841 Wing Lake Road
Bloomfield Hills, MI 48301
voice 586.996.5800
fax 248.524.2909
geoffreyorley@aol.com
shabahangcarpets.com

240 South County Road
Palm Beach, FL 33480
voice 561.655.3371
fax 561.655.0037
shabahangorley@adelphia.net

223 East Silver Spring Drive
Whitefish Bay, WI 53217
voice 414.332.2486
fax 414.332.9121
shabahangcarpets@gmail.com

Ornamentum
506.5 Warren Street
Hudson, NY 12534
518.671.6770
fax 518.822.9819
info@ornamentumgallery.com
ornamentumgallery.com

Perimeter Gallery, Inc.
210 West Superior Street
Chicago, IL 60610
312.266.9473
fax 312.266.7984
perimeterchicago@
 perimetergallery.com
perimetergallery.com

Pistachios
55 East Grand Avenue
Chicago, IL 60611
312.595.9437
fax 312.595.9439
pistach@ameritech.net
pistachiosonline.com

Portals Ltd.
742 North Wells Street
Chicago, IL 60610
312.642.1066
fax 312.642.2991
artisnow@aol.com
portalsgallery.com

R. Duane Reed Gallery
7513 Forsyth Boulevard
St. Louis, MO 63105
314.862.2333
fax 314.862.8557
reedart@primary.net
rduanereedgallery.com

529 West 20th Street
New York, NY 10011
212.462.2600
fax 212.462.2510
reedartnyc@primary.net

Raglan Gallery
5-7 Raglan Street
Manly, Sydney, NSW 2095
Australia
61.2.9977.0906
fax 61.2.9977.0906
jankarras@hotmail.com
raglangallery.com.au

Rami G. Abboud Jewelers
44 Rue des Tournelles
Paris 75004
France
832.794.4913
fax 213.891.0661
info@ramiabboud.com
ramiabboud.com

550 South Hill Street
Los Angeles, CA 90013

Sabbia
66 East Walton Street
2nd floor
Chicago, IL 60611
312.440.0044
fax 312.440.0007
sabbiafinejewelry@hotmail.com

Sherrie Gallerie
937 North High Street
Columbus, OH 43201
614.298.8580
fax 614.298.8570
info@sherriegallerie.com
sherriegallerie.com

**Sherry Leedy
Contemporary Art**
2004 Baltimore Avenue
Kansas City, MO 64108
816.221.2626
fax 816.221.8689
sherryleedy@sherryleedy.com
sherryleedy.com

Sienna Gallery
80 Main Street
Lenox, MA 01240
413.637.8386
sienna@siennagallery.com
siennagallery.com

Snyderman-Works Galleries
303 Cherry Street
Philadelphia, PA 19106
215.238.9576
fax 215.238.9351
bruce@snyderman-works.com
snyderman-works.com

Tai Gallery/Textile Arts
616 1/2 Canyon Road
Santa Fe, NM 87501
505.984.1387
fax 505.989.7770
gallery@textilearts.com
textilearts.com

Thomas R. Riley Galleries
28699 Chagrin Boulevard
Cleveland, OH 44122
216.765.1711
fax 216.765.1311
trr@rileygalleries.com
rileygalleries.com

UrbanGlass
647 Fulton Street
Brooklyn, NY 11217-1112
718.625.3685
fax 718.625.3889
info@urbanglass.org
urbanglass.org

W

WEISSPOLLACK Galleries
521-531 West 25th Street
Ground floor #9
New York, NY 10001
212.989.3708
fax 212.989.6392
info@weisspollack.com
weisspollack.com

2938 Fairfield Avenue
Bridgeport, CT 06605
203.333.7733
fax 203.362.2628

Wexler Gallery
201 North 3rd Street
Philadelphia, PA 19106
215.923.7030
fax 215.923.7031
info@wexlergallery.com
wexlergallery.com

William Siegal Galleries
135 West Palace Avenue
Suite101
Santa Fe, NM 87501
voice 505.820.3300
info@williamsiegalgalleries.com
williamsiegalgalleries.com

William Zimmer Gallery
10481 Lansing Street
Mendocino, CA 95460
707.937.5121
fax 707.937.2405
wzg@mcn.org
williamzimmergallery.com

Yaw Gallery
550 North Old Woodward
Birmingham, MI 48009
248.647.5470
fax 248.647.3715
yawgallery@msn.com
yawgallery.com

Z

**ZeST Contemporary
Glass Gallery**
Roxby Place
London SW6 1RS
England
44.20.7610.1900
fax 44.20.7610.3355
naomi@zestgallery.com
zestgallery.com

Aaronson, Adam
ZeST Contemporary
Glass Gallery

Abait, Luciana
Jean Albano Gallery

Abboud, Rami G.
Rami G. Abboud Jewelers

Abraham, Françoise
Modus Art Gallery

Abrams, Jackie
Katie Gingrass Gallery

Abrasha
William Zimmer Gallery

Adams, Hank Murta
Elliott Brown Gallery
Wexler Gallery

Aguilar, Jorge
Option Art

Ahlgren, Jeanette
Mobilia Gallery

Akagi, Chieko
Yaw Gallery

Akers, Adela
browngrotta arts
Jane Sauer Thirteen
Moons Gallery

Akitomo, Miho
Charon Kransen Arts

Albert, Sean
Chappell Gallery

Alepedis, Efharis
Charon Kransen Arts

Allen, Rik
Thomas R. Riley Galleries

Allen, Shelley Muzylowski
Thomas R. Riley Galleries

Allert, Henrik
Berengo Fine Arts

Allison, Di
Despard Gallery

Aloni, Mical
Hibberd McGrath Gallery

Amrhein, Scott
Mowen Solinsky Gallery

Andersen, Carsten From
Galerie Metal

Anderson, Dan
Snyderman-Works Galleries

Anderson, Dona
browngrotta arts

Anderson, Jeanine
browngrotta arts

Anderson, Kate
Snyderman-Works Galleries

Anderson, Ken
Katie Gingrass Gallery

Andrus, Bruno
Option Art

Angelino, Gianfranco
del Mano Gallery

Anis, Michael
Pistachios

Anselmo, Paolo
Berengo Fine Arts

Aoki, Mikiko
The David Collection

Appel, Nicolai
Galerie Metal

Arata, Tomomi
Mobilia Gallery

Arentzen, Glenda
Aaron Faber Gallery

Arman
ART+

Arneson, Robert
Franklin Parrasch Gallery
John Natsoulas Gallery

Arnold, Christian
Kirra Galleries

Arp, Marijke
browngrotta arts

Arria, Maria Cristina
Aldo Castillo Gallery

Artman, Ron
Thomas R. Riley Galleries

Aslanis, George
Kirra Galleries

Autio, Rudy
R. Duane Reed Gallery

Babetto, Giampaolo
Sienna Gallery

Babula, Mary Ann
Chappell Gallery

Bach, Carolyn Morris
Gallery 500 Consulting

Badessi, Laurent Ellie
ART+

Bak, Kirsten
Charon Kransen Arts

Baker, Jill
Andora Gallery

Bakker, Ralph
Charon Kransen Arts

Baldwin, Gordon
Barrett Marsden Gallery

Baldwin, Philip
Thomas R. Riley Galleries
Wexler Gallery

Balsgaard, Jane
browngrotta arts

Barker, Jo
browngrotta arts

Barnaby, Margaret
Aaron Faber Gallery

Barnes, Dorothy Gill
browngrotta arts

Barrios, Rafael
ART+

Barry, Donna
Mobilia Gallery

Bartels, Rike
Charon Kransen Arts

Bartlett, Caroline
Andora Gallery
browngrotta arts

Basch, Sara
The David Collection

Bass, Kim
Mobilia Gallery

Bauer, Carola
Charon Kransen Arts

Bauermeister, Michael
del Mano Gallery

Beaulieau, Maria
Yaw Gallery

Beck, Rick
Marx-Saunders Gallery, Ltd.

Becker, Michael
Charon Kransen Arts

Becker, Pamela
Snyderman-Works Galleries

Behar, Linda
Mobilia Gallery

Behennah, Dail
browngrotta arts

Behrens, Hanne
Mobilia Gallery

Belfrage, Clare
Beaver Galleries

Ben Tre, Howard
Wexler Gallery

Bencomo, Derek
del Mano Gallery

Bennett, David
Habatat Galleries

Bennett, Garry Knox
Leo Kaplan Modern

Bennett, Jamie
Sienna Gallery

Benzle, Curtis
Sherrie Gallerie

Benzoni, Luigi
Berengo Fine Arts

Bergner, Lanny
Snyderman-Works Galleries

Berman, Harriete Estel
Charon Kransen Arts
Mobilia Gallery

Bernstein, Alex Gabriel
Chappell Gallery

Bero, Mary
Ann Nathan Gallery

Bess, Nancy Moore
browngrotta arts

Bettison, Giles
Bullseye Connection Gallery
Wexler Gallery

Bienvenu, Micajah
Freed Gallery

Biggs, Dixie
del Mano Gallery

Bikakis, Myron
Yaw Gallery

Bilenker, Melanie
Sienna Gallery

Biles, Russell
Ferrin Gallery

Birch, Karin
Snyderman-Works Galleries

Birkkjaer, Birgit
browngrotta arts

Bisetto, Gabriella
Australian Contemporary

Bishoff, Bonnie
Function + Art/PRISM
 Contemporary Glass

Bjerring, Claus
Galerie Tactus

Black, Sandra
Raglan Gallery

Blacklock, Kate
Jane Sauer Thirteen
 Moons Gallery

Blackmore, Cassandria
R. Duane Reed Gallery

Blackwood, Jaye
Freed Gallery

Blade, Danielle
Lost Angel Glass

Blank, Alexander
The David Collection

Blank, Martin
Habatat Galleries

Blavarp, Liv
Charon Kransen Arts

Bloch, Janet
gescheidle

Bloch, Ruth
Galeria Mundial

Block, Susan
Freed Gallery

Bloomfield, Greg
Leo Kaplan Modern

Bobrowicz, Yvonne
Snyderman-Works Galleries

Bodemer, Iris
Ornamentum

Bodker, Lene
Marx-Saunders Gallery, Ltd.

Boï, Massimo
Galerie Vivendi

Bokesch-Parsons, Mark
Maurine Littleton Gallery

Boldon, Brian
Dubhe Carreño Gallery

Book, Flora
Mobilia Gallery

Booker, Chakaia
G.R. N'Namdi Gallery

Boregaard, Pedro
Sabbia

Borgenicht, Ruth
Sherry Leedy Contemporary Art
Snyderman-Works Galleries

Borghesi, Marco
Aaron Faber Gallery

Borgman, Mary
Ann Nathan Gallery

Borowski, Pawel
Habatat Galleries

Borowski, Stanislaw
Habatat Galleries

Borowski, Stanislaw Yan
Habatat Galleries

Boucard, Yves
Leo Kaplan Modern

Bowden, Jane
Australian Contemporary

Boyd, Michael
Mobilia Gallery

Braeuer, Antje
Charon Kransen Arts

Brandes, Juliane
Ornamentum

Brandt, Susie
gescheidle

Braque, Georges
ART+

Bravura, Dusciana
Berengo Fine Arts

Bredsted, Yvette N.S.
Galerie Metal

Bremers, Peter
Thomas R. Riley Galleries

Brennan, Sara
browngrotta arts

Brenno, Brian
Freed Gallery

Breskin Adams, Renie
Mobilia Gallery

Bridgwater, Margaret
Galerie Metal

Briggs, Jason
Sherry Leedy Contemporary Art

Brinkmann, Beate
The David Collection

Britton, Alison
Barrett Marsden Gallery

Broadhead, Caroline
Barrett Marsden Gallery

Brock, Charissa
Jane Sauer Thirteen
 Moons Gallery

Brock, Emily
Habatat Galleries

Bromley Marks, Patricia
Despard Gallery

Brooks, Lola
Sienna Gallery

Brown, Jeff
William Zimmer Gallery

Brown, Melanie
The Gallery, Ruthin Craft Centre

Brychtová, Jaroslava
Caterina Tognon Arte
 Contemporanea
Donna Schneier Fine Arts
Galerie Pokorná

Buchert, Wilhelm
Aaron Faber Gallery

Buckman, Jan
browngrotta arts

Buescher, Sebastian
Charon Kransen Arts

Büge, Ute
Aaron Faber Gallery

Bump, Raissa
Sienna Gallery

Burchard, Christian
Andora Gallery
del Mano Gallery

Burgel, Klaus
Mobilia Gallery

Burger, Falk
Yaw Gallery

Burgess, Cefyn
The Gallery, Ruthin Craft Centre

Bursuker, Moshe
UrbanGlass

Bussières, Maude
Galerie des Métiers d'Art
 du Québec/Galerie CREA

Butt, Harlan
Yaw Gallery

Byczewski, Jacek
Snyderman-Works Galleries

Caballero, Ernest
Mowen Solinsky Gallery

Cain, Charlotte
Sherry Leedy Contemporary Art

Calder, Alexander
ART+

Caldwell, Dorothy
Mobilia Gallery
Snyderman-Works Galleries

Camden, Emma
Chappell Gallery

Campbell, Pat
browngrotta arts

Cantin, Annie
Galerie des Métiers d'Art
 du Québec/Galerie CREA

Cantwell, Christopher
WEISSPOLLACK Galleries

Carlin, David
del Mano Gallery

Carlson, William
Leo Kaplan Modern
Marx-Saunders Gallery, Ltd.

Carney, Shannon
Charon Kransen Arts

Carter, Carol Ann
G.R. N'Namdi Gallery

Casanovas, Claudi
Galerie Besson

Cash, Sydney
Chappell Gallery

Castillo, Aldo
Aldo Castillo Gallery

Castle, Wendell
Wexler Gallery

Cathie, Christie
Chappell Gallery

Cederquist, John
Franklin Parrasch Gallery

Celotto, Afro
Function + Art/PRISM
 Contemporary Glass

Cepka, Anton
Charon Kransen Arts

Cěrmák, Richard
Galerie Pokorná

Cěrmáková, Lenka
Galerie Pokorná

Chandler, Gordon
Ann Nathan Gallery

Chardiet, José
Leo Kaplan Modern
Marx-Saunders Gallery, Ltd.
Wexler Gallery

Charles, Don
Thomas R. Riley Galleries

Chase, Dale
del Mano Gallery

Chaseling, Scott
Leo Kaplan Modern

Chatt, David K.
Mobilia Gallery

Chatterley, Mark
Gallery 500 Consulting

Chavent, Claude
Aaron Faber Gallery

Chavent, Françoise
Aaron Faber Gallery

Chereau, Jacques
Modus Art Gallery

Cherry, M. Ivan
gescheidle

Chesney, Nicole
Heller Gallery

Chicago, Judy
John Natsoulas Gallery

Chihuly, Dale
Donna Schneier Fine Arts
Elliott Brown Gallery
Holsten Galleries
Wexler Gallery

Christie, Barbara
The David Collection

Chung, Richard
Sherry Leedy Contemporary Art

Cigler, Václav
Caterina Tognon Arte
 Contemporanea
Galerie Pokorná

Clague, Lisa
John Natsoulas Gallery

Class, Petra
Pistachios

Clausager, Kirsten
Mobilia Gallery

Clayman, Daniel
Habatat Galleries

Clayton, Deanna
Habatat Galleries

Clayton, Keith
Habatat Galleries

Clegg, Tessa
Barrett Marsden Gallery
Wexler Gallery

Coates, Kevin
Mobilia Gallery

Cocks, Deb
Glass Artists' Gallery

Cohen, Barbara
Snyderman-Works Galleries

Cohen, Carol
Wexler Gallery

Cohen, Mardi Jo
Snyderman-Works Galleries

Coleman, Rod
Glass Artists' Gallery

Collingwood, Peter
Galerie Besson

Colombino, Carlos
Aldo Castillo Gallery

Colquitt, Susan
Katie Gingrass Gallery

Consentino, Cynthia
Dubhe Carreño Gallery

Constantine, Greg
Jean Albano Gallery

Conty, Angela
Aaron Faber Gallery

Cook, Lia
Mobilia Gallery
Perimeter Gallery, Inc.

Cooper, Diane
Jean Albano Gallery

Coper, Hans
Galerie Besson

Corcoran, Annette
Ferrin Gallery

Cordova, Cristina
Ann Nathan Gallery

Corvaja, Giovanni
Charon Kransen Arts

Côte, Marie-Andrée
Galerie des Métiers d'Art
 du Québec/Galerie CREA

Cottrell, Simon
Charon Kransen Arts

Coulson, Valerie Jo
Aaron Faber Gallery

Crain, Joyce
Snyderman-Works Galleries

Craste, Laurent
Galerie des Métiers d'Art
 du Québec/Galerie CREA

Cribbs, KéKé
Leo Kaplan Modern

Croasdale, Martha
Lost Angel Glass

Crooks and Beers
R. Duane Reed Gallery

Crow, Nancy
Snyderman-Works Galleries

Cutrone, Daniel
Snyderman-Works Galleries

Cylinder, Lisa
Snyderman-Works Galleries

Cylinder, Scott
Snyderman-Works Galleries

Da Silva, Jack
Mobilia Gallery

Da Silva, Marilyn
Mobilia Gallery

Daga, Oscar
Artempresa

Dahm, Johanna
Ornamentum

Dailey, Dan
Leo Kaplan Modern
Wexler Gallery

Dali, Salvador
Aldo Castillo Gallery
ART+

Dam, Steffen
Galleri Grønlund

Danberg, Leah
del Mano Gallery

Dardek, Dominique
Modus Art Gallery

de Corte, Annemie
Charon Kransen Arts

De Keyzer, Dirk
Galerie Vivendi

De Lafontaine, Elyse
Galerie des Métiers d'Art
 du Québec/Galerie CREA

de Santillana, Laura
Elliott Brown Gallery
Wexler Gallery

Debroeck
House of Colors Gallery

DeFrancesca, Sophie
Option Art

DeMonte, Claudia
Jean Albano Gallery

Derry, Donald
Thomas R. Riley Galleries

DeStaebler, Stephen
Franklin Parrasch Gallery

Detarando, Dawn
Option Art

DeVore, Richard
Donna Schneier Fine Arts
Franklin Parrasch Gallery

Di Fiore, Miriam
Mostly Glass Gallery

Diaz, Raul
Jerald Melberg Gallery

Dick, Pearl
Kraft Lieberman Gallery

Dickinson, Ellen
Snyderman-Works Galleries

Dillingham, Rick
Donna Schneier Fine Arts

Dixon, Stephen
Bluecoat Display Centre

Docter, Marcia
Snyderman-Works Galleries

Dodd, John
William Zimmer Gallery

Dolack, Linda
Mobilia Gallery

Dombrowski, Joachim
The David Collection

Donazetti, Suzanne
Katie Gingrass Gallery

Donefer, Laura
R. Duane Reed Gallery

Donzelli, Maurizio
Caterina Tognon Arte
 Contemporanea

Doolan, Devta
Aaron Faber Gallery

Dorph-Jensen, Sidsel
Galerie Tactus

Dragon, Patrick
Katie Gingrass Gallery

Dresang, Paul
Ferrin Gallery

Drivsholm, Trine
Galleri Grønlund

Drury, Chris
browngrotta arts

Dubois, Valerie
The David Collection

Dunn, J. Kelly
del Mano Gallery

Duong, Sam Tho
Ornamentum

Durot, Louis
House of Colors Gallery

Earl, Jack
Perimeter Gallery, Inc.

Eastman, Ken
Barrett Marsden Gallery

Eastman, Michael
R. Duane Reed Gallery
Sherry Leedy Contemporary Art

Ebendorf, Robert
Snyderman-Works Galleries

Eberle, Edward
Perimeter Gallery, Inc.

Echols-Howell, Tammy
Snyderman-Works Galleries

Eckert, Carol
Jane Sauer Thirteen
 Moons Gallery

Eckert, Tom
Mobilia Gallery

Edgerley, Susan
Galerie des Métiers d'Art
 du Québec/Galerie CREA

Edlund, Jenny
Galerie Tactus

Edols, Benjamin
Beaver Galleries

Eglin, Philip
Barrett Marsden Gallery

Ehmck, Nina
Aaron Faber Gallery
The David Collection

Elia, Paul
Andora Gallery

Eliás, Bohumil
Galerie Pokorná

Elkins, Julie
Ferrin Gallery

Elliott, Kathy
Beaver Galleries

Ellis-Smith, Wendy
Portals Ltd.

Ellsworth, David
del Mano Gallery

Elyashiv, Noam
Sienna Gallery

Emery, Leslie
Katie Gingrass Gallery

Entner, Barry
Lost Angel Glass

Erickson, Robert
Mowen Solinsky Gallery

Eriksson, Petronella
The David Collection

Eskuche, Matt
Thomas R. Riley Galleries

Espersen, Helle Løvig
Galerie Metal

Espersen, Morten Løbner
Galleri Nørby

Evans, Ann Catrin
The Gallery, Ruthin Craft Centre

Falkesgaard, Lina
Galerie Tactus

Fanourakis, Lina
Aaron Faber Gallery
Sabbia

Farey, Lizzie
browngrotta arts

Farge, Catherine
Galerie Ateliers d'Art de France

Federighi, Christine
Gallery 500 Consulting

Feibleman, Dorothy
Mobilia Gallery

Fein, Harvey
del Mano Gallery

Fekete, Alex
Function + Art/PRISM
 Contemporary Glass

Feller, Lucy
Ferrin Gallery

Fennell, J. Paul
del Mano Gallery

Fernandez, Magdalena
Aldo Castillo Gallery

Ferrari, Gerard
Ann Nathan Gallery

Fidler, Greg
Function + Art/PRISM
 Contemporary Glass

Fielder, Larry
Katie Gingrass Gallery

Filippetti, Giampietro
Filippetti

Firmager, Melvyn
del Mano Gallery

Fisch, Arline
Mobilia Gallery

Fleck-Stabley, Deb
Snyderman-Works Galleries

Fleming, Ron
del Mano Gallery

Flockinger, CBE, Gerda
Mobilia Gallery

Fok, Nora
Mobilia Gallery

Ford, John
Snyderman-Works Galleries

Forlano, David
Snyderman-Works Galleries

Frank, Mark
del Mano Gallery

Frank, Peter
Charon Kransen Arts

Franzin, Maria Rosa
Ornamentum

Freda, David
Mobilia Gallery

Frève, Carole
Galerie des Métiers d'Art
 du Québec/Galerie CREA

Frey, Viola
Donna Schneier Fine Arts
Franklin Parrasch Gallery

Frith, Donald E.
del Mano Gallery

Fritsch, CBE, Elizabeth
Mobilia Gallery

Fritz, Don
gescheidle

Fujinuma, Noboru
Tai Gallery/Textile Arts

Fujita, Emi
Mobilia Gallery

Fujita, Kyohei
Thomas R. Riley Galleries

Fukuchi, Kyoko
The David Collection

Funaki, Mari
Australian Contemporary

Furimsky, Erin
Dubhe Carreño Gallery

Galazka, Rafal
Mattson's Fine Art

Galazzo, Barbara
Pistachios

Gall, Theodore
Niemi Sculpture
 Gallery & Garden

Gallas, Tania
The David Collection

Galloway-Whitehead, Gill
The David Collection

Gardner, Mark
Andora Gallery

Gargano, John
Next Step Studio and Gallery

Garrett, John
Jane Sauer Thirteen
 Moons Gallery

Gartner, Stephen Rolf
Lost Angel Glass

Gather, Michael
Despard Gallery

Gavotti, Elizabeth
Artempresa

Geertsen, Michael
Galleri Nørby

Geldersma, John
Jean Albano Gallery

Gellner
Pistachios

Gentille, Thomas
Ornamentum

Georgieva, Ceca
browngrotta arts

Gérard, Bruno
Galerie des Métiers d'Art
 du Québec/Galerie CREA

Gerbig-Fast, Lydia
Mobilia Gallery

Giard, Monique
Galerie des Métiers d'Art
 du Québec/Galerie CREA

Gilbert, Chantal
Galerie des Métiers d'Art
 du Québec/Galerie CREA

Gilbert, Karen
Sherrie Gallerie

Giles, Mary
browngrotta arts
R. Duane Reed Gallery

Gill, Seamus
Galerie Tactus

Gillespie, Ty
Katie Gingrass Gallery

Girdler-Engler, Kathy
Mary Pauline Gallery

Gjaltema, Jan
Freed Gallery

Glasgow, Susan Taylor
Heller Gallery

Glickman, Larry
Freed Gallery

Gnaedinger, Ursula
Charon Kransen Arts
The David Collection

Godbout, Rosie
Option Art

Goetschius, Stephen
Andora Gallery
Katie Gingrass Gallery

Gonnet, Bernard
Galerie Ateliers d'Art de France

Gonzales, Arthur
John Natsoulas Gallery

Good, Michael
Aaron Faber Gallery
The David Collection

Goodman, Jeff
Andora Gallery

Gordon, Alasdair
Kirra Galleries

Gordon, Rish
Kirra Galleries

Gori-Montanelli, Danielle
Snyderman-Works Galleries

Gottlieb, Dale
Gallery 500 Consulting

Grace, Holly
Glass Artists' Gallery

Gray, Katherine
Elliott Brown Gallery

Grebe, Robin
Heller Gallery
Wexler Gallery

Grecco, Krista
Ann Nathan Gallery

Green, Linda
browngrotta arts

Greenaway, Victor
Raglan Gallery

Gross, Michael
Ann Nathan Gallery

Grossen, Françoise
browngrotta arts

Guggisberg, Monica
Thomas R. Riley Galleries
Wexler Gallery

Guyon, Marjorie
G.R. N'Namdi Gallery

Hagedorn, Christine
G.R. N'Namdi Gallery

Halabi, Sol
Artempresa

Hall, Laurie
Hibberd McGrath Gallery

Hall, Patrick
Despard Gallery

Halt, Karen
Portals Ltd.

Hamm, Ulrike
The David Collection

Hamma, Michael
The David Collection

Hanagarth, Sophie
Charon Kransen Arts

Hancock, Mark
Andora Gallery

Hanning, Tony
Kirra Galleries

Hannon, Rebecca
Ornamentum

Hansen, Bente
Galleri Nørby

Hansen, Else Nicolai
Galerie Metal

Harari, Yossi
Sabbia

Harbin, Angie
del Mano Gallery

Hardenberg, Torben
Galerie Tactus

Harley, Niki
Kirra Galleries

Harris, Mark
Thomas R. Riley Galleries

Harris, Rain
Ferrin Gallery

Hart, Margit
Mobilia Gallery

Hart, Noel
Kirra Galleries

Hatakeyama, Norie
browngrotta arts

Hatakeyama, Seido
Tai Gallery/Textile Arts

Hauss, Sabine
Ornamentum

Hawksley, Rozanne
The Gallery, Ruthin Craft Centre

Hay, David
Glass Artists' Gallery

Hayashibe, Masako
The David Collection

Hayes, Peter
William Zimmer Gallery

Hector, Valerie
Charon Kransen Arts

Heilig, Marion
The David Collection

Heine, Elisabeth
Ornamentum

Heinrich, Barbara
Aaron Faber Gallery
Pistachios
William Zimmer Gallery

Held, Archie
William Zimmer Gallery

Henderson, Ewen
Galerie Besson

Hendrickson, Carrianne
del Mano Gallery

Henricksen, Ane
browngrotta arts

Henriksen, Mette Laier
Galerie Metal

Henton, Maggie
browngrotta arts

Hernmarck, Helena
browngrotta arts

Hibbert, Louise
del Mano Gallery

Hicks, Sheila
browngrotta arts

Higuchi, Kimiake
Habatat Galleries

Hildebrandt, Marion
browngrotta arts

Hill, Chris
Ann Nathan Gallery

Hill, Thomas
Bluecoat Display Centre

Hiller, Mirjam
Charon Kransen Arts

Hilton, Eric
Habatat Galleries

Hindsgavl, Louise
Galleri Nørby

Hirte, Lydia
The David Collection

Hlava, Pavel
Galerie Pokorná

Hlavicka, Tomas
Habatat Galleries

Hoadley, Thomas
Sherrie Gallerie

Hobin, Agneta
browngrotta arts

Hoge, Susan
Yaw Gallery

Hole, Nina
Galleri Nørby

Hollibaugh, Nick
Mobilia Gallery

Holmes, Kathleen
Chappell Gallery

Honda, Syoryu
Tai Gallery/Textile Arts

Honma, Hideaki
Tai Gallery/Textile Arts

Honma, Kazue
browngrotta arts

Hooper, Richard
Bluecoat Display Centre

Hopkins, Jan
Mobilia Gallery

Hora, Petr
Habatat Galleries

Horn, Robyn
del Mano Gallery

Hosaluk, Michael
Mobilia Gallery

Howe, Brad
Adamar Fine Arts

Howell, Catrin
The Gallery, Ruthin Craft Centre

Hoyer, Todd
del Mano Gallery

Hoyt, Judith
Snyderman-Works Galleries

Hromek, Peter
del Mano Gallery

Hu, Mary Lee
Mobilia Gallery

Huang, David
del Mano Gallery

Huchthausen, David
Leo Kaplan Modern

Huff, Melissa
Aaron Faber Gallery

Hunt, Kate
browngrotta arts

Hunter, Lissa
Jane Sauer Thirteen
Moons Gallery

Hunter, William
del Mano Gallery

Hurlbert, Jacqueline
Mowen Solinsky Gallery

Hutter, Sidney
Marx-Saunders Gallery, Ltd.

Huycke, David
Galerie Tactus

Hydman-Vallien, Ulrica
Wexler Gallery

Ide, Hisaya
gallery gen

Iezumi, Toshio
Chappell Gallery

Ikeda, Yoshiro
Sherry Leedy Contemporary Art

Ikemoto, Kazumi
Chappell Gallery

Ionesco, Ion
Yaw Gallery

Ipsen, Steen
Galleri Nørby

Isaacs, Ron
Snyderman-Works Galleries

Ishida, Meiri
Charon Kransen Arts

Ishikawa, Mari
The David Collection

Ishiyama, Reiko
Charon Kransen Arts

Isupov, Sergei
Ferrin Gallery

Iversen, John
Yaw Gallery

Iwata, Hiroki
Charon Kransen Arts

Iwata, Kiyomi
Perimeter Gallery, Inc.

Izawa, Yoko
The David Collection

J

Jacobs, Ferne
Snyderman-Works Galleries

James, Judith
Snyderman-Works Galleries

James, Michael
Snyderman-Works Galleries

Jameson, Kerry
Snyderman-Works Galleries

Janacek, Vlastislav
Mostly Glass Gallery

Janich, Hilde
Charon Kransen Arts

Jauquet, William
Katie Gingrass Gallery

Jenkins, Caitlin
The Gallery, Ruthin Craft Centre

Jensen, Mette
Charon Kransen Arts

Jivetin, Sergey
Andora Gallery
Ornamentum

Jocz, Dan
Mobilia Gallery

Johansson, Karin
Charon Kransen Arts

Johanson, Rosita
Mobilia Gallery

Jolley, Richard
Leo Kaplan Modern
Mary Pauline Gallery

Jones, Taliaferro
Andora Gallery

Jónsdóttír, Kristín
browngrotta arts

Jordan, John
del Mano Gallery

Jordan, Roxana
Galeria Mundial

Joy, Christine
browngrotta arts

Juenger, Ike
Charon Kransen Arts

Juparulla, Sam
Glass Artists' Gallery

Jupp, Mo
Galerie Besson

Kahn, Wolf
Jerald Melberg Gallery

Kaiser, Virginia
Raglan Gallery

Kaldahl, Martin Bodilsen
Galleri Nørby

Kallenberger, Kreg
Leo Kaplan Modern

Kamata, Jiro
Ornamentum

Kamens, Kim
Snyderman-Works Galleries

Kaminski, Vered
Sienna Gallery

Kaneko, Jun
Sherry Leedy Contemporary Art

Karash, Deb
Mobilia Gallery

Karlslund, Micha Maria
Galleri Grønlund

Karnes, Karen
Ferrin Gallery

Katsushiro, Soho
Tai Gallery/Textile Arts

Kaufman, Glen
browngrotta arts

Kaufmann, Martin
Charon Kransen Arts
Galerie Tactus

Kaufmann, Ruth
browngrotta arts

Kaufmann, Ulla
Charon Kransen Arts
Galerie Tactus

Kawano, Shoko
Tai Gallery/Textile Arts

Kawashima, Shigeo
Tai Gallery/Textile Arts

Kawata, Tamiko
browngrotta arts

Keefe, Hannah
Mobilia Gallery

Keeler, Walter
The Gallery, Ruthin Craft Centre

Kelman, Janet
Function + Art/PRISM
Contemporary Glass

Kennard, Steven
del Mano Gallery

Kent, Ron
del Mano Gallery

Kerman, Janis
Aaron Faber Gallery
Option Art

Key, Ray
del Mano Gallery

Khan, Kay
Jane Sauer Thirteen
Moons Gallery

Kim, Hwa-Jin
Ornamentum

Kim, Kyung Shin
The David Collection

Kim, Yoon Jeong
Charon Kransen Arts

Kindelmann, Heide
The David Collection

King, Gerry
Mostly Glass Gallery

Kinnaird, MBE, Alison
ZeST Contemporary
 Glass Gallery

Kirk, Richard
Galerie Tactus

Kirkpatrick, Joey
Elliott Brown Gallery

Klancic, Anda
browngrotta arts

Klein, Bonnie
del Mano Gallery

Klein, Steve
Bullseye Connection Gallery

Klemp, Stefanie
Charon Kransen Arts

Kline, Jonathan
Snyderman-Works Galleries

Klingebiel, Jutta
Mobilia Gallery
Ornamentum

Knauss, Lewis
browngrotta arts
Jane Sauer Thirteen
 Moons Gallery

Kngwarreye, Emily Kame
Aboriginal Galleries of Australia

Knobel, Esther
Sienna Gallery

Knowles, Sabrina
R. Duane Reed Gallery

Kobayashi, Mazakazu
browngrotta arts

Kobayashi, Naomi
browngrotta arts

Kobayashi, Shirobe
gallery gen

Kochansky, Ellen
Katie Gingrass Gallery

Koenigsberg, Nancy
browngrotta arts
Snyderman-Works Galleries

Kohl-Spiro, Barbara
Katie Gingrass Gallery

Kohyama, Yasuhisa
browngrotta arts

Kolesnikova, Irina
browngrotta arts

Koons, Jeff
Adamar Fine Arts

Kopecký, Vladimir
Chappell Gallery

Korowitz-Coutu, Laurie
UrbanGlass

Kosonen, Markku
browngrotta arts

Koven, Mark
ART+

Kraen, Annette
Mobilia Gallery

Kraft, Jim
Freed Gallery

Krakowski, Yael
Charon Kransen Arts

Kratz, Mayme
Elliott Brown Gallery

Kremer, Martin
Lost Angel Glass

Kreuder, Loni
Modus Art Gallery

Krueger, Winfried
Charon Kransen Arts

Kruger, Daniel
Sienna Gallery

Kuhn, Jon
Marx-Saunders Gallery, Ltd.
Wexler Gallery

Kumai, Kyoko
browngrotta arts

Kurakawa, Okinari
Mobilia Gallery

Kuraoka, David
Mowen Solinsky Gallery

Kusumoto, Mariko
Mobilia Gallery

Kypris, Yorgos
Freed Gallery

Kyriakou, Costas
The David Collection

L

La Scola, Judith
Maurine Littleton Gallery

Labino, Dominic
Wexler Gallery

Lacoursiere, Leon
del Mano Gallery

LaCross, Curt
R. Duane Reed Gallery

Lahover, Shay
Yaw Gallery

Lake, Tai
William Zimmer Gallery

Laken, Birgit
Mobilia Gallery

Laky, Gyöngy
browngrotta arts

Lamar, Stoney
del Mano Gallery

Lamarche, Antoine
Galerie des Métiers d'Art
 du Québec/Galerie CREA

Langley, Warren
Raglan Gallery

Langton, Gilly
Bluecoat Display Centre

Larochelle, Christine
Galerie des Métiers d'Art
 du Québec/Galerie CREA

Larsen, Brooke L.
gescheidle

Larsen, Merete
del Mano Gallery

Larssen, Ingrid
The David Collection

Latven, Bud
del Mano Gallery

Lawrence, Wendy
The Gallery, Ruthin Craft Centre

Layport, Ron
del Mano Gallery

Layton, Peter
Freed Gallery

Lechman, Patti
del Mano Gallery

Lee, Dongchun
Charon Kransen Arts

Lee, Ed Bing
Snyderman-Works Galleries

Lee, Jennifer
Galerie Besson

Lee, Michael
del Mano Gallery

Lee, Seung-Hea
Sienna Gallery

Lee, Whitney
gescheidle

Leib, Shayna
Function + Art/PRISM
 Contemporary Glass

Lemieux Berubé, Louise
Galerie des Métiers d'Art
 du Québec/Galerie CREA

Lepisto, Jeremy
Thomas R. Riley Galleries

Leuthold, Marc
Sherrie Gallerie

Levenson, Silvia
Caterina Tognon Arte
 Contemporanea

Levin, Mark
Function + Art/PRISM
 Contemporary Glass

Leviton, Linda
Katie Gingrass Gallery

Lewis, Anna
The Gallery, Ruthin Craft Centre

Lewis, John
Leo Kaplan Modern

Liao, Chun
Barrett Marsden Gallery

Libenský, Stanislav
Caterina Tognon Arte
 Contemporanea
Donna Schneier Fine Arts
Galerie Pokorná

Lieglein, Wolli
Ornamentum

Liles, Robin
House of Colors Gallery

Lillie, Jacqueline
Sienna Gallery

Lindhardt, Louise Hee
Galerie Metal

Lindqvist, Inge
browngrotta arts

Lipofsky, Marvin
R. Duane Reed Gallery
Wexler Gallery

Littleton, Harvey K.
Maurine Littleton Gallery
Wexler Gallery

Littleton, John
Maurine Littleton Gallery

Ljones, Åse
browngrotta arts

Loeser, Thomas
Leo Kaplan Modern

Lohman, Jan
Mobilia Gallery

Lolek
Modus Art Gallery

Lomné, Alicia
Bullseye Connection Gallery

Look, Dona
Perimeter Gallery, Inc.

Lory, David
Katie Gingrass Gallery

Lotz, Tyler
Dubhe Carreño Gallery

Loughlin, Jessica
Bullseye Connection Gallery

Louiselio
Galerie Ateliers d'Art de France

Løvaas, Astrid
browngrotta arts

Lovera, James
Andora Gallery

Løvschal, Lone
Galerie Tactus

Lucero, Michael
Donna Schneier Fine Arts

Lugossy, Maria
Habatat Galleries

Lukacsi, Laszlo
Habatat Galleries

Lundberg, Tom
Hibberd McGrath Gallery
Mobilia Gallery

Luttenbacher, Géraldine
Galerie Ateliers d'Art de France

Lynch, Sydney
William Zimmer Gallery

Lyon, Lucy
Thomas R. Riley Galleries

Maberley, Simon
Kirra Galleries

Macdonald, Marcia
Hibberd McGrath Gallery

Mace, Flora C.
Elliott Brown Gallery

MacEwan, Tracy
Freed Gallery

Machata, Peter
Charon Kransen Arts

MacKenzie, Warren
gallery gen

Mackin, Brian
Freed Gallery

Macnab, John
del Mano Gallery

MacNeil, Linda
Leo Kaplan Modern

MacNutt, Dawn
browngrotta arts

Madsen, Sten Lykke
Galleri Nørby

Maeda, Asagi
Mobilia Gallery

Maestre, Jennifer
Mobilia Gallery

Magni, Vincent
Modus Art Gallery

Maierhofer, Fritz
Mobilia Gallery

Mailland, Alain
del Mano Gallery

Majoral, Enric
Aaron Faber Gallery

Maldonado, Estuardo
Aldo Castillo Gallery

Maldonado, Ricky
del Mano Gallery

Malinowski, Ruth
browngrotta arts

Manz, Bodil
Galleri Nørby

Marchetti, Stefano
Charon Kransen Arts

Marder, Daniel N.
Kraft Lieberman Gallery

Marder, Donna Rhae
Mobilia Gallery

Mares, Ivan
Heller Gallery

Marioni, Dante
Marx-Saunders Gallery, Ltd.

Marquis, Richard
Elliott Brown Gallery
Wexler Gallery

Marsden, Robert
Barrett Marsden Gallery

Marsh, Bert
del Mano Gallery

Martin, Jim
Mowen Solinsky Gallery

Martin, Rick
Freed Gallery

Maruyama, Tomomi
Mobilia Gallery

Mason, Concetta
Wexler Gallery

Mason, John
Franklin Parrasch Gallery
Perimeter Gallery, Inc.

Massaro, Karen Thuesen
Perimeter Gallery, Inc.

Massei, Lucia
Charon Kransen Arts

Mathews, Mark
Thomas R. Riley Galleries

Matouskova, Anna
Chappell Gallery

Mattar, Wilhelm Tasso
The David Collection

Matthias, Christine
Charon Kransen Arts

Mattia, Alphonse
Mobilia Gallery

May, Susan
Bluecoat Display Centre

Mayeras, Françoise
House of Colors Gallery

Mayeri, Beverly
Perimeter Gallery, Inc.

Mazzoni, Ana
Artempresa

McArthur, Brian
Option Art

McBride, Kathryn
Ferrin Gallery

McClellan, Duncan
Thomas R. Riley Galleries

McCorrison, Ruth
Snyderman-Works Galleries

McDevitt, Elisabeth
Charon Kransen Arts

McLeod, James
WEISSPOLLACK Galleries

McNicoll, Carol
Barrett Marsden Gallery

McQueen, John
Elliott Brown Gallery
Mobilia Gallery
Perimeter Gallery, Inc.

Mears, Elizabeth
Function + Art/PRISM
 Contemporary Glass

Melchione, Becki
UrbanGlass

Merkel-Hess, Mary
browngrotta arts

Meszaros, Mari
R. Duane Reed Gallery

Metcalf, Bruce
Charon Kransen Arts

Metz, Matthew
Ferrin Gallery

Meyer, Gudrun
Pistachios

Meyer, Sharon
Thomas R. Riley Galleries

Michaels, Guy
William Zimmer Gallery

Michel, Nancy
Mobilia Gallery

Micheluzzi, Massimo
Wexler Gallery

Michikawa, Shozo
Galerie Besson

Mickelsen, Robert
Function + Art/PRISM
 Contemporary Glass

Miguel
Charon Kransen Arts

Miles, Cathy
Bluecoat Display Centre

Miller, John
Thomas R. Riley Galleries

Millett, Adia
G.R. N'Namdi Gallery

Mincham, Jeff
Raglan Gallery

Minn, Sewon
Dubhe Carreño Gallery

Minnhaar, Gretchen
Adamar Fine Arts
Aldo Castillo Gallery

Minoura, Chikuho
Tai Gallery/Textile Arts

Mitchell, Dennis Lee
Dubhe Carreño Gallery

Mitchell, Tyrone
G.R. N'Namdi Gallery

Mitsushima, Kazuko
Mobilia Gallery

Miyaji-Zeltserman, Yoko
Mobilia Gallery

Miyamura, Hideaki
Andora Gallery

Møhl, Tobias
Galleri Grønlund

Monden, Yuichi
Tai Gallery/Textile Arts

Mongrain, Jeffrey
Perimeter Gallery, Inc.

Montini, Milissa
Snyderman-Works Galleries

Moore, Debora
R. Duane Reed Gallery

Moore, Marilyn
del Mano Gallery

Mori, Junko
Bluecoat Display Centre

Morigami, Jin
Tai Gallery/Textile Arts

Morinoue, Hiroki
William Zimmer Gallery

Moro, Luigi
Galerie Vivendi

Morris, Darrel
gescheidle

Morris, William
Thomas R. Riley Galleries
Wexler Gallery

Morsberger, Philip
Mary Pauline Gallery

Mossman, Ralph
Thomas R. Riley Galleries

Moulthrop, Matt
del Mano Gallery

Moulthrop, Philip
del Mano Gallery

Mount, Nick
Thomas R. Riley Galleries

Mowen, John
Mowen Solinsky Gallery

Mueller, Louis
Elliott Brown Gallery

Muerrle, Norbert
Pistachios

Muhlfellner, Martina
The David Collection

Mulford, Judy
browngrotta arts

Munn, Alice Ballard
Jerald Melberg Gallery

Munsteiner, Bernd
Aaron Faber Gallery

Munsteiner, Tom
Aaron Faber Gallery

Murray, David
Chappell Gallery

Murray, Paula
William Zimmer Gallery

Myers, Joel Philip
Marx-Saunders Gallery, Ltd.
Wexler Gallery

Myers, Rebecca
Next Step Studio and Gallery

Nagakura, Kenichi
Tai Gallery/Textile Arts

Nagano, Kazumi
Mobilia Gallery

Nahabetian, Dennis
Andora Gallery
del Mano Gallery

Nakamura, Naoka
Charon Kransen Arts

Nancey, Christophe
Galerie Ateliers d'Art de France

Napanangka, Makinti
Aboriginal Galleries of Australia

Negre, Suzanne Otwell
The David Collection

Neilson, Rosalie
Freed Gallery

Nemec-Kessel, Charlene
Ann Nathan Gallery

Nemtoi, Ioan
Art Novell

Neuman, Jeremy
Thomas R. Riley Galleries

Newell, Catharine
Bullseye Connection Gallery

Newell, Steven
Barrett Marsden Gallery

Nicholson, Laura Foster
Katie Gingrass Gallery

Nicholson, Janet
Mowen Solinsky Gallery

Nicholson, Rick
Mowen Solinsky Gallery

Nickerson, John
Hibberd McGrath Gallery

Niemeijer, Martin
Charon Kransen Arts

Niemi, Bruce A.
Niemi Sculpture
 Gallery & Garden

Niessing
Pistachios

Nijland, Evert
Charon Kransen Arts

Nio, Keiji
browngrotta arts

Nishi, Etsuko
Chappell Gallery

Nishizaki, Satoshi
WEISSPOLLACK Galleries

Niso
Adamar Fine Arts

Nittman, David
del Mano Gallery

Nobles, Beth
Hibberd McGrath Gallery

Noyons, Karina
Galerie Metal

Nuñez, Cristina
Artempresa

Obrecht, Sarah
Function + Art/PRISM
 Contemporary Glass

O'Connor, Harold
Mobilia Gallery

O'Dorisio, Joel
Lost Angel Glass

O'Dwyer, Kevin
Galerie Tactus

O'Hanrahan, Brigid
Mobilia Gallery

Ohira, Yoichi
Wexler Gallery

Okore, Nnenna
gescheidle

Olsen, Fritz
Niemi Sculpture
 Gallery & Garden

Olson, Lena
The David Collection

Onofrio, Judy
Sherry Leedy Contemporary Art

Onofrio-Fornes, Jennifer
Sherry Leedy Contemporary Art

Orchard, Jenny
Despard Gallery

Orme, Turiya
Raglan Gallery

Orth, David
Function + Art/PRISM
 Contemporary Glass

Ossipov, Nikolai
del Mano Gallery

Osterrieder, Daniela
Charon Kransen Arts

Otis, Jeanne
Sherrie Gallerie

Ott, Helge
The David Collection

Ouellette, Caroline
Galerie des Métiers d'Art
 du Québec/Galerie CREA

Owczarzak, Tom
Freed Gallery

Owen, Doug
Sherry Leedy Contemporary Art

Paganin, Barbara
Charon Kransen Arts

Pala, Štěpán
Galerie Pokorná

Paley, Albert
Hawk Galleries
Jerald Melberg Gallery

Palma, Hugo
Aldo Castillo Gallery

Palová, Zora
Galerie Pokorná

Palusky, Robert
Habatat Galleries

Pañeda, Maria Ester
Artempresa

Pantano, Chris
Kirra Galleries

Papesch, Gundula
Charon Kransen Arts

Pappas, Marilyn
Snyderman-Works Galleries

Parcher, Joan
Mobilia Gallery

Pardon, Tod
Aaron Faber Gallery

Paredes, Miel-Margarita
Mobilia Gallery

Park, Eunjung
Ferrin Gallery

Parker-Eaton, Sarah
del Mano Gallery

Parmentier, Silvia
Artempresa

Patti, Tom
Heller Gallery
Wexler Gallery

Paulsen, Stephen Mark
Andora Gallery

Paust, Karen
Mobilia Gallery

Pearse, Mary
Sienna Gallery

Peich, Francesc
Galerie des Métiers d'Art
 du Québec/Galerie CREA

Peiser, Mark
Donna Schneier Fine Arts
Wexler Gallery

Peitz, Lorraine
gescheidle

Perez, Jesus Curia
Ann Nathan Gallery

Pérez-Guaita, Gabriela
Artempresa

Perkins, Danny
R. Duane Reed Gallery

Perkins, Flo
Hawk Galleries
Wexler Gallery

Perkins, Sarah
Mobilia Gallery

Perrotte, Simone
Galerie Ateliers d'Art de France

Persson, Stig
Galleri Grønlund

Pessolano, Ron
Andora Gallery

Peters, David
del Mano Gallery

Peters, Ruudt
Ornamentum

Peterson, George
Andora Gallery

Peterson, Michael
del Mano Gallery

Petersen, Huib
Snyderman-Works Galleries

Petrovic, Marc
Ferrin Gallery

Petter, Gugger
Mobilia Gallery

Petyarre, Anna
Aboriginal Galleries of Australia

Petyarre, Gloria
Aboriginal Galleries of Australia

Petyarre, Kathleen
Aboriginal Galleries of Australia

Pezzi, Daniel
Artempresa

Phardel, Tom
Next Step Studio and Gallery

Pheulpin, Simone
browngrotta arts

Phillips, Maria
The David Collection

Pho, Binh
del Mano Gallery

Pierce, Karen
Andora Gallery

Pierson, Markus
Galeria Mundial

Pierzchala, Theresa
Next Step Studio and Gallery

Pimental, Alexandra
The David Collection

Pinchuk, Anya
Charon Kransen Arts

Pinchuk, Natalya
Charon Kransen Arts

Pino, Claudio
Galerie des Métiers d'Art
 du Québec/Galerie CREA

Pohlman, Jenny
R. Duane Reed Gallery

Poissant, Gilbert
Option Art

Pon, Stephen
Galerie des Métiers d'Art
 du Québec/Galerie CREA

Portaleo, Karen
Ferrin Gallery

Portnoy, Sallie
Raglan Gallery

Powell, Stephen Rolfe
Donna Schneier Fine Arts
Marx-Saunders Gallery, Ltd.

Powers, Jill
del Mano Gallery

Powers, Pike
Elliott Brown Gallery

Powning, Peter
Habatat Galleries

Pragnell, Valerie
browngrotta arts

Prasch, Camilla
Galerie Metal

Prasil, Peter
Despard Gallery

Preston, Mary
Ornamentum

Priest, Linda Kindler
Aaron Faber Gallery

Primeau, Patrick
Galerie des Métiers d'Art
 du Québec/Galerie CREA

Prip, Janet
Mobilia Gallery

Pugh, Michael
Kraft Lieberman Gallery

Putnam, Toni
Portals Ltd.

Pwerle, Minnie
Aboriginal Galleries of Australia

Quadri, Giovanna
Mobilia Gallery

Quigley, Robin
Mobilia Gallery

Rack, Annette
Mobilia Gallery

Radda, Tania
del Mano Gallery

Radstone, Sara
Barrett Marsden Gallery

Raible, Kent
Aaron Faber Gallery
Mowen Solinsky Gallery

Rais, John
Jane Sauer Thirteen
 Moons Gallery

Rais, Lindsay K.
Jane Sauer Thirteen
 Moons Gallery

Ramshaw, OBE RDI, Wendy
Mobilia Gallery

Randal, Seth
Thomas R. Riley Galleries

Rankin, Susan
Option Art

Rannik, Kaire
Charon Kransen Arts

Rath, Tina
Sienna Gallery

Rauschke, Tom
Katie Gingrass Gallery

Rawdin, Kim
Aaron Faber Gallery

Rawnsley, Pamela
The Gallery, Ruthin Craft Centre

Rea, Kirstie
Bullseye Connection Gallery

Rea, Mel
Thomas R. Riley Galleries

Reekie, David
Thomas R. Riley Galleries

Reichert, Sabine
The David Collection

Reid, Colin
Maurine Littleton Gallery

Reitz, Don
Maurine Littleton Gallery

Rena, Nicholas
Barrett Marsden Gallery

Rench, Scott
Dubhe Carreño Gallery

Reymann, Julia
The David Collection

Rezac, Suzan
Mobilia Gallery

Rhoads, Kait
Chappell Gallery

Rich, Douglas
Function + Art/PRISM
 Contemporary Glass

Richmond, Ross
R. Duane Reed Gallery

Richmond, Vaughn
del Mano Gallery

Rickets, III, Rowland
Snyderman-Works Galleries

Ricks, Madelyn
Mostly Glass Gallery

Rie, Lucie
Galerie Besson

Rieber, Paul
William Zimmer Gallery

Riedel, Veronica
Aldo Castillo Gallery

Rieger, Patricia
Dubhe Carreño Gallery

Ries, Christopher
Hawk Galleries

Rietmeyer, Rene
Adamar Fine Arts

Riis, Jon Eric
Jane Sauer Thirteen
 Moons Gallery

Rinaldi, Zorine
Andora Gallery

Riond-Sibony, Anne-Lise
ZeST Contemporary
 Glass Gallery

Ritter, Richard
Marx-Saunders Gallery, Ltd.

Roberson, Sang
Hibberd McGrath Gallery

Roberts, Constance
Portals Ltd.

Robinson, John Paul
Galerie des Métiers d'Art
 du Québec/Galerie CREA

Rodgers, Emma
Bluecoat Display Centre
William Zimmer Gallery

Roebuk, Tiana
Option Art

Roethel, Cornelia
Yaw Gallery

Rohde, Michael
Katie Gingrass Gallery

Rose, Jim
Ann Nathan Gallery

Rose, Marlene
Adamar Fine Arts

Rose, Tim
William Zimmer Gallery

Rosenfeld, Erica
UrbanGlass

Rosin, Maria Grazia
Caterina Tognon Arte
 Contemporanea

Rosol, Martin
Function + Art/PRISM
 Contemporary Glass

Rossano, Joseph
Thomas R. Riley Galleries

Rossbach, Ed
browngrotta arts

Rothmann, Gerd
Ornamentum

Rothstein, Scott
browngrotta arts
Mobilia Gallery

**Rousseau-Vermette,
Mariette**
browngrotta arts

Route, Jon Michael
Katie Gingrass Gallery

Rowe, Michael
Barrett Marsden Gallery

Rubino, Silvano
Wexler Gallery

Ruffner, Ginny
R. Duane Reed Gallery

Rugge, Caroline
Mobilia Gallery

Ruhwald, Anders
Galleri Nørby

Russell, Brian
Jerald Melberg Gallery

Russmeyer, Axel
Andora Gallery

Russo, JoAnne
del Mano Gallery
Jane Sauer Thirteen
 Moons Gallery

Rust, Brian
Mary Pauline Gallery

Ruzsa, Alison
Mostly Glass Gallery

Ryan, Jackie
Charon Kransen Arts

Rydmark, Cheryl
William Zimmer Gallery

Sabokova, Gisela
Caterina Tognon Arte
 Contemporanea

Sachs, Debra
Andora Gallery
browngrotta arts

Safire, Helene
UrbanGlass

Saito, Kayo
The David Collection

Saito, Yuka
Mobilia Gallery

Salas, Jorge
Aldo Castillo Gallery

Sales, Michelle
Snyderman-Works Galleries

Salesin, Joshua
del Mano Gallery

Salomon, Alain
Modus Art Gallery

Sammartino, Mariana
Aaron Faber Gallery

Samplonius, David
Option Art

Sano, Takeshi
Chappell Gallery

Sano, Youko
Chappell Gallery

Sarneel, Lucy
Charon Kransen Arts

Satava, Richard
William Zimmer Gallery

Sato, Naoko
ZeST Contemporary
 Glass Gallery

Saylan, Merryll
del Mano Gallery

Schick, Marjorie
Mobilia Gallery

Schleeh, Colin
Katie Gingrass Gallery
Option Art

Schmid, Renate
Charon Kransen Arts

Schmitz, Claude
Charon Kransen Arts

Schmuck, Jonathan
Snyderman-Works Galleries

Schroeder, Scott
Function + Art/PRISM
 Contemporary Glass

Schunke, Michael J.
Next Step Studio and Gallery

Schutz, Biba
Charon Kransen Arts

Schwarz, David
Marx-Saunders Gallery, Ltd.

Schwieder, Paul
Hawk Galleries

Scoon, Thomas
Marx-Saunders Gallery, Ltd.

Scott, Joyce
Mobilia Gallery

Searles, Charles
G.R. N'Namdi Gallery

Seelig, Warren
Snyderman-Works Galleries

Segura, Rosa
Aldo Castillo Gallery

Seide, Paul
Leo Kaplan Modern

Seidenath, Barbara
Sienna Gallery

Sekiji, Toshio
browngrotta arts

Sekijima, Hisako
browngrotta arts

Sekimachi, Kay
browngrotta arts
del Mano Gallery

Semecka, Lada
Chappell Gallery

Semeraro, Alessia
Sienna Gallery

Sengel, David
del Mano Gallery

Sepkus, Alex
Sabbia

Sepulveda, Polimnia
Artempresa

Sewell, Benjamin
Chappell Gallery

Shabahang, Bahram
Orley & Shabahang

Shapiro, Karen
Snyderman-Works Galleries

Shapiro, Mark
Ferrin Gallery

Shaw, James
Freed Gallery

Shaw, Richard
John Natsoulas Gallery
Mobilia Gallery

Shaw, Tim
Glass Artists' Gallery

Sheffer, Avital
Beaver Galleries

Shelsher, Amanda
Raglan Gallery

Sheng, Shan Shan
Berengo Fine Arts

Sherman, Sondra
Sienna Gallery

Sherrill, Micah
Ferrin Gallery

Sherrill, Michael
Ferrin Gallery

Shimada, Kyoko
gallery gen

Shimaoka, Tatsuzo
Galerie Besson

Shimazu, Esther
John Natsoulas Gallery

Shimizu, Yoko
Mobilia Gallery

Shindo, Hiroyuki
browngrotta arts

Shinn, Carol
Hibberd McGrath Gallery

Shirley, Adam
Next Step Studio and Gallery

Shuler, Michael
del Mano Gallery

Simon, Michael
Ferrin Gallery

Simpson, Tommy
Leo Kaplan Modern

Sinner, Steve
del Mano Gallery

Sipkes, Evelien
Charon Kransen Arts

Sisson, Karyl
browngrotta arts
del Mano Gallery

Sjovold, Erling
gescheidle

Skau, John
Katie Gingrass Gallery

Skidmore, Brent
Function + Art/PRISM
 Contemporary Glass

Skjøttgaard, Bente
Galleri Nørby

Slee, Richard
Barrett Marsden Gallery

Sloan, Susan Kasson
Aaron Faber Gallery

Smelvær, Britt
browngrotta arts

Smith, Barbara Lee
Snyderman-Works Galleries

Smith, Christina
Mobilia Gallery

Smith, Fraser
Katie Gingrass Gallery

Smith, Hayley
del Mano Gallery

Smith, John
Despard Gallery

Smith, Martin
Barrett Marsden Gallery

Smith, Penny
Despard Gallery

Smuts, Butch
del Mano Gallery

So, Jin-Sook
browngrotta arts

Solis, Diana
Dubhe Carreño Gallery

Sonobe, Etsuko
Mobilia Gallery

Soosloff, Philip
Gallery 500 Consulting
Kraft Lieberman Gallery

Sørenson, Grethe
browngrotta arts

Spano, Elena
Charon Kransen Arts

Speckner, Bettina
Sienna Gallery

Spencer, Sharon
Mowen Solinsky Gallery

Spicer, Kathleen
G.R. N'Namdi Gallery

Spitzer, Silke
Ornamentum

Sramkova, Ivana
Heller Gallery

Standhardt, Kenneth
Mowen Solinsky Gallery

Stanger, Jay
Leo Kaplan Modern

Stankard, Paul
Marx-Saunders Gallery, Ltd.
Wexler Gallery

Stankiewicz, Miroslaw
Mattson's Fine Art

Starr, Ron
Kraft Lieberman Gallery

Statom, Therman
Maurine Littleton Gallery

Stebler, Claudia
Charon Kransen Arts

Stein, Carol
Andora Gallery

Sterling, Lisabeth
Marx-Saunders Gallery, Ltd.

Stern, Ethan
Chappell Gallery

Stern, Rob
ART+

Stevens, Missy
Hibberd McGrath Gallery
Katie Gingrass Gallery

Stiansen, Kari
browngrotta arts

St-Michael, Natasha
Galerie des Métiers d'Art
 du Québec/Galerie CREA

Straker, Ross
Despard Gallery

Strickstein, Scott
Next Step Studio and Gallery

Striffler, Dorothee
Charon Kransen Arts

Strokowsky, Cathy
Andora Gallery

Strommen, Jay
Perimeter Gallery, Inc.

Stuart, Kraft
Portals Ltd.

Stubbs, Crystal
Kirra Galleries

Stutman, Barbara
Charon Kransen Arts

Sugawara, Noriko
Aaron Faber Gallery

Sugita, Jozan
Tai Gallery/Textile Arts

Suh, Hye-Young
Charon Kransen Arts

Suidan, Kaiser
Next Step Studio and Gallery

Sullivan, Brandon
Mobilia Gallery

Sultan, Donald
Adamar Fine Arts
Kraft Lieberman Gallery

Sung-Hwan, Hong
ZeST Contemporary
 Glass Gallery

Suo, Emiko
Snyderman-Works Galleries

Superior, Mara
Ferrin Gallery

Surgent, April
Bullseye Connection Gallery

Sutton, Polly Adams
Katie Gingrass Gallery

Suzuki, Hiroshi
Galerie Tactus

Swyler, Karen
Dubhe Carreño Gallery

Syron, J.M.
Function + Art/PRISM
 Contemporary Glass

Syvanoja, Janna
Charon Kransen Arts

T

Tagliapietra, Lino
Holsten Galleries
Wexler Gallery

Takaezu, Toshiko
Donna Schneier Fine Arts
Perimeter Gallery, Inc.

Takamiya, Noriko
browngrotta arts

Takayama-Ogawa, Joan
Ferrin Gallery

Tamaian, Ion
Art Novell

Tanaka, Chiyoko
browngrotta arts

Tanaka, Hideho
browngrotta arts

Tanigaki, Ema
del Mano Gallery

Tanikawa, Tsuroko
browngrotta arts

Tanner, James
Maurine Littleton Gallery

Tate, Blair
browngrotta arts

Tawney, Lenore
browngrotta arts

Taylor, Michael
Leo Kaplan Modern

Tedesco, Chris
Freed Gallery

Tepper, Irv
Franklin Parrasch Gallery

Thakker, Salima
Charon Kransen Arts

Thayer, Susan
Ferrin Gallery

Thiel, Susan
Pistachios

Thiele, Mark
Raglan Gallery

Thompson, Cappy
Leo Kaplan Modern

Tiitsar, Ketli
Charon Kransen Arts

Timm-Ballard, Charles
Sherry Leedy Contemporary Art

Tisch, Tomas
Wexler Gallery

Tjapaltjarri, Mick Namerari
Aboriginal Galleries of Australia

Tjapaltjarri, Walala
Aboriginal Galleries of Australia

**Tjupurrula, Johnny
Warrangkula**
Aboriginal Galleries of Australia

Tjupurrula, Turkey Tolson
Aboriginal Galleries of Australia

Tolla
Adamar Fine Arts
Galerie Vivendi

Tolosa, Maria Alejandra
Artempresa

Tolvanen, Terhi
Charon Kransen Arts

Tom, Gregory
Next Step Studio and Gallery

Tomita, Jun
browngrotta arts

Toops, Cynthia
Mobilia Gallery

Topescu, Mihai
Art Novell

Torii, Ippo
Tai Gallery/Textile Arts

Torma, Anna
Snyderman-Works Galleries

Toro, Elias
Artempresa

Toso, Gianni
Leo Kaplan Modern

Toth, Margit
Habatat Galleries

Townsend, Kent
William Zimmer Gallery

Townsend, Milon
Thomas R. Riley Galleries

Trask, Jennifer
Andora Gallery
Mobilia Gallery

Trekel, Silke
Charon Kransen Arts

Trenchard, Stephanie
Thomas R. Riley Galleries

Trujillo, Sandra
Ferrin Gallery

Tsuji, Noriko
UrbanGlass

Tuccillo, John
Ann Nathan Gallery

Turner, Julia
Ornamentum

Turner, Robert
Helen Drutt: Philadelphia/
 Hurong Lou Gallery

Tyler, James
R. Duane Reed Gallery

Ueno, Masao
Tai Gallery/Textile Arts

Umbdenstock, Jean-Pierre
Modus Art Gallery

Ungvarsky, Melanie
UrbanGlass

Upton, Gary
Mowen Solinsky Gallery

Urbán, Ramon
Jerald Melberg Gallery

Urbschat, Erik
Charon Kransen Arts

Vagi, Flora
Charon Kransen Arts

Vallien, Bertil
Donna Schneier Fine Arts
Marx-Saunders Gallery, Ltd.
Wexler Gallery

Valoma, Deborah
browngrotta arts

van Aswegen, Johan
Sienna Gallery

Van Cline, Mary
Leo Kaplan Modern

van der Leest, Felieke
Charon Kransen Arts

van Kesteren, Maria
Barrett Marsden Gallery

van Orshaegen, Ben
Charon Kransen Arts

Van Rensselaer, Miles
Heller Gallery

Van Stom, Feyona
Artempresa

Vandershoot, Wim
Mobilia Gallery

Vanhille, Goedelle
Jane Sauer Thirteen
 Moons Gallery

Vaughan, Grant
del Mano Gallery

Vaughan, Jim
Despard Gallery

Veilleux, Luci
Galerie des Métiers d'Art
 du Québec/Galerie CREA

Verkoyen, Claire
Snyderman-Works Galleries

Vermandere, Peter
Charon Kransen Arts

Vermette, Claude
browngrotta arts

Vermeulen, Tim
gescheidle

Vesery, Jacques
del Mano Gallery

Vigliaturo, Silvio
Berengo Fine Arts

Vikman, Ulla-Maija
browngrotta arts

Vilhena, Manuel
Charon Kransen Arts

Virden, Jerilyn
Ann Nathan Gallery

Vischer-Wolfinger, Barbara
Ornamentum

Visintin, Grazianna
Mobilia Gallery

Vizner, Frantisek
Donna Schneier Fine Arts
Wexler Gallery

Vogel, Kate
Maurine Littleton Gallery

Vogt, Luzia
Ornamentum

Volkov, Noi
William Zimmer Gallery

Votsi, Elena
Aaron Faber Gallery

Voulkos, Peter
Donna Schneier Fine Arts
Franklin Parrasch Gallery

W

Wagle, Kristen
browngrotta arts

Wagner, Karin
Charon Kransen Arts

Wahl, Wendy
browngrotta arts

Walentynowicz, Janusz
Marx-Saunders Gallery, Ltd.

Walgate, Wendy
Ferrin Gallery

Walker, Audrey
The Gallery, Ruthin Craft Centre

Walker, Jason
Ferrin Gallery

Walker, Robert
Jean Albano Gallery

Wallstrom, Mona
The David Collection

Walsh, Michaelene
Dubhe Carreño Gallery

Walz, Sylvia
Mobilia Gallery

Wang, Kiwon
Snyderman-Works Galleries

Warashina, Patti
John Natsoulas Gallery

Watanuki, Yasunori
Charon Kransen Arts

Watkins, Alexandra
Mobilia Gallery

Watson, Emily
Snyderman-Works Galleries

Webb, Roger
Despard Gallery

Weiland, Julius
Mostly Glass Gallery

Weinberg, Steven
Leo Kaplan Modern
Marx-Saunders Gallery, Ltd.

Weisel, Mindy
Jean Albano Gallery

Weiss, Beate
The David Collection
Ornamentum

Weissflog, Hans
del Mano Gallery

Weldon-Sandlin, Red
Ferrin Gallery

Westermark, Hedvig
The David Collection

Westphal, Katherine
browngrotta arts

Whiteley, Richard
Marx-Saunders Gallery, Ltd.

Wiken, Kaaren
Katie Gingrass Gallery

Willenbrink-Johnsen, Karen
Thomas R. Riley Galleries

Williams, Maureen
Australian Contemporary

Williamson, Dave
Snyderman-Works Galleries

Williamson, Roberta
Snyderman-Works Galleries

Wilson, Emily
Jerald Melberg Gallery

Wingfield, Leah
Habatat Galleries

Winqvist, Inge
browngrotta arts

Wise, Jeff
Aaron Faber Gallery

Wise, Susan
Aaron Faber Gallery

Woffenden, Emma
Barrett Marsden Gallery

Wolfe, Andi
del Mano Gallery

Wolfe, Rusty
William Zimmer Gallery

Wolfhagen, Marty
Despard Gallery

Wood, Beatrice
Donna Schneier Fine Arts

Woodman, Betty
Donna Schneier Fine Arts

Wunderlich, Janis Mars
Sherrie Gallerie

Wynne, Robert
Raglan Gallery

Yagi, Yoko
Snyderman-Works Galleries

Yamada, Mizuko
Mobilia Gallery

Yamaguchi, Ryuun
Tai Gallery/Textile Arts

Yamamoto, Yoshiko
Mobilia Gallery

Yamano, Hiroshi
Marx-Saunders Gallery, Ltd.

Yonezawa, Jiro
browngrotta arts
Jane Sauer Thirteen
 Moons Gallery

Yoshida, Masako
browngrotta arts

Yoshimura, Masaya
gallery gen

Yuki, Yoshiaki
gallery gen

Z

Zaborski, Maciej
Mattson's Fine Art

Zadeh, Catherine M.
Sabbia

Zámečnková, Dana
Galerie Pokorná

Zanella, Annamaria
Charon Kransen Arts
Mobilia Gallery

Zaytceva, Irina
Ferrin Gallery

Zehavi, Michal
R. Duane Reed Gallery

Zeleznicov, Nicu
Art Novell

Zembok, Udo
Galerie Ateliers d'Art de France

Zhitneva, Sasha
Chappell Gallery

Zobel, Michael
Aaron Faber Gallery
Pistachios

Zucca, Ed
Leo Kaplan Modern

Zynsky, Toots
Elliott Brown Gallery

SOFA
NEW YORK

SOFA
CHICAGO

The International Exposition of
Sculpture Objects & Functional Art

SOFA NEW YORK 2006

June 1-4
Seventh Regiment Armory

Opening Night
Wednesday, May 31

SOFA CHICAGO 2006

November 10-12
Navy Pier

Opening Night
Thursday, November 9

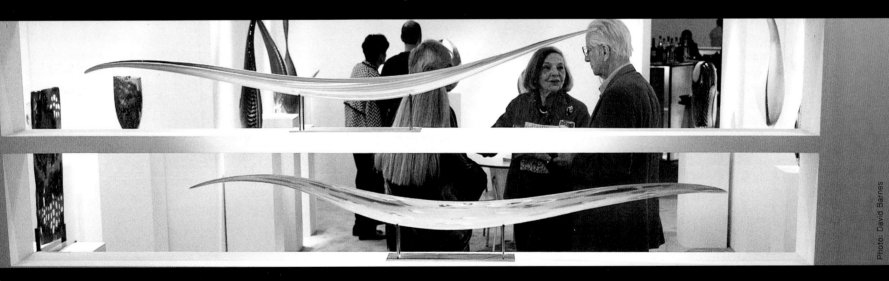

Photo: David Barnes

Information:
800.563.7632
info@sofaexpo.com

sofaexpo.com
For the latest news & information!